Painting Women's Portraits

JOE SINGER

Painting Women's Portraits

WATSON-GUPTILL PUBLICATIONS/NEW YORK
PITMAN PUBLISHING/LONDON

Copyright © 1977 by Watson-Guptill Publications

First published 1977 in the United States and Canada by Watson-Guptill Publications,
a division of Billboard Publications, Inc.
1515 Broadway, New York, New York 10036

Library of Congress Cataloging in Publication Data
Singer, Joe, 1923-
 Painting women's portraits.
 Bibliography: p.
 Includes index.
 1. Portrait painting—Technique. 2. Women—
Portraits. I. Title.
ND1329.3.W6S56 1977 751.4'5 76-57765
ISBN 0-8230-3882-3

Published in Great Britain by Pitman Publishing, Ltd.
39 Parker Street, London WC2B 5PB
ISBN 0-273-01050-6

Manufactured in U.S.A.

First printing, 1977

To the memory of my parents,
Israel and Genia Singer

Contents

Color Gallery

Artists at Work

Acknowledgments

I wish to thank several people who have helped bring this project to fruition: Don Holden for conceiving it; Andrea Ericson of Portraits, Inc. for her gracious assistance; Mimi Forsyth, Stephen Burns, Tony Mesok, and Eugene Dubno for their photographic contributions; Charles Baskerville, Paul C. Burns, Peter Cook, Clifford Jackson, Everett Raymond Kinstler, and David A. Leffel for allowing me to invade their studios and draw upon their valuable time and effort; and all the other artists who kindly contributed examples of their work to this book.

Introduction

Painting Women's Portraits doesn't purport to serve as a manual on portraiture for the raw beginner. The very specificity of the title establishes the presumption that the reader is familiar with at least the rudiments of painting in general and is ready to focus his attention on more singular areas. What the book does intend to do is to sharpen the reader's awareness of the peculiar challenges attending the painting of a woman's portrait—to alert him to detect, acknowledge, and confront these problems and then translate them into practical solutions.

The book is, therefore, organized into two major parts, with a color gallery between them. The first section deals with problems and solutions. It defines the object of the portrait, analyzes the physical aspects of the sitter, probes the attitudes and reactions of artist and sitter, and determines the demands and aspirations of both participants in this mutual effort. It then proceeds to diagnose the results of this investigation and indicate how they can be transmitted to canvas.

The color gallery shows examples of the work of a number of prominent contemporary portrait painters and includes color views of various stages of the demonstration paintings done by the six artists featured in the section of the book dealing with artists at work.

The book's second major section is based on searching interviews with six well-known professional artists who have faced the problems and challenges of painting women's portraits and have resolved them—each in his own individual fashion. Each chapter includes a step-by-step demonstration of how the featured artist draws upon his knowledge, experience, and expertise to paint a woman's protrait from start to finish. Thus, the book guides the reader from concept to plan to conclusion.

While the book points out the intriguing dissimilarities between the genders, it also acknowledges the individuality of every woman and shows how this precious identity can be preserved and enhanced in the finished portrait. I hope, all in all, that it provides you as much fun, stimulus, and edification in reading it as it did me in writing it.

PROBLEMS
AND
SOLUTIONS

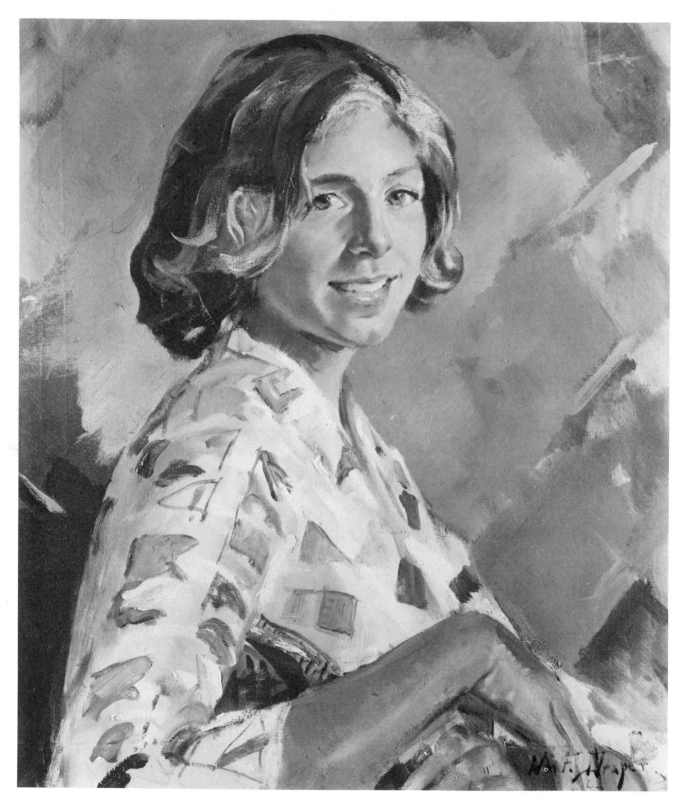

Francesca Draper by William F. Draper, oil on canvas, 24″ x 20″ (61 x 51 cm). In this sparkling portrait of his daughter, Bill Draper has elected to show the happy side of a young girl on the verge of womanhood. The direct look and the open, ingenuous expression characterize a youthful person who hasn't yet learned the need to conceal her emotions or present a guarded face to the world. The portrait is executed in high key and in bright color. Note how the bottom of the jawline has picked up the reflected light from the blouse.

CHAPTER ONE

Analyzing the Portrait

Essentially, the process of painting a portrait can be divided into three stages: analysis, diagnosis, and execution.

The first stage involves envisioning the overall problem by breaking it down into components. The second stage involves considering and resolving each of these components in conceptual terms. The third stage means executing your solutions.

Let us begin at the beginning.

Can a portrait be painted by rushing in helter-skelter, plopping the subject down in the nearest chair, squeezing out paint, and slapping out a reasonable likeness of her?

You bet it can—and too often that's just how portraits are painted. But this is morally reprehensible. How would a young woman about to have her first baby feel if the obstetrician responded to her enthusiasm in a bored, matter-of-fact fashion, looked her over perfunctorily, threw her some pills, and hustled her out of the office? The artist must forever remind himself that while he may have painted hundreds of portraits, this is probably his subject's first experience. A portrait painter is no less a professional practitioner than a doctor, a dentist, or a lawyer. He must approach each portrait with care, affection, intelligence, enthusiasm, and no preconceived notions whatsoever.

Each portrait must represent a totally new and fresh challenge. The worst possible approach to portraiture is to allow it to become a commercial venture in which the commodity happens to be a painting. Painting portraits by formula becomes a deadly exercise in futility. The artist grows quickly stale, bored, and cynical, and the product he grinds out assumes all the superficiality of a circus poster. No two subjects are alike. No two portraits should be alike. The way to avoid this is to conscientiously analyze each one so that it can be carefully diagnosed and executed.

Breaking Down the Problems

We can break down the analysis of a portrait into five specific and successive components:

1. Determine the purpose of the portrait.
2. Get to know the physical characteristics, dimensions, and proportions of the sitter.
3. Assess the emotional traits of the sitter.

4. Learn the sitter's attitudes, demands, and expectations regarding her portrait.
5. Determine what you, the artist, want to achieve in painting this particular portrait.

Let's consider each of these components in turn.

Purpose of the Portrait

Every portrait has, or should have, a specific purpose aside from its inherent function as a good work of art. There is the personal portrait, the family portrait, the institutional portrait, the commemorative portrait, the official portrait, etc. But within each category are further, more subtle divisions. Assuming the portrait is commissioned, the artist must ask and answer the following questions:

Who is paying for it: The sitter herself? Her husband? Her parents? Her children? A board of directors? A fraternal organization? A school? A governmental body?

These questions are important because they lead to the next question: Why is the person or group ordering the portrait? To pay a debt? To express love and admiration? Out of fear? To honor the sitter? To fill an empty space on a blank wall? Out of custom or tradition? To curry favor?

This leads to the next question: Is the subject willing? Reluctant? Eager? Doubtful? Apprehensive?

And the next question: Why was I chosen to paint it? Because my price is right? Because I was available at the time? Because I'm known as a good "women's painter"? Because it's assumed I'll agree to flatter? Because I'm currently "hot"? Because I painted her neighbor? Because I live nearby? Or because the client genuinely admires my work?

Having satisfied yourself on all or most of these questions, you should have a better idea what the portrait is intended to do. This leads to the next consideration.

Physical Aspects of Your Sitter

With rare exceptions, artists agree that getting to know the sitter may be the most important factor of the portrait. While this knowledge includes both the inner and outer traits of the person, only the latter are most apparent. To anyone working in such a visual medium as painting, these are apt to be considered first.

Charles Baskerville (whose demonstration appears on pages 76-77 and 94-97) maintains that a woman entering a room projects a certain flair or impact that's individually her own. This first impression is valued by many painters, and they strive to fix it in their minds when first encountering the subject. It subsequently serves as the basis upon which they construct the entire portrait. Ray Kinstler (whose demonstration appears on pages 84-85 and 136-139) is wary of this first impression and hesitant to accept it on face value. Paul Burns (whose demonstration appears on pages 78-79 and 104-109) feels the process of getting to know the sitter is an evolving one throughout the duration of the portrait. Peter Cook (whose demonstration appears on pages 80-81 and 116-119) looks not for the first impression, but for the general impact of the sitter.

Despite these varied responses to first impressions, a woman does convey an air, an individual image that the skilled portraitist will want to get down on canvas. This image transcends mere likeness. It projects the individual aspect of the subject which she presents to the world—through her carriage, posture, bearing, gestures, gait, grace, and movement—characteristics that go beyond the simple configuration of features and limbs.

To fully collect this data, the experienced portraitist will eagerly seek every opportunity to study his subject prior to the actual painting session. He might arrange a casual meeting, ostensibly to chat, but actually to observe his subject when she's relaxed and under no strain. He knows that once in the studio, the average sitter becomes tense and tends to strike unnatural poses. He therefore makes every effort to assess her physical presence under the most favorable conditions. He tucks these impressions away in his memory to be drawn upon during the painting of the portrait.

At times this valuable preliminary meeting isn't possible, and the artist is forced to receive impressions and evaluate his reactions in the few moments prior to actually painting. When this happens, some painters will sacrifice much of the first day's effort by pretending to paint while they're actually contemplating, weighing, and making decisions concerning the subject's physical appearance.

Once the portrait commences, the artist will use every means at hand to keep the sitter relaxed, animated, and above all looking her natural self and not consciously "posing." He might play music for her. He'll certainly converse, and he might even place a mirror behind him in such a way that she'll be able to follow the progress of the painting stroke by stroke.

Assessing Her Emotional Traits

Any competent painter can in time learn to paint a person's likeness. It's merely a matter of developing one's craft, and it's not the miracle most nonpainters believe it to be. The difficult, but more meaningful, aspect of painting portraits is to get something of the person's inner quality down on canvas.

Human beings are not divided into two parts—the physical and the emotional. These factors are welded into a single, homogenous package. It's fair to say that in most cases an adult's face shows pretty much what she or he is really like. Still, it takes great skill on the part of the artist to show this inner character, or soul, or whatever one may choose to call it. In some cases, it may not even be politic to show it, since it may reveal a side of a person she would rather keep hidden. Nevertheless, the honest portrait painter should go as far as he can in portraying the complete woman, not merely the outer shell we know as skin, bones, and muscles.

Again, it takes the perceptive eye, ear, and brain to pierce the sitter's defenses in an unobtrusive manner and to gather what she's really like at a deep level. Interestingly enough, of all the artists featured in this book, only David Leffel (whose demonstration appears on pages 86-87 and 145-148) feels that probing a subject's emotional traits isn't necessary to the success of the portrait. Perhaps it's instinctive with him. All the others placed great emphasis on this practice, something which I cannot emphasize too strongly.

The main factor that exalts the portraits of the masters is the deep soulfulness that permeates the faces of their subjects. I think immediately of the portraits of Rembrandt, Velásquez, and Goya—the intense sense of humanity that exudes from their portraits of women and men whose identity couldn't begin to concern us.

I can't urge you strongly enough to search deeply into the soul of your subject, remembering at all times to exercise extreme discretion and diplomacy.

What Does She Want from the Portrait?

Unless you resolve this question, it's like saddling yourself with a crutch while trying to run the mile in under five minutes. The artist must acknowledge the fact that his sitter's demands for the portrait are at least as important as his, if not more so. If it's a commissioned portrait, she's paying a fee and is entitled to receive a satisfactory product. If it's noncommissioned, she is investing time and hope into the effort, and she has every right to have her expectations fulfilled.

In order to gratify her wishes, the artist first has to discover what they are and then weigh them carefully to determine if they're reasonable. Occasionally they aren't. Some women expect to be flattered at the expense of the portrait's honesty and quality. In such cases the artist must firmly refuse. However, contrary to popular opinion, most women today insist on being painted just as they are—imperfections and all. A new attitude prevails in portraiture in which the subjects are more knowledgeable about art and artists are more insistent upon maintaining integrity.

Still, the painter must ascertain just what it is the sitter expects from her portrait. Does she wish it as part of an inheritance she will pass along to her children? Is she simply gratifying her vanity or ego? Does she want to establish a permanent record of a fading beauty? Is it intended as a token of her love for her husband? Is she curious as to how others see her? Does she want to acquire a sample of the artist's work, and the portrait aspect is merely inciden-

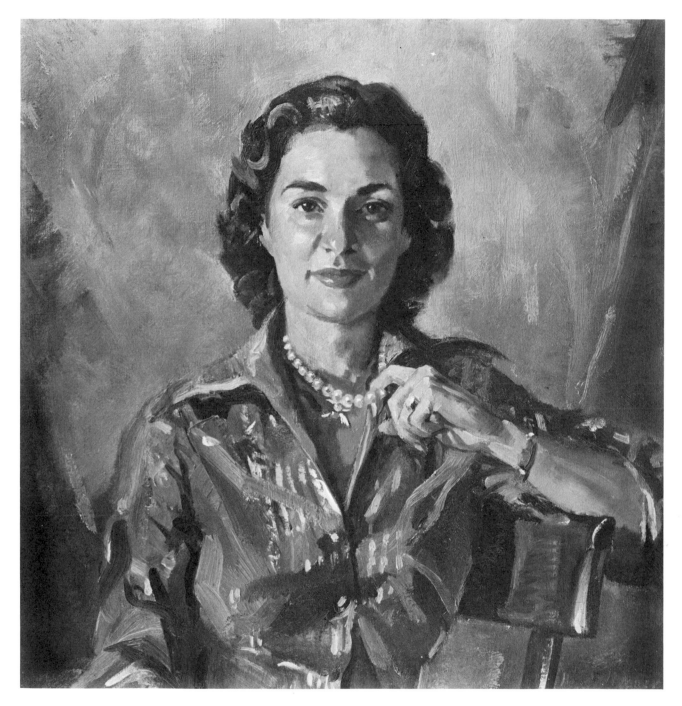

Mrs. John Hart *by William F. Draper, oil on canvas, 29" x 27" (74 x 69 cm), collection the Hart family. In this charming portrait, we can almost feel that we know the subject. With such an artful device as having the subject hook her finger through her pearls, the artist pokes gentle fun at convention and indicates that his sitter has a healthy sense of humor. The dash and bravura of Draper's technique is evident throughout. The brushstrokes are bold, the patterns crisp and vivid. Note how skillfully Draper arranged the composition of this painting so that it didn't emerge merely another head and bust portrait. Block out the left arm and see what it does to the general design.*

Pamela *by Richard L. Seyffert, oil on canvas, 24″ x 20″ (61 x 51 cm), collection the artist. The deliberately planned composition here leads your eye quickly up the right sleeve to the face where your eye lingers before traveling down the left arm and around to the right elbow again. This illustrates how you can use light and shadow to guide the viewer's eye to the important point of focus. Note how softly Seyffert rounds his planes in comparison with Draper's blockier technique. The edges here are alternately lost and found, varying the intensity of the line. This adds an interest to the painting which wouldn't exist if the edges were consistent throughout.*

tal? Is she trying to be "in" by having herself painted by a currently fashionable painter? Is she doing it out of boredom? Is she having herself painted because all her friends are doing it?

Determining her true motives for having the portrait done and the expectations she brings to it will help you establish the kind of rapport and interaction that, when present between artist and sitter, leads to the outstanding, the striking portrait. Knowing her feelings also helps you sort out your own priorities. Certainly you want to maintain your integrity as an artist. But just as certainly you owe your sitter every reasonable consideration.

What Do You Hope to Accomplish?

At this point the artist (hopefully) knows the objective of the portrait, his sitter's physical attributes, her emotional makeup, and what she expects of the portrait. It's time to consider yet another aspect of analysis—your own goals and aspirations for the particular portrait.

Artists list various goals they set for themselves in painting a woman's portrait. These include:

1. Gaining a likeness.

2. Achieving a good work of art.

3. Bringing out the sitter's personality.

4. Attaining a sense of animation in the subject.

5. Displaying competent craft.

6. Gaining the approbation of respected fellow artists.

7. Demonstrating the artist's personality.

8. Attaining truth, honesty, and sincerity in the painting.

9. Achieving superior drawing, color, value, proportion, and composition.

10. Providing the illusion of a body or figure in space.

11. Capturing the characterization of the woman's individual impact.

The list can go on and on, since obviously, the goals depend upon the individual painter. What's important is not *which* goals the artist sets for himself, but that he *sets* goals. No one but you can tell which goals you must establish for any particular portrait. Each entails special considerations. However, it is indisputable that painting a portrait aimlessly and with no goals to shoot for sharply reduces its chances of fulfillment. It becomes a strictly hit-or-miss proposition in which failure is as likely as success.

By conscientiously probing and evaluating the first four aspects of analysis I've outlined, the fifth—the formulation of your own goals—is that much more easily resolved.

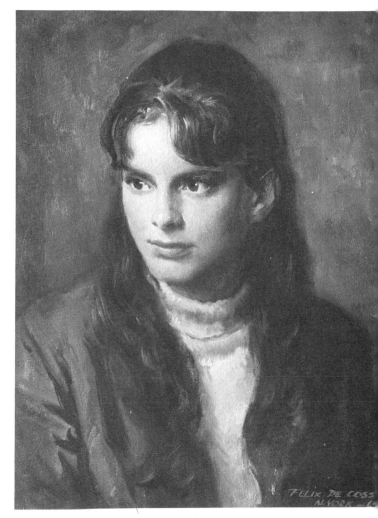

Portrait of Maureen by Felix de Cossio, oil on canvas, 20″ x 16″ (51 x 51 cm), private collection. In sharp contrast to Francesca Draper (page 12), this is a completely different portrayal of a young woman of approximately the same age. That the mood of a portrait is an important consideration can be appreciated by comparing the two divergent approaches. Here the artist used darker clothing and background and an oblique gaze in which the model seems to be looking off into some beyond. This achieves a feeling of quiet, pensive introspection. In comparing these two portraits, you can see that varying the mood of the painting can help you avoid a feeling of sameness in your portraits.

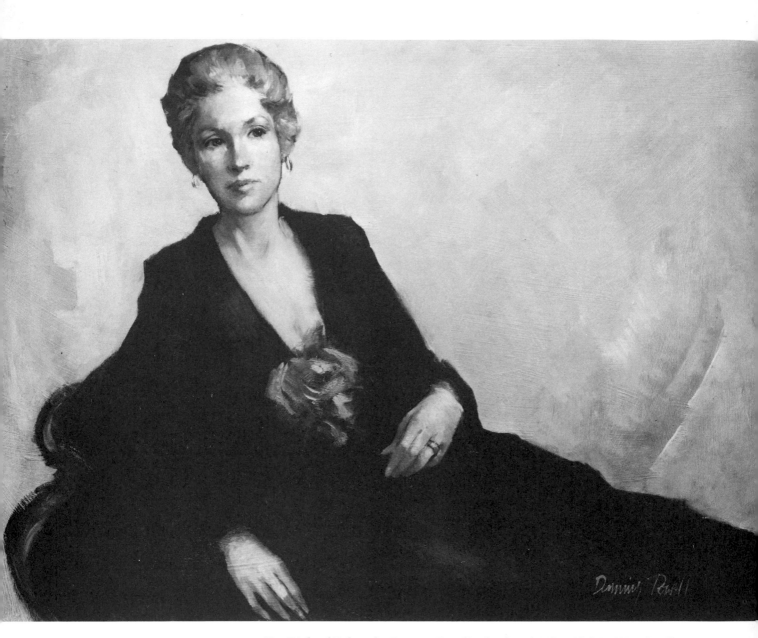

Mrs. Richard Balsam by Dunning Powell, oil on board, 36″ x 48″ (91 x 122 cm), collection Richard Balsam, M.D. Horizontal portraits, once a common device, are rarely seen in contemporary portraiture. To show a woman reclining may frighten some painters who fear being dated, but you couldn't ask for a more modern painting than this very handsome portrait. The treatment is bold, simple, and loose throughout. Edges are sharper around the contours and softer within the form. The figure stands out boldly against the light background, and the large flower lends a sharp splash of contrast against the black dress.

CHAPTER TWO
Visualizing the Portrait

We now enter a more advanced stage of planning the woman's portrait. This involves putting into positive terms some of the decisions already reached. The intellectual responses and decisions will begin to be translated visually as we picture how the finished portrait might appear on canvas. Naturally the planning at this stage is still open to modification. We're still engrossed in the process of diagnosis—trying to fix in our minds the possible steps that would best fit the individual situation. A number of considerations arise during this process.

Setting the Mood

A vital aspect of any portrait is its mood. A woman's portrait can be somber, gay, forceful, placid, disturbing, uplifting—the possibilities are endless. However, it must attain this characteristic strictly by design, never by chance.

Peter Cook speaks with deep regard of the moods he encountered in the portraits of Eugene Speicher. To Cook, Speicher's moods conveyed an almost religious spirit. These moods seemed more alive than the subjects of the paintings. Although the tendency is to paint women (and children) in a higher key and in a brighter mood than men, the artist must try to avoid such generalization and treat each subject on her individual basis.

The mood of a portrait may be determined by several factors:

What general impact does the subject project: Happy? Sad? Stern? Frivolous?

What is the purpose of the portrait: A gift from a loving husband or family? Recognition of services rendered a person, cause or profession? A paean to the subject's beauty? A monument to her memory?

What is the subject's age: Is she a child? An adolescent? A young woman? A matron? A dowager?

How would you characterize her: Is she plain? Ugly? Attractive? Feminine? Athletic? Clingy? Pushy? Retiring? What is her social or professional status: Is she an heiress? A school principal? A courtesan? A colonel in the Marines?

Each of the above calls for a different mood. For me to match them to the conditions outlined would be sophomoric—any person of intelligence knows the obvious answers. But the obvious is not always the best. Possibly you might create a sensation by painting Little Nell with the glower

and menace of a Genghis Khan. It's strictly up to you. But what is important is that you acknowledge the necessity of predetermining *some* mood for a portrait, but only after considerable deliberation. The urge to slip thoughtlessly into stereotypical solutions is very tempting.

Formal or Informal Approach

Still another consideration in visualizing the portrait is whether to execute it in a formal or informal approach. This isn't based on costume alone, but is better categorized by translating it into terms of casual or traditional. Not only dress, but pose, composition, mood, and background also enter into this aspect. *Formal* connotes a dignified costume, a fairly conservative pose, and a more or less stable composition, with the figure pretty much centered within the frame. The mood ranges from regal to reserved, but certainly not smiling or displaying any strong emotion. The background tends to be darker than lighter.

Informal implies casual wear and perhaps the sitter in a relaxed pose such as sitting with legs drawn up under her or squatting in the yoga lotus position on the floor. Note the Seyffert portrait of Thea on page 48. The composition can be radical, with head, arms, or legs partially out of the frame or centered on one side of the picture. The mood can be anything from grim to frivolous, but less inclined to be neutral. The background might be light, dead-white, or a riot of color.

Again, the artist must reach within himself to decide on a formal or informal approach, based on the considerations listed above, plus all the other data he has gathered.

Choosing a Background

Shrewd painters either create or arrange portrait backgrounds to suit their requirements. But there's a difference between creating and arranging a background.

Creating a background means using factors of color, tone, and line lying all around the subject to make up a background of one's own invention.

Arranging a background means putting up screens, draperies, chairs etc., and then painting these elements *as they appear* now that they have fulfilled the artist's goals.

Applying either of these two measures is perfectly acceptable. Painting a background *as is*, just because it hap-

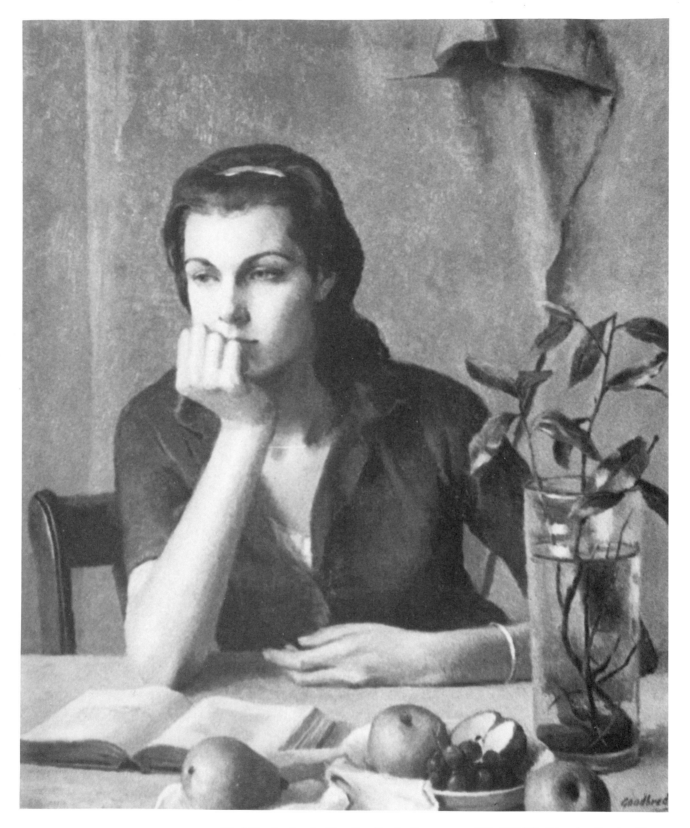

Madeline Lackey by Ray Goodbred, oil on canvas, 30″ x 25″ (76 x 64 cm), collection Mr. and Mrs. Bushrod Howard. Here is a good example of how the artist incorporated elements of background and foreground into the painting to express the character of the portrait. The open book, the plant, the fruit—all contribute to the quiet, thoughtful mood of the portrait due to the of restful nature of the still-life genre. An equally effective way to achieve a dynamic, turbulent mood would have been to pose the model against an ominously clouded sky or a stormy sea. Background can't be removed from subject—both must be used in meaningful conjunction to make a cohesive, all-encompassing statement.

pens to be there, is definitely unacceptable. It's an un-imaginative, lazy, uncreative approach.

A background, with one exception, is an essential component of a good portrait. You can't arbitrarily separate the figure from its surroundings without suffering loss of quality in the painting. The one exception is the vignetted portrait in which the background is left unfinished or eliminated altogether.

It takes a hell of a good painter to execute a *successful* vignetted portrait of a head set against a blank, white canvas. He must have the experience of first having painted hundreds of heads under various lighting situations. If, on the other hand, the canvas has been previously toned, then this is no longer a pure vignette, but a portrait with a background of sorts.

Incisive painters treat the background as atmosphere in which the head and figure sit, float, or hover—as the case may be. This atmosphere lends (or should lend) an illusion of reality to the portrait, since few of us see each other in an absolutely sterile setting in which no other colors, tones, objects or lines exist. I suppose you could mimic such a setting in life by standing someone in front of a white sheet that extended beyond the periphery of human vision. But normally we see people in rooms, gardens, streets, crowds, or what have you. They are not alone. Animate or inanimate objects brush up to or near them to modify their colors, crisscross their contours, somehow impose upon their image. That's how most portraits are painted—with some sort of background calculated to project, embellish, enhance the head and figure. Without a background, there is no foreground. A successfully executed background lends roundness and dimension to the figure. You should, in Clifford Jackson's words: ". . . feel that you can go back around the head . . ."

Backgrounds can be either darker or lighter than the figure. Note the Kinstler portraits of Mrs. Miller and Mrs. Littleford on pages 135 and 133. Mrs. Miller, a brunette is painted against a light background; Mrs. Littleford's hair is light and the background dark. This may sound like a simple and obvious device, but you'd be surprised how many artists commit themselves early in their career to a light or dark background. They then stick with this mannerism rigidly for the rest of their lives, regardless of their subject's coloring, costume, or other attributes.

The wise (I hate to say *clever*) portrait painter creates or arranges an individual background each time he embarks on a new portrait. Instead of locking himself into an unyielding mannerism in which each portrait emerges just like all the ones before and all the ones to follow, he selects a background to fit the case. One time he may paint the background as mass, the next time delineate objects within it. This time he'll paint it dark, the next time light. Sometimes he'll omit it altogether. Other times he'll pose his subjects outdoors and create a little landscape out of the background. Or he may create the background from an interior, or even an abstraction.

Backgrounds can be neutral or suffused with color. They may be painted thickly or thinly. They may be thin and su-perficial or dark and deeply mysterious. The background can also supply mood for the portrait through ominous clouds, dappled sunshine, dramatic shadows. . .

The possibilities are obviously infinite. Use the background intelligently to help fulfill the purpose of the portrait. It's an integral part of the picture.

Shape and Size of the Portrait

In commissioned portrait painting, the factor of size is usually predicated on the fee the client is willing to pay. Variations in inches may mean thousands of dollars in price difference. While this condition *seems* to brook no intercession by the artist, nothing is so rigid in life that it can't be changed. The artist who cares passionately will move heaven and earth to change the status quo. All the professional portraitists I've spoken with expressed the urge to be free to choose the size of the portrait necessary to meet particular requirements. Few of them (to be honest) have done anything to gain this right, but most have left such an important artistic decision to gallery owners, agents, and business managers.

No one but the artist has the obligation—the duty—to determine the size of a portrait! Barring the factor of where it will ultimately hang (which may dictate specific dimensions), the painter himself must decide what size portrait will best express his interpretation of the subject.

Besides size, the artist must also consider the most desirable shape for the portrait, predicated on its purpose and character. Should it be square, round, rectangular, vertical, horizontal? Note the portrait of Mrs. Adams by Paul Burns on page 102. Doesn't it seem just right in this format? Would it be served as well if it were rectangular?

Consider the shape along with size when you're visualizing your portrait.

Years ago, when homes were immense and walls seemingly endless, there was plenty of room to go big. These days, with space more limited, the tendency is toward the more modest-sized portrait. Still, there's sufficient room for diversity within this range.

Given the freedom to choose, the artist must give serious thought to what size would best serve his needs. This involves such considerations as the purpose of the portrait, since, in most cases, a personal portrait would be painted somewhat smaller than one that would hang in some institutional setting.

Another factor is the degree of attractiveness of the subject's body. Would her cause be better served by showing or concealing her arms, shoulders, bust, etc.?

If you have decided to include her furnishings or other favorite objects, a head-and-shoulder portrait would hardly be sufficient.

If she's anxious to include some favorite costume, a larger picture is indicated.

If she wants herself painted in an outdoor setting, room is needed to show the garden, backyard, or some aspect of that environment.

If she wants to include a pet, room must be left for its inclusion.

Self-Portrait by Mary Beth McKenzie, oil on canvas, 36" x 24" (91 x 61 cm), collection Tony Mysak. Mary Beth McKenzie chose to show herself in informal pose and attire, since this is obviously her concept of herself. Had she been of a different temperament, she may have wanted herself painted in a gown and jewelry. It's vital that the portrait provide insight into the way the artist responds to the subject, whether she is someone close or a total stranger. Merely presenting a physical likeness without digging deeper does not make a successful portrait.

Artist's Daughter (opposite page) by Marilyn Conover, courtesy Portraits, Inc. Here is a more formal approach to the portrait. The steady, level gaze hints at a sense of strength and self-assurance. This young woman apparently knows who she is and faces the world with confidence in her identity and beauty. I particularly like the way the bottom two fingers of the left hand dangle down. This lends a touching, rather childlike accent and alleviates some of the seriousness of the pose. The paint is applied crisply, with passages of scraped-out color that make an interesting, provocative texture.

If it's important to show her in a uniform or academic robes, more of her must be shown.

If she's particularly proud of her figure, this might call for a three-quarter or a full-length portrait.

These are the kinds of factors that guide the decision regarding the portrait's dimensions. Many of them, however, can be resolved by an allied consideration—*the size the subject herself will be painted.*

Lifesize, Under-lifesize, Over-lifesize

The final decision about how big the subject's head will be painted can help determine the size of the portrait itself. Charles Baskerville, David Leffel, and John Koch can and do paint effective portraits as small as one-tenth of actual lifesize. Some of Rembrandt's heads measure inches bigger than life, and I have seen an Ingres portrait with a head almost two feet long.

Obviously, there is no unanimity of thought concerning this factor. Some artists feel it's important to paint the head and figure in exactly their correct size. Others maintain that painting the head slightly below lifesize gives more an illusion of reality, since we actually never see our fellow beings in actual size, but from some distance away, which reduces their image somewhat to our eye.

A third category of painters believes in painting heads a touch larger than life to compensate for the distance the portrait usually hangs from the viewer's eye. The subsequent reduction of image, they claim, brings the head down to actual lifesize.

A fourth group believes in painting heads small, since to them bigness represents grossness; and they feel true artistry is demonstrated in making a small head appear realistically alive.

Which of these approaches is the correct one? No one can say, since they all represent a strictly subjective view. The artist must weigh each of these contentions and then run them through his own mental computer. Somewhere within this diversity of opinion lies an answer that will most closely coincide with the painter's personal tastes, style, and artistic perception. Possibly, he may elect to employ each approach at various times. In any case the factor of how big to paint his subject will vitally influence his choice of how big to paint the portrait, and both these decisions must be carefully calculated and resolved.

Summing Up

We have analyzed the problems and conditions presented by the subject, as outlined in the first chapter, and have considered such factors as mood, degree of formality, type of background, size and shape of the portrait, and the size of the subject to be painted based on these earlier findings. We are now ready to proceed to the next, more specific, stages of advancing the portrait to fruition.

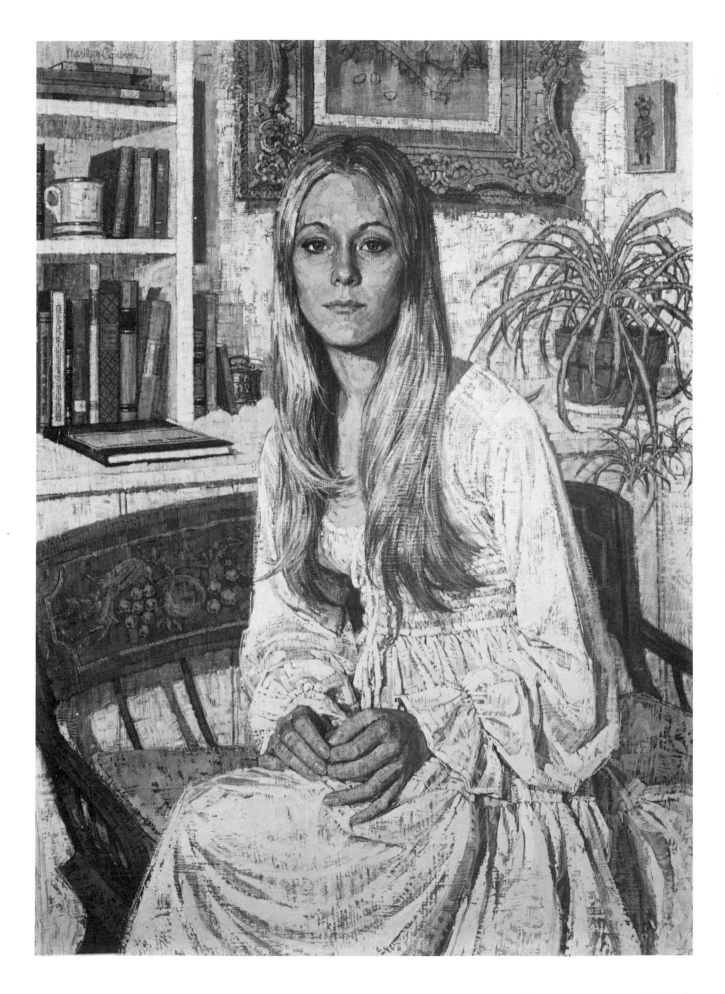

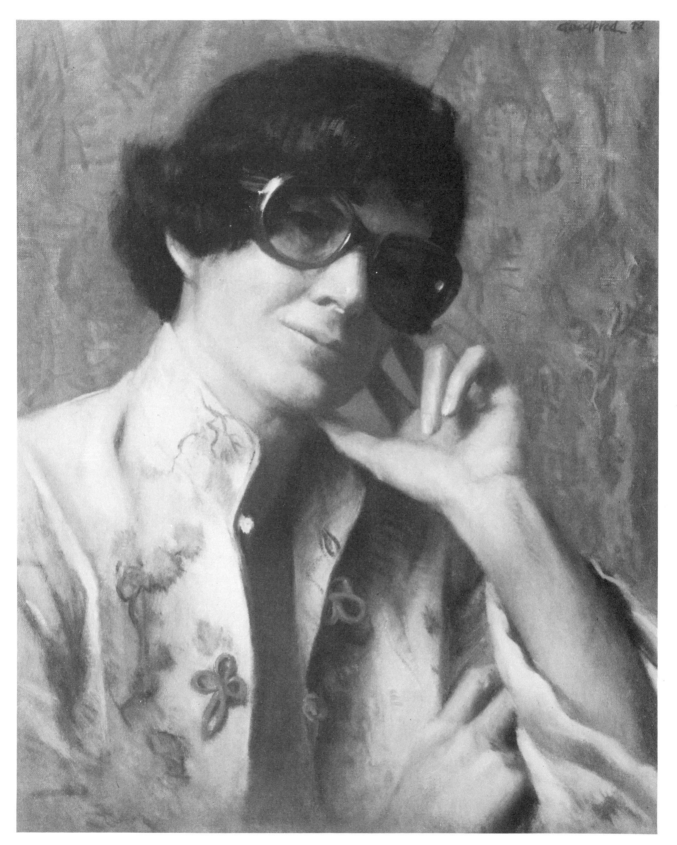

Elizabeth by Ray Goodbred, oil on canvas, 20″ x 16″ (51 x 41 cm), private collection. Note how skillfully the artist employed the eyeglasses as part of the total design. They seem proper and correct sitting on the subject's face, not as some alien appendage. Goodbred wisely didn't lighten the left lens but let it remain as part of the deep shadow enveloping that side of the head. Nor are the reflections and highlights of the glass indicated. Such inclusions may call attention to the artist's facility, but they tend to vitiate the strength of the form and are best excluded. Although we can't clearly see the subject's eyes, we are aware of their presence and expression.

CHAPTER THREE

Clothing and Props

Having met and gotten to know the subject; having learned the purpose of the portrait, the sitter's goals, and *our* goals; and having considered its mood, size, and allied considerations—the next consideration is the practical one of clothing and other accoutrements.

Costume

The choice of appropriate dress for a portrait is again one that demands some measure of judgment. Most professional portraitists ask the woman to bring along several changes of costume from which she and the artist can make a mutually satisfactory selection. Today's artists lean toward simple, solid-colored garments. A few—especially those who work in a rougher technique—like clothing with a decided nap or texture. Most painters abhor fabrics that are so "busy" that they take the spotlight away from the portrait's main attraction, the face. Those such as David Leffel, who paint the head and figure as if it were emerging from shadow, naturally prefer dark clothing, since in this type of painting clothes constitute part of the background.

Artists who paint in a higher key are more likely to choose light, bright-colored attire. Those who are essentially colorists will be intrigued by material of striking hue and will consciously incorporate this element into the painting.

Generally speaking, the treatment of clothing in the portrait can be divided into two basic approaches: *Subduing* the color, value, and texture of clothes to those of the face; *Playing up* the color, value, and texture of garments so that they become an integral part of the portrait's design, tonality and coloration.

The artist's style is apt to dictate the approach. As already indicated, if he paints in a lower key, a somber mood, and with the light focused on the face, he will lean toward the first approach. But if he tends toward a higher key, a gayer mood and flatter light, he will more likely choose the second.

One way to resolve this decision is ask to yourself: Which is essentially my way of painting? Then follow the approach most conducive to your technique.

An even more meaningful solution is to let the individual portrait dictate the approach. For example, if the previously stated guidelines have led you to decide that the portrait calls for a low key, a solemn mood, and dramatic lighting—you'll dress the subject in dark clothing and let it serve as a backdrop for the face. Or having decided on a high key, a happy mood, a brightly colored portrait, you'll pick a more vivid, lighter costume.

Or perhaps you'll ignore all these precepts and go on to paint a brightly colored, high-key portrait of a woman dressed all in black. After all, only the timid are reluctant to defy the rules, and the suggestions I have offered are only intended as such, never as absolute "laws."

Another aspect of this decision process is to become keenly attuned to the subject's wishes and inclinations. Women are very conscious of what's most flattering to them, and the artist should listen attentively. However, some sitters grow cowed in the presence of the painter and fail to express their preferences. So it's up to you to urge them to indicate their favorite outfit.

A third consideration, and one already touched upon, is to coordinate the costume with the object of the portrait. Obviously, you wouldn't paint an *official* portrait of a college dean in her tennis dress. But it might be fun to show her dressed this way in a *personal* portrait . . .

If a woman demands a portrait in her best ballgown, you might just find this an exciting challenge. Although the so-called "society portrait" is no longer in vogue, you may find enough interesting aspects about it to exploit them into a striking painting.

Above all, remember that clothing—both in life as in portraiture—is intended to show what the wearer thinks of herself and what image she chooses to present to the world. There are, unfortunately, those who pervert this intention. But should you be forced to cope with someone who exhibits atrocious taste, don't seek to educate. Utilize all your artistic insight and ingenuity to either suggest a change of costume or, failing this, paint her as handsomely as you can—beads, spangles, bows, rickrack, and all.

Jewelry and Eyeglasses

Some women believe in the theory: "More is better." They'll come to you loaded down with earrings, brooches,

Sara by David A. Leffel, oil on canvas, 22″ x 18″ (56 x 46 cm), collection Mr. and Mrs. McDaniel. Leffel paints jewelry with the skill of an old master. Although the pearls on the neck and forehead are painted with a degree of accuracy, they don't intrude or steal attention from the face. Their edges are treated softly enough so that a harsh "cut-out" effect is avoided. Also, they are basically lower in value than the skin tones. Had the situation been reversed, our eyes would be drawn to the pearls, and the face would become background.

necklaces, pins, bracelets, rings, tiaras, chokers, etc.

Don't panic. Try one of several approaches. Either ask them very diplomatically to put some of the stuff back in their safe, since there have been several robberies in the area lately. Or failing to register with this, ask them if they are willing to let their baubles take attention away from their flawless features. Now, if you strike out once again, paint them, but innocently leave out half the collection.

Or, creatively use the line, hue, or texture of the trinkets to enhance the design, color, and mood of your portrait without actually showing each bauble.

As for eyeglasses, this is a decision that you and the sitter have to make together. If she doesn't object to leaving them on, and if they are worn all day, therefore forming a part of her normal image, by all means include them in the portrait.

There are two ways of painting eyeglasses: have the sitter wear them throughout the portrait; or paint her eyes without the glasses, then add them later.

Proponents of the first method claim that theirs is the way to paint glasses so that they appear real and not glued on. Since lenses do not sit flush against the eyes, they must be treated as an additional feature, not as some unrelated appendage.

The opposing faction argues that to paint the glasses upon the face without first resolving the underlying area causes the eyes to emerge bizarre, due to the distortion created by prescription lenses.

Another factor to remember is that lenses, particularly strong ones, tend to alter the contour of the cheek, and the artist must decide whether to show this distortion or ignore it.

Still another consideration is the problem of reflection—light bouncing back from the glass. Most artists tend to agree that—reality aside—such reflections are best disregarded.

Ray Kinstler stresses the necessity of painting in glasses carefully, since their line affects the shape of the cheek, and the shape of the cheek can affect the appearance of the entire face.

Whatever means you employ to paint glasses, do remember that while you must be correct in your proportions, you must also not give so much importance to lenses and frames that they draw attention away from the features beneath and beside them.

Cosmetics

Excessive makeup is another problem that crops up in painting women. Most artists dislike it. Clifford Jackson is so averse to cosmetics that he will offer the woman a tissue! He prefers the shiny nose. But, painters' preferences aside, some women insist on powdering and rouging their faces, and the artist must adjust to this predilection when he comes up against it.

First, he must realize that powder tends to flatten the planes of the face; makeup base alters its true color; and eyeliner lends a hard line to the eyes, as lipstick does to the lips. Also, women are apt to change or enlarge the shapes of their mouths, to arbitrarily darken or lighten areas they wish to project or diminish, and to use all kinds of other tricks to alter natural configurations of their lips.

Short of urging the sitter to remove *all* makeup—a request that will most likely be met with polite disdain—you must learn to compensate and to adjust yourself to prevailing conditions. This, in most cases, means minimizing excessive makeup, reducing its presence whenever possible, and painting features as they really are beneath all the cosmetics, not as they're calculated to appear.

Paul Burns warns against painting the edges of lip-sticked mouths too sharply. This admonition might be applied to all the other aspects of makeup. Remember that you are painting a portrait, not a cosmetic ad. Use discretion, taste, and your God-given good sense to subdue, leave out, and adjust anything that is garish and ridiculous.

The Challenge of Dyed Hair

A woman's crowning glory has become, in our age, a product of chemistry and technology. Blond hair has turned platinum, ash, or silver; brown hair—a hideous red, orange, or bronze; black hair—a dull, matte ebony; gray hair—a yellowish, bluish, or mauve peculiarity. Hair is dipped,

Linda Fay *by Richard L. Seyffert, oil on canvas, 36″ x 30″ (91 x 76 cm), collection Mr. and Mrs. J. K. Fay. By showing the subject in her riding habit, the artist does more than simply let us know that Miss Fay is an equestrienne. He is providing a natural environment for an individual, just as an interior decorator designs a house to suit the temperament of its owner. Were this an artificial device, the young woman wouldn't feel comfortable in such attire, and the portrait would show her discomposure. Costume must be used creatively to display the essence of the sitter — not for striking effect only, regardless of appropriateness.*

Lynn Penney *by Paul C. Burns, oil on canvas, 36″ x 30″ (76 x 91 cm), collection the artist. The treatment of the hands here removes this painting from the ordinary and helps achieve a striking, most attractive design. By tilting the first two fingers forward and letting the other two fade off into the right forearm, Burns lends a sparkling note to what might have otherwise emerged a good but conventional portrait. Hands should always be used to enhance the composition, not merely to rest idly without reason. Pose your sitter's hands as you would her face—purposefully.*

tipped, streaked, blown, ironed, curled, and sprayed until it assumes the color and texture of plastic. The artist's concern is not to vent esthetic indignation, but to confront the problem of how to translate these frequently exotic shades onto canvas.

Charles Baskerville stoutly maintains that his solution might be to simply refuse to paint a subject with hideously colored hair. This is a decision we might vigorously applaud; however it doesn't solve the dilemma.

Painting hair of natural color is a challenge in itself. You have to paint it softly, not making its edges too hard. It must flow into the face naturally, and not create sharp divisions between skin and hair. Painting hair that's dyed poses all these difficulties plus another—that of color.

What do you do about hair that's garishly colored?

You either tone it down or you paint it as is. If you paint it as is, you can rationalize this decision by contending that if a woman elects to present herself to the world with blue hair, it's your obligation to show this eccentricity.

I wonder if this is a solution. Doesn't your obligation to produce a viable portrait take precedence over your reportorial obligations? Perhaps the answer lies somewhere in between. Yes, do show some of the unfortunate color, but don't overdo it. Use artistic license to modify the startling effect. This seems a reasonable compromise.

What is important in painting hair, whether natural or dyed, is to remember to relegate it to the status of background. The character and essence of a person isn't contained within her hair. Hair is merely the frame that sets off the main attraction—the face.

What about Hands?

Critics tend to place much importance on the artistic treatment of hands. Artists who include hands in their portraits are often accused of painting them poorly, while those who leave hands out are accused of being unable to paint hands and are attacked for taking the coward's way out.

To some painters, hands obviously pose a dilemma. Others pride themselves on their ability to paint hands and try to include them even in small portraits where they may not belong.

Peter Cook challenges the gratuitous inclusion of hands in a portrait. If hands are shown, Cook wants their presence explained. Kinstler values hands as a possible asset to the portrait's compositional aspect, as does Charles Baskerville. Baskerville feels that few artists paint hands skillfully. Jackson believes the secret of painting hands well is to first pose them attractively, a contention shared by Da-

vid Leffel. Paul Burns loves to paint hands and does so whenever possible.

I urge every prospective portrait painter to devote all the time he can spare to learning the anatomy, symmetry, and configurations of hands, for they can be a fascinating addition to a portrait, or a damning embarrassment.

You can, more or less, fake your way through poorly drawn facial features by employing cheap tricks to lull the unsophisticated viewer—tricks such as sharp catchlights in the irises, startling reflected lights in the shadows, or hard-edged, exaggerated highlights. It's not that easy to bluff with hands. Even the untrained eye quickly perceives a lamely constructed knuckle or finger.

Next to faces, hands are the feature by which the general public separates the poor from the skilled portraitist. They are worth all the study and attention you can give them.

Draperies, Screens, and Furniture

To avoid a sameness in portraits painted mostly under similar circumstances requires the utmost of the artist's inventiveness and ingenuity. He must draw upon every resource to lend his works a sense of variety. Screens and draperies are a prime means of achieving this diversity within the studio. By shifting those props about freely, the artist can add tang to a potentially stale painting. John Koch has painted dozens, if not hundreds, of detailed interiors within a single room; yet they all manage to project a fresh and different look due to Koch's imaginative deployment of screens, furniture, and other objects.

Since most portrait subjects are posed sitting, the chairs or stools you employ for your model must also be carefully considered. I've seen portraits painted by a noted artist in which the same chair appears at least two dozen times. This gentleman is either too literal minded or too lazy to buy a new chair or to paint the old one differently.

Since chairs and other articles of furniture may also play a part in your pictures' composition, do collect enough of them to achieve diversity in your portraits. Some of these pieces may in themselves be so interesting in design, ornamentation, texture, or color, that you'll want to incorporate these features into your portraits. However, be sure again to avoid repetition.

You'll also want to collect stools of varying heights, since a tall stool can be used to simulate a standing pose. Your screens should be hinged that they can be easily manipulated. And there is no end to the cloths and draperies you can accumulate so that you can create any shade, texture, or color of background you want without trouble.

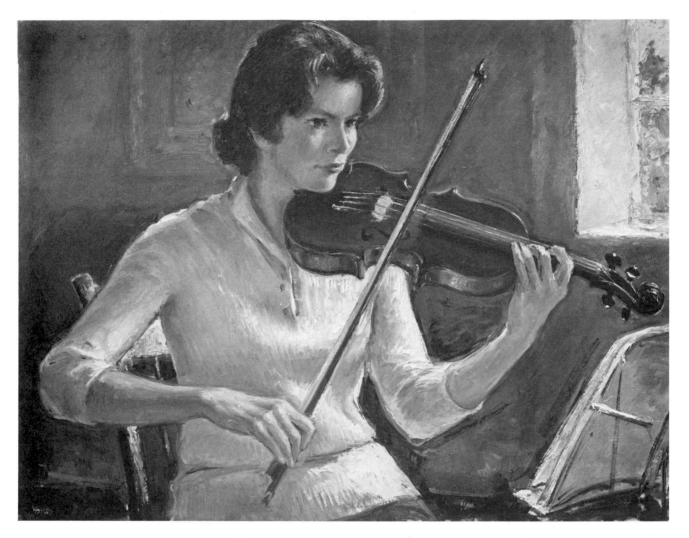

The Violin Player *by Peter Cook, oil on canvas, 30″ x 40″ (76 x 102 cm), collection Mrs. Klaus Florey. Showing a subject doing what she enjoys and obviously does well is a device that's not employed often enough in portraiture. The action portrait can be enormously effective as can be seen from the absorption displayed here in the sitter's face and figure. Could such intense preoccupation have been captured had she been shown sitting in a chair? Try to convince your subjects to allow themselves to be painted in some favorite occupation. It's great fun and a challenge to be eagerly confronted.*

CHAPTER FOUR
Posing and Composing

By this point, the subject has been analyzed and clothed, and her demands and your goals have been resolved. You've settled on the shape, size, mood, and approach to the portrait, decided on a background, and selected the props. Now the time comes to arrange a suitable pose.

Sitting, Standing, and Other Poses

Most women are painted sitting. One reason for this is that it is the most comfortable pose. Second, it allows the hands to be shown naturally. Third, if a model stand is used, the seated position provides the artist the desirable eye-level view most portraitists seem to prefer.

Also, this pose best suits the medium-sized picture because it allows the knees and lap of the sitter to be included. This makes it easier to compose a more attractive design. In addition, the sitting pose provides a greater degree of latitude by allowing the subject to do something intriguing with her hands or shift her shoulders or body about more interestingly.

Granting all these positive factors, the sitting pose—by the very virtue of its popularity—also presents the tempting danger of platitude and banality. How often do we see the same tired portrait of the well-fed matron staring vacuously into our faces with her hands clasped rather smugly in her lap?

Most subjects beyond the first flush of youth would hesitate to assume a standing pose. It's tiring to stand for two or more hours, and the fatigue inevitably reflects in the face and thus in the portrait. Still, a young, attractive woman can be shown to great advantage in a standing pose that displays her lithe contours, bearing, and stature.

The full-length standing portrait, of which Sargent is certainly the most memorable exponent, is, alas, a thing of the past. Few clients have the courage to display it, few artists the temerity to tackle it. Yet it can be a work of distinction. A fine example is Kinstler's portrait of Irene du-Pont on page 32.

On the other hand, painting a standing subject in less than full-length dimension poses the problem of just where to cut the figure off at the bottom. Also, there is the question of what to do about the hands.

Besides sitting and standing, a woman can even be painted in a reclining position (which is something few modern-day painters attempt) or involved in some sort of physical activity. This too is rare, since depicting a subject *doing something*, rather than posing, strikes most observers as removing the painting from the category of pure portraiture. I disagree. It may be even more authentic to show a ballerina performing on stage or a noted horsewoman astride her mount than to have them sitting docilely in a chair.

Full-face, Three-quarter-face, or Profile?

You can pose your subject facing you squarely, or with her head turned partially away, or in full profile. Each of these poses presents different problems.

The full-face view isn't usually selected, since it tends to flatten the form and negate the interesting shadows that the three-quarter-view provides. Charles Baskerville paints full-face portraits without hesitation and with little concern for any disadvantages they may present. He cheerfully concedes that some flatness may result, but his frontal views—while admittedly projecting a kind of decorative, stylized effect—carry very nicely indeed. Perhaps this is due to Baskerville's long experience as a mural painter. Most of the other artists in this book seem to prefer the three-quarter view which does lend more roundness to the form and usually presents the fullest range of tonal gradation.

Many of the artists I've spoken with stated their desire to do more profile portraits, but most agreed that this probably wasn't something clients would readily accept. Jackson suggested (facetiously, I presume) that most people would feel cheated to get only half a portrait, so to speak.

Yet, one of the most famous portraits is Sargent's *Portrait of Madame X*, a pure profile. In all fairness, while today we admire its daring composition, in its day, it caused a storm of protest and nearly destroyed Sargent's career.

I personally am dedicated to the profile portrait, and I urge you to try as many as you can if only as an exercise of your versatility and innovation. It's admittedly harder to paint just one side of a head and endow it with as much roundness and form as a two-sided shape. However, it's a challenge worth taking and overcoming. That it can be carried off is proven by Kinstler's portrait of his wife

Irene duPont (right) by Everett Raymond Kinstler, oil on canvas, 96″ x 40″ (144 x 102 cm), collection Mr. and Mrs. Irenée duPont, Jr. The standing, full-length portrait works particularly well with an attractive young subject such as this one. The regal pose and proud bearing combined with the formal gown make for a Sargent-like painting that unfortunately is rarely encountered today. How many young women do you know today who would consent to shed their jeans and casual posture to strike such an imposing pose? This painting is a reminder of the positive values of formality.

Portrait of a Lady (opposite page) by Felix de Cossio, oil on canvas, 50″ x 32″ (127 x 81 cm), collection the artist. This is a different approach to the standing pose as compared with that of Irene duPont. Here de Cossio poses his model head-on, with the arms forming an interesting circular design that guides the eye in a clockwise direction up to the face again. The device of a totally dark background helps propel the light figure forward. Had this picture been painted in Rembrandt's time, the gown would doubtless have been thrown into darkness, and only the face and hands would have caught the light. Today artists feel free to paint light figures against dark backgrounds and vice versa without adherence to rule or convention.

Eva Gabor by Charles Baskerville, oil on canvas, 30″ x 24″ (76 x 61 cm), collection the artist. The famous actress and jet-set personality exhibits her well-known zest and joie de vivre in this charming, tongue-in-cheek "formal" portrait. To spare his model fatigue, the artist painted her sitting on a high stool, then made it appear as if she were in motion. The illumination is flat and little shadow appears in the face or figure, but it all seems appropriate for the pose and subject. Baskerville has orchestrated the conditions to meet the object of the portrait.

shown in the gallery on page 70 and on the book jacket.

Choosing the Perspective and Angle

You can paint looking up to, down at, or from the same level as your subject. Each angle provides a different perspective and each has its appropriate usage.

Artists usually elect to be at eye-level with their model. This is the most natural view and one that offers a true and honest perspective of the subject. In some cases, however, painters find it productive to look down at the sitter. Paul Burns finds that this works best when the woman presents a distinctively heart-shaped face, a characteristic that wouldn't be apparent when seen from any but an elevated angle.

Such a viewpoint might also be used to advantage for a woman with a particularly heavy jawline, a feature that would be minimized when seen from above. The same principle might apply to a particularly burly or broad-shouldered subject. Conversely, a woman with a long nose or a weak chin might better be shown from below.

Clifford Jackson raises an interesting point in this regard. He suggests that painting a woman from somewhat below eye-level lends the portrait an air of regality and prestige—something like a queen on a throne.

Choose your angle of view with some of these considerations in mind.

The Model Stand

Portraitists find the model stand a valuable asset in gaining an eye-level, or a below eye-level view of the sitter. These platforms usually stand about 18″ off the ground and are big enough to accommodate a chair or even a small settee. It's desirable that they be set on casters or wheels and have steps to facilitate mounting, especially for elderly sitters.

Interestingly enough, only Peter Cook objects to the use of model stands. He has found that they made his sitters anxious.

Using a model stand allows the artist to work standing up, while his subject sits. However, to the best of my knowledge, model stands aren't sold, and you'll have to construct your own or have someone build it.

How Much Air?

Air is the term artists use to describe the space lying above and around the subject's head and figure. Air is actually background, but it differs from it in that it refers only to the actual *space* within the frame, not to the elements painted within this space.

Artists generally agree that some air is necessary, since few actively seek a cluttered portrait. As to the actual amount of air, opinions vary. Between three to five inches from the top of the picture to the top of the head seems to be the norm. Leffel likes lots of air all around, since he feels that this is generally the way we see people, and this effect promotes the sense of reality.

Baskerville wants enough air so that his subjects can "get up and move." He places much emphasis on where the head is to be positioned within the picture. It's a device that helps him to indicate the height of the subject. him to indicate the height of the subject.

Many artists find it helpful to leave excess canvas around the stretchers; then when the portrait approaches completion, they can remove it and restretch it again so that the head and figure are properly and advantageously placed. This practice is one you might borrow, since it allows a second look at a time when all the elements of the portrait are visible. At this point you can formulate a more perceptive judgment regarding its composition.

Purpose in Pose and Composition

The question of how to pose and compose your subject is not an easy one to answer. There are so many different factors at work and so many different ways of resolving them that no one book or even course of study can provide specific directives. The only way to approach the problem is to once again submit yourself to a self-imposed questionnaire to gain sufficient data to point a general direction.

Here are some of the questions you might ask yourself:

1. What is to be the size of the portrait?
2. Will it be horizontal or vertical?
3. How much of the figure will it show?
4. Will the background be simply tone, or will it include objects?
5. Will the background be dark or light?
6. Is it a formal or an informal portrait?
7. Is it to be personal or official?
8. Where will it hang?
9. How old is the subject?
10. Is she a sportswoman, a business executive, a housewife, a schoolgirl, a matron?
11. Is she essentially soft, dynamic, languid, forceful, arch, tough, sexy, cold?
12. Is she slim, average, stout?
13. Are her features generally symmetrical, or are there problems?
14. What will she be wearing—something clinging, loose, or bouffant?
15. Is her costume dark, light or medium?
16. How does she perceive herself?

Armed with this and the additional information you have gathered, you can now select a pose that will best satisfy the object of the portrait and your and your subject's goals and expectations.

Do remember that there's never any one definite way the subject should be posed or positioned within the portrait. Various possibilities always exist, and you'll have to make one commitment based on logic and on the impulses and vibrations that flow between you and the sitter.

CHAPTER FIVE
Lighting and Values

The next logical step is the matter of tonality: the various degrees of dark and light in painting, and how light affects the subject and, consequently, the portrait.

Nine Values in Painting

The human hand can't possibly duplicate the variety of tonal gradations visible to the human eye. So this discrepancy must be compensated for by greatly simplifying these degrees of value and reducing them, for the practical considerations of painting, to nine. Artists have found this number both manageable and capable of showing the complete gamut of value—from darkest dark to lightest light—in terms of paint mixtures.

By identifying and classifying the tones we see on the subject into one of these nine standardized grades, we're able to mix an *approximate* shade to simulate the real thing. This is the only way that realistic painting can achieve some illusion of reality.

To facilitate this process, you can buy a ready-made tonal chart in an art materials store, or make one of your own. It's quite easy. Merely cut a piece of canvas or board or paper into a rectangular strip and measure off nine squares. Then get a tube of white and a tube of black paint. Proceeding from black, mix seven progressively lighter shades. I say seven because one is pure white and one pure black. Number these degrees from 1 to 9; white is the first and black is the ninth.

That's all there is to it. Now if you're ever in doubt as to what degree of value an object presents, consult your chart and assign it to one of these nine categories.

Six Kinds of Value

In addition to breaking up light into nine degrees, an addi-

tional system is employed by artists to help them make value distinctions. Under this system, values are divided into six categories:

1. Light
2. Halftone
3. Shadow
4. Highlight
5. Reflected light
6. Cast shadow

Basically, the light illuminating a form is either *light, halftone,* or *shadow.* The last three classifications (*highlight, reflected light,* and *cast shadow*) are merely modifications of these basic three categories.

HIGHLIGHT. This is where light has been pinpointed for some reason. Most often, it is the lightest light in the painting. But it doesn't have to be, since a highlight falling on a dark area may only *appear* bright due to the dark areas surrounding it. For example, a highlight falling on pale skin is obviously going to be lighter than one falling on dark skin.

REFLECTED LIGHT. This usually catches the reflection of a bright surface (not the main source of light) and is then bounced back into the form, lightening or coloring it at that point.

CAST SHADOW. This is really little different from regular shadow. It results from some protrusion within the object—such as a nose—which throws additional shadow onto the form, often not within the *general* shadow area. Few artists bother to differentiate it from general shadow, but you should be familiar with the term.

If you want to paint the head so that it appears solid and three-dimensional, stick to light, halftone, and shadow. Don't get overly involved with highlights, cast shadows, or reflected lights. They are mere frosting on the cake; if not kept under tight rein, they'll turn your painting into one of those wedding portraits you see in neighborhood photography shops. There are those who go even more basic and divide values into just two categories: light and shadow, with so-called halftones relegated to either one category or the other. David Leffel belongs to this school. He

Grace Holmes by Ray Goodbred, oil on canvas, 52" x 34" (132 x 86 cm), private collection. Fairly tightly painted and moderately low in key, this fine painting shows a quality of light that's essentially cool in character. We sense the absence of warm sunlight and the presence of a brooding autumnlike atmosphere. This ambience is reflected in the girl's far-off, subdued gaze. Would the effect have been as successful if the light were warm and the key high? I rather doubt it. I cannot sufficiently stress the importance of matching the color, mood, temperature, and angle of light—as well as other conditions—to the overall objective of the portrait.

teaches his students to look for lights and for shadows, and to treat the areas where the two meet simply as edges. It's a concept worth thinking about.

The approach most experienced artists follow is to first block in the head in *basic* light, halftone, and shadow. They then refine it by breaking up each of these big areas into further divisions and gradations *while still maintaining these three general value categories*. They conclude by adding whatever few highlights or reflected lights are present. Most portrait painters employ this procedure and nearly all begin with the darks and work their way progressively to the lightest areas of the form.

High, Medium, or Low Key

Key represents the general tonality of a painting, in which the nine degrees of value range are present. In a high-key painting, everything is fairly light, even the darks; while in a low-key painting, everything is fairly dark, even the lights. Thus in a high-key painting, the darkest or *9th* degree may be equal to only the *6th* degree in a low-key painting.

An artist generally paints all his pictures in a similar key—a predisposition based on his own character, personality, and other instinctive forces. Charles Baskerville says that he paints in a high key to express his happiness with life. David Leffel paints in low key. Ray Kinstler feels he falls somewhere between.

Although artists express their desire to change key from portrait to portrait, I rather doubt that they can. It seems that key is a natural, uncontrollable factor that's beyond one's intervention. The thing to do is decide early in which key you feel most comfortable. Then live with the knowledge that you'll probably stay within it for the remainder of your career. Knowing and accepting this condition may save you many days of frustration and let you concentrate on factors you *can* control and correct.

Angle and Direction of Light

Light can fall on your subject from directly overhead, from high on either side, from a level side position, from below, from the back, or from several sources at once. The thing to eliminate immediately is multisource illumination, since it destroys the basic three-value concept of the form. It creates various conflicting conditions which are totally unacceptable in serious realistic painting.

Assuming single-source illumination, let's discuss the various possibilities available within this area.

OVERHEAD LIGHT. This is the so-called Rembrandt lighting favored by the Master and his numerous disciples and imitators. In it, the light presumably issues from a ceiling skylight. But the effect can be simulated by hanging a single bulb just over the model or slightly off center.

This set-up casts deep shadows into the eye sockets and throws the lower part of the face, except for possibly the tip of the chin, into nearly total darkness. The forehead, nose, cheekbone, and shoulders catch some of the light.

It's a rather somber, deeply dramatic illumination that

few commissioned portraitists attempt, since rare is the client who would consent to have herself painted mostly in shadow. For the artist who expresses himself essentially in color, it's to be avoided like the plague; it's basically an exercise in value—the play of light against shadow. It calls for a low-key, dark background and a rather grim, solemn mood. It also makes it very difficult to achieve likeness, since so much of the subject isn't visible.

HIGH SIDE LIGHTING. Lighting that comes from the side and slightly above the head is the angle most favored by portraitists. It gives the head sufficient form by producing a full range of value, but it also allows enough color to be seen and doesn't darken the shadows excessively. Baskerville likes it because it creates an interesting triangle of shadow beneath the nose. It's the kind of illumination that permits the most latitude in background, key, and mood.

SAME-LEVEL SIDE LIGHTING. Placing the light to the side of the head and on the same level as the sitter tends to flatten the form and reduce the degree of tonality so that the light and shadow begin to come closer together. If the subject is posed facing this light squarely, it will result in a flat, even look, in which all planes will tend to be equal or only slightly varied in value. It's not the type of illumination most painters would choose, but unless they have studios with high windows and shades that roll up from the bottom, it's the kind of light they're most likely to be stuck with. Actually, it's the kind of light most of us live by, since the average window begins about 36 inches from the floor; its light hits our heads just about amidships.

LIGHT FROM BELOW. If you want to play Dr. Frankenstein with your subject, light her from below and she'll emerge just like the Monster.

BACK LIGHTING. Placing the model in front of the light so that the head is in silhouette with just a bit of light around the edges produces an interesting effect. However, it is hardly applicable to a portrait unless you use a secondary light source to throw additional light into the face. It's an effect you can use as an exercise or experiment, but I'd be reluctant to recommend it for most indoor portraiture. It is something to be tested outdoors where the disparity of light is not as severe and where enough illumination strikes the face to produce a charming and effective portrait. Ray Kinstler informs me that the great Anders Zorn used back lighting extensively for portraits.

Direct or Diffused Light

Light is considered *direct* if it strikes a form without passing through something that breaks up the rays—such as screens, veils, glass, plastic, cloth, paper, or any other intervening substances. Light that's *diffused* is clearly the opposite of direct light.

Direct light tends to create deeper shadows, sharper edges, stronger forms. Diffused light reverses these conditions. Artists generally select a flatter, more diffused light for women's portraits in order to lend softness to the face and to avoid a hard, harsh appearance.

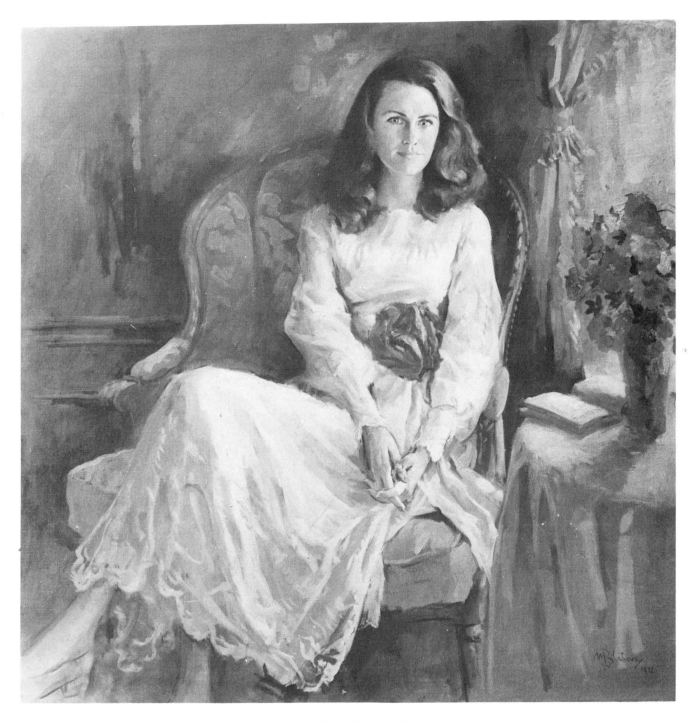

Mrs. Arthur Lee Quinn by Marcos Blahove, oil on canvas, 40" x 40" (102 x 102 cm), collection Mr. and Mrs. Arthur Lee Quinn. Here the light obviously issues from the side window and is level with the subject's face. In such instances, when painting on location, the artist must do his best with the conditions at hand. This kind of side lighting doesn't produce the often more dramatic shadows gained from a higher angle of illumination. However, it does provide a more natural effect, since most of us live and observe our fellow human beings under such conditions. Note how little variation in value exists between the light and the shadow sides of the face, yet the head seems round and turns nicely.

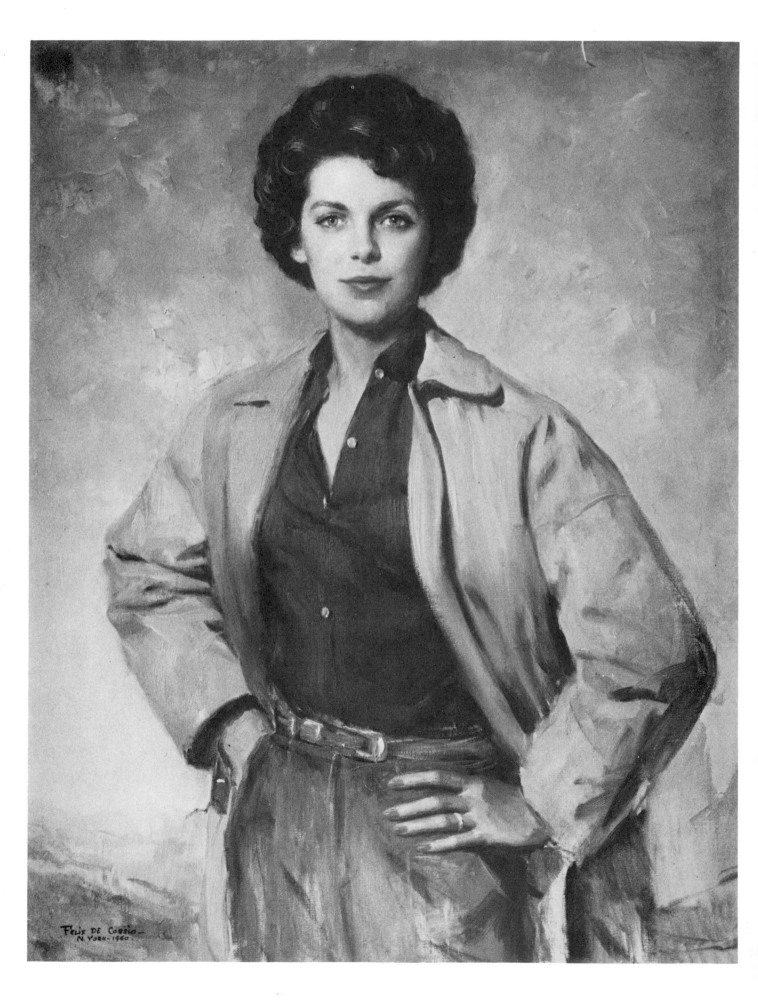

Light can be deliberately diffused by the use of plastic screens or cheesecloth. Clifford Jackson occasionally uses the latter to cut down the harshness of light and to negate some of the blueness of the sky. Also, unwashed glass does a marvelous job of diffusing light, and most city studio windows carry a lovely patina of ancient dust and grime.

Artificial or Natural Light

No artist who paints portraits would choose artificial light over natural light. Of those I've questioned, Kinstler, Burns, and Leffel conceded that they would make do with artificial light if forced to. The others would wait for daylight. Their reluctance is understandable. Artificial light affects color to a great degree. Many of the subtle and delicate shades are altered sharply, while others vanish.

If you must use artificial light, try for the type that most nearly approximates daylight. Some of the fluorescent bulbs come close. But until you've made a thorough study of what happens to color under electric illumination so that you can compensate for the discrepancies, stay away from artificial light.

Of all daylight sources, most artists agree that north light is best. It provides a steadier, less changeable light, and it keeps the sun out of your studio. If you can't have north light, you can use shades, screens, etc. to block out the sun and keep your light as consistent as possible.

The Outdoor Portrait

Nearly all the artists in this book said that they've enjoyed the challenge of painting portraits outdoors, and most expressed the urge to do more of them. Outdoor light lends sparkle and animation to the form and eliminates that "studio look" which can be stilted, airless, and musty.

Painting outdoors can be done in all kinds of weather, but the light must remain consistent from session to session. Since you can't control the light outdoors as you can, to some degree, in your studio, you have to postpone the portrait until you obtain exactly the same conditions. Movie directors who spend thousands of dollars waiting for a certain light effect that might last three seconds on the screen can sympathize with the outdoor portraitist's problem.

Outdoor subjects can be posed in sunlight or in shade, but the latter is usually chosen. Sunlight makes a person squint, sweat, and burn—while shade is comfortable. But even if you choose to place your subject in the sun, make

Mrs. Sherlock Hackley by Felix de Cossio, oil on canvas, 40" x 40" (102 x 91 cm), collection Mrs. Sherlock Hackley. Here is a painting in which natural elements are merely indicated in the background, yet we instinctively know that it's an outdoor portrait. The subject has her eyes opened normally, so we know she wasn't posed in sunlight. The light on her face is fairly high in value, but the main source of illumination is not directly overhead, since no distinct cast shadow has formed beneath the nostrils. Was it painted indoors to simulate the outside? Perhaps. But what matters is the overall effect which has been successfully achieved. In painting, the end justifies the means.

sure to set up your canvas and palette in the shade, or you'll run into terrible difficulties. If you paint in sunlight and bring the picture inside, you'll be horrified by the results. The values will all be distorted, colors will be washed out—the effect will be a total disaster.

You will find that the light outdoors produces altogether different effects than inside. Shadows are lighter and more suffused with color. There is much more reflected light. Colors have a tendency to appear less uniform and more mosaic like—broken up into little patches of various color. Take notice of these changes and try to incorporate them into the painting so that it appears natural to its locale.

Some artists, when faced with the need to paint an outdoor portrait, will paint the subject inside and then add elements of landscape to make the painting appear as if it had been painted outside. However, this is a risky procedure, since the portrait may reflect this subterfuge. If you want to paint an outdoor portrait, do it outdoors, but be wary of the potentially dangerous effects of sunlight.

Warm or Cool Light

Natural light is either warm or cool. It all depends on the weather, the geographic region, the time of day, the season, and other variables. Sunlight is naturally warmer than the light from an overcast sky, and summer is more likely to present warmer light than winter. Sunsets also produce warmer light. Certain geographical regions are warmer than others. For example, the general light of Southern France is warmer than that of Holland or Norway, and desert light is generally warmer than light around the seashore. The plain is also warmer in light than the mountain.

Be aware of the *temperature* of the light in which you live and work and determine if it's essentially cool or warm. Naturally, this will vary from season to season and from day to day. But be conscious of this phenomenon and either adapt it to your painting or adjust it to fit the concept you wish to portray.

Best Light for a Woman's Portrait

On this subject, I'll go back to my ongoing contention—let the subject dictate the conditions, not the other way around!

If, for instance, you live in Southern Arizona, the easiest thing is to accept the fact that the light is warm and the atmosphere is dry; therefore, paint every portrait to reflect these conditions. But suppose the subject—because of her character, coloring, costume, or attitude—dictates a portrait in cool light? Must you remain constrained by local conditions and slavishly knuckle under to what *is*? Or shouldn't you rather take the bit in hand and paint the portrait as cool as it deserves to be?

You know the answer.

The best light for a woman's portrait is that which best suits her individual image, makeup, character, presence, coloring, status, age, bearing, stature, etc. If the lighting conditions in your studio can't provide the type of illumination you demand, either change them to suit your requirements or adjust by painting the portrait the way it

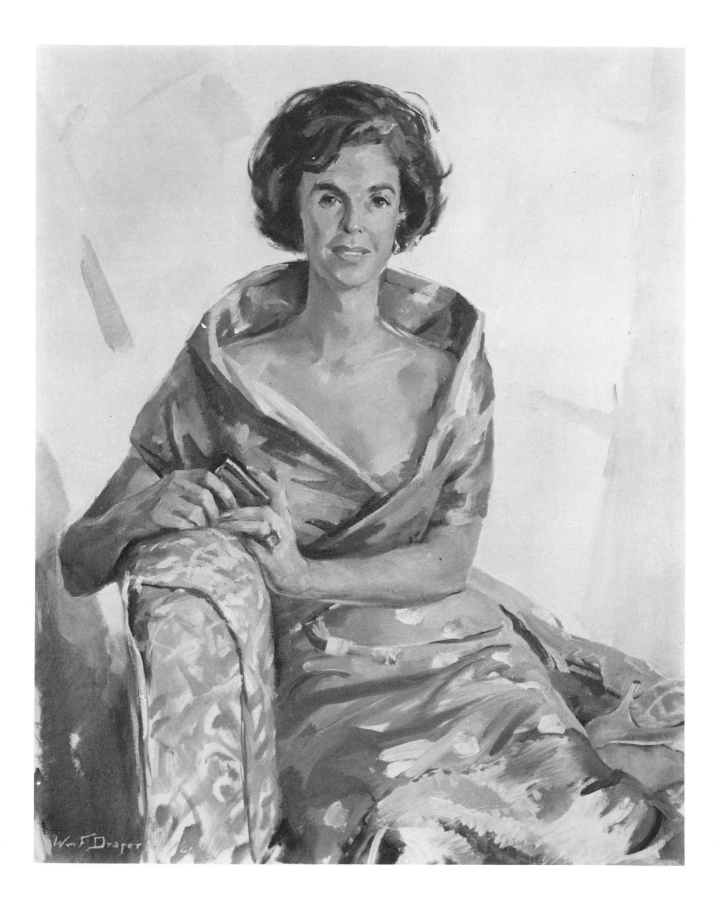

should look according to your visualization.

Above all, don't do either of the following things:

Don't sublimate your visualization to the conditions.

Don't try to remold your subject to fit the conditions. She'll resent this intrusion upon her individuality, and you'll end up with a dishonest portrait.

Summing Up

The gist of this chapter can be briefly summarized:

1. The head is best painted in three general value gradations—light, halftone, and shadow. All other touches, such as highlights, reflected lights, and cast shadows, are mere incidentals.

2. If possible, select the key that's most suitable to the sitter for each individual portrait. I say "if possible," since key is a built-in characteristic of the painter.

3. High side lighting is best for most portraits.

4. A flat, diffused light is considered desirable for women.

5. Painting under natural light is preferable.

6. Outdoor portraits can be fun, but be wary of sunlight.

7. Determine by the sitter's physical and emotional traits if she'd look better painted in warm or cool light.

8. Arrange your illumination to meet the demands of the portrait; don't meekly accept things as they are.

Mrs. Harcourt Amory by William F. Draper, oil on canvas, 36″ x 30″ (91 x 76 cm), collection the Amory family. Here is a fine example of a bright-color, high-key painting executed in the artist's usual dashing style by one of today's foremost portrait painters. Painting in high key tends to promote an "up," joyous effect that works particularly well with such a pretty, youthful subject as Mrs. Amory. Note the great variety of tonal gradations within the skin tones of the figure. High key doesn't indicate a lack of values. The gamut may be extensive; only the general overall tonality is higher than it would be in a low-key painting.

The Korean Girl—Hyo Chang Yoo *by Mary Beth McKenzie, oil on canvas, 14″ x 11″ (36 x 28 cm), collection the artist. Oriental skin tones vary as much as Caucasian; however, they generally tend toward the sallow, ivory, ochre shades as opposed to the pink, rosy, or florid. On page 49 you will find some suggested mixtures from which to arrive at a basic skin color for the Oriental subject. However, always remember that each situation depends upon the individual sitter and upon the light that illuminates her. Here, McKenzie has executed a powerful portrait in which the planes are distinctly delineated so that the head assumes a plastic, sculptured quality.*

CHAPTER SIX
Color

We are now ready to consider color. This is such a complex and subjective area that there are no firm "rules." I can no more implant good color sense in another person than I can teach my St. Bernard to compose a sonata. All I can do is make you aware of certain things which I've been lucky enough to absorb through conversations with many experienced artists, through extensive reading and observing, and through years of often frustrating trial and error.

Warm and Cool Colors

Artists automatically separate color into warm and cool. This division is often quite arbitrary and differs from painter to painter. Although some specific rules regarding the temperature of color have been postulated, it is well to reject such a didactic approach. Response to color is a purely personal experience and I'm convinced that no two people see a color alike.

Still, there are some accepted means of classification that I will mention as a possible aid to clarifying the subject.

Generally speaking, red, orange, and yellow are considered warm, while blue, green, and violet are considered cool.

Going a bit further and employing the nomenclature of colors in terms of artist's paints, there are *warm* reds such as cadmium red light, cadmium red medium, burnt sienna, vermilion, and Venetian red; there are also *cool* reds such as alizarin crimson, Indian red, rose madder, and magenta.

There are *warm* oranges and yellows such as cadmium yellow medium, cadmium yellow deep, cadmium orange, and Indian yellow; and there are *cool* oranges and yellows such as lemon yellow, yellow ochre, raw sienna, naples yellow, and mars orange.

There are *warmer* blues like cobalt and ultramarine; and *cooler* blues like Prussian blue and thalo blue.

There are *warm* greens such as cadmium green and chromium oxide green and cooler greens such as viridian and thalo green.

And so on and on.

The average palette runs between twelve and fifteen colors. Most painters break it up into a cool and a warm side, with white in between. Most blacks and grays are relegated to the cool side, and most browns to the warm.

But since such a useful color as raw umber is both brown and cool, where does it belong—on the warm or cool side of the palette?

Who cares? The colors are merely separated to make your job easier, not to bring on anxiety attacks. Put it on one side or put it on the other. Separate the warms and cools by instinct and *for your own convenience only!* What matters is whether a color provides you the desirable mixture, not where it rests on the palette.

Selecting Your Palette of Colors

This is a most important process, since it provides you with the proper tools to do your job. No surgeon picks his instruments more deliberately than the conscientious artist selecting the colors for his palette. However, it's not usually something you accomplish in a short time. It involves a long and arduous process of selection, trial, and elimination. Artists often keep changing their palettes to their last breath. As people grow in knowledge, skill, and experience, they keep adjusting their views and attitudes. They accept some new concepts and reject some old. It's the same with colors. We learn that we can do without some and not without others. It's a constantly evolving process, which is as it should be.

However, there has to be some sort of commitment, or else all will be chaos.

Where to begin?

With logic. We know that the colors of nature can be simulated with a certain complement of artist's colors consisting of various hues approximating those seen in the prism. These include red, orange, yellow, yellow-green, blue-green, blue, and violet.

Out of these seven colors, theoretically every color shade in nature can be mixed. Since we also know that to lighten these colors, we also need white, we have arrived at a point of departure. The next problem is how to translate these colors into those found in artist's paints, and additionally, to determine if we want to *mix* the unavailable shades or to obtain additional paints that approximate them.

Let's do one thing at a time.

First, we'll translate the colors of the spectrum into approximately matching artist's paints.

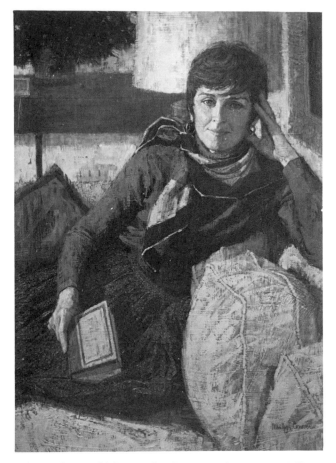

Mrs. Natalie Herold, by Marilyn Conover, oil on canvas, 36" x 26" (91 x 66 cm), collection Mrs. Herold. The artist has cleverly posed the sitter to appear as if she has caught her at home during a moment of quiet relaxation. Although the color can't be determined here, it's evident that bright, vivid hues dominate the portrait. Notice how much detail Conover is able to show in the shadow side of the face—a clear indication that the key is high even in the dark areas of the painting. This is the way the Impressionists painted, and it's a method adopted by many artists of today who rebel against the dark, deep, basically colorless shadows of the old masters.

Red: cadmium red light or medium

Orange: cadmium orange

Yellow: cadmium yellow pale

Yellow-green: chromium oxide green

Blue-green: cerulean

Blue: ultramarine or cobalt

Violet: cobalt violet

White: lead, or zinc, or titanium

With these eight colors, you can ostensibly get by. But, there's absolutely no reason, scientific or artistic, for arbitrarily selecting a palette on the basis of what appears in the spectrum! By all means pick some reds, yellows, oranges, blues, greens, and violets. But no one can or should tell you which or how many (if any) you must select in any category! This is something you'll have to go through yourself, just as I and all the artists in this book had to do. Nor is there any reason you shouldn't pick such colors as ready-mixed browns, grays, blacks, or what-have-you.

I paint with seven colors, *not one of which* is included in Clifford Jackson's array of twenty-six. What does that mean? Only that we approach fairly similar problems from totally different directions.

If you do seek some starting point, consider the palettes used by the artists listed in this book, or in similar books, and begin from there. Or get one of the books that list the palettes allegedly employed by the masters. Or bone up all you can on color and make up your own palette. Or ask a friend who paints what his or her preferences are.

Only by long and determined testing and experimenting will you finally arrive at a palette that's more or less right for you.

Do keep in mind that artist's oil colors are not only warm and cool, but also transparent and opaque—and they vary in drying time.

Selecting an Overall Color Scheme

One way of handling color in a portrait (or in any painting) is to consciously predetermine an overall color scheme so that the picture emerges basically green, red, orange, yellow, etc. One way to do this is to pre-mix every color on the palette with some of the basic color. For instance, if the overall scheme of the picture is yellow, you would mix some yellow into every color on the palette.

There are strongly divided opinions on the concept of an overall color scheme. Some painters feel that it's a positive, challenging way to paint a picture, since it creates a kind of harmonious cohesiveness. Others feel that it's detrimental because it negates an imaginative use of color and tends toward sameness and monotony.

Both arguments carry weight, and it's a question open to debate. However, before accepting or rejecting this or any concept, the artist should test it first.

Dull or Intense Color

Since artists are people, and since people's color sense varies from individual to individual, it's natural that some painters would prefer muted colors and others intense colors. This is invariably a result of personal temperament and is not subject to outside criticism or interference. What seems most natural and attractive to you dictates the trend you should follow. It's true that people's taste changes as they grow, and that a complete reversal in an artist's color preferences is possible. Obviously, the Impressionists opened up new vistas in the use of color in art, a practice carried even further by the Fauves and the Expressionists.

But even though no one can tell you how dull or intense your color should be, there are restrictions imposed upon portrait painters that don't prevail upon those painting landscapes, still lifes, interiors, or what have you. This is particularly true if the artist seeks to paint realistically, and especially so if he paints on commission. Although a number of artists do employ brighter color than was once acceptable, the average portrait still remains within the bounds of rather conservative coloration.

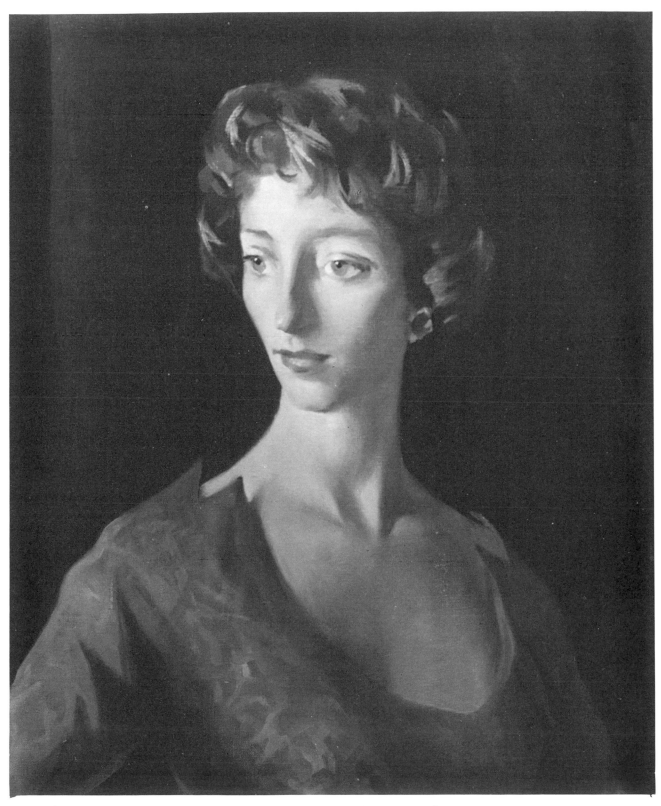

Cynthia *by Richard L. Seyffert, oil on canvas, 24″ x 20″ (61 x 51 cm), collection Mrs. Rich-*
ard Botsford. Another fine instance of imaginative use of a dark background. Seyffert drifts
the edges of the hair and dress into the deep shadows that surround the figure but keeps the
tonal gradation within the figure fairly even and close. This helps to make the form appear
to emerge from the background and fosters the illusion of reality. Seyffert's color is more
toward the subdued rather than the intense, and his general technique is smooth and flow-
ing. Note how the tone of the whites of the eyes is kept down to avoid a harsh, unnatural
contrast between them and the surrounding skin tones.

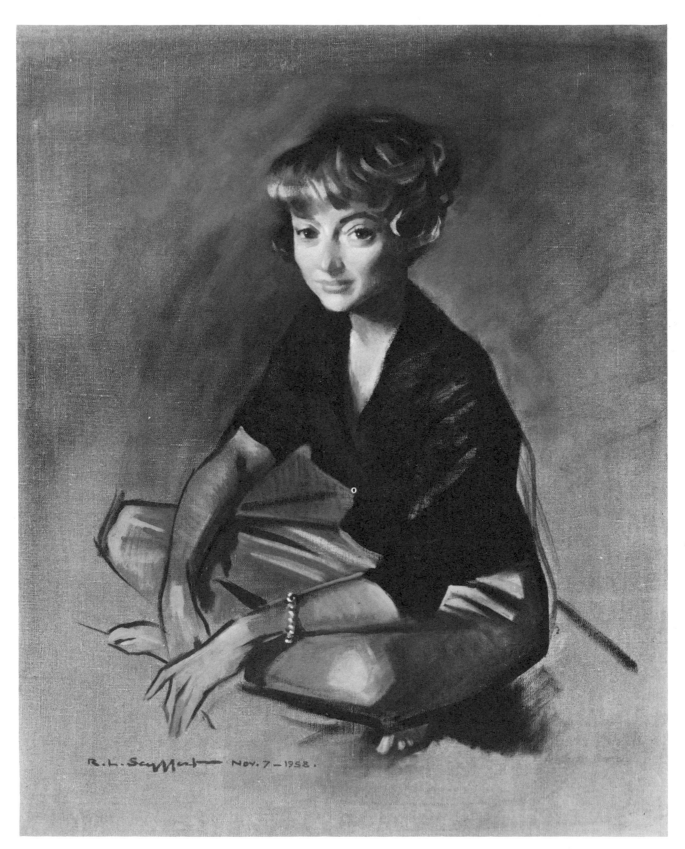

Thea *by Richard L. Seyffert, oil on canvas, 40″ x 34″ (102 x 86 cm), collection Mr. and Mrs. J. Gildemeister. I have to presume that this is a noncommissioned portrait since few clients (or artists) would be daring enough to agree to such an informal pose. Yet the fact that it works so well should give pause to those who never vary their presentation. Seyffert has used the principle of selective focus to concentrate on the face and treat the rest of the body in a rather sketchy fashion. Had he done otherwise, we would be galloping haphazardly all over the picture, and the impact of the portrait would be mitigated or lost.*

Clifford Jackson and Clyde Smith (whose portrait of Adele Bernard appears on page 72) come as close as anyone I know in professional portraiture to an almost Expressionistic use of color. Whether this is the forefront of a trend or merely an isolated case of individual expression, only time will tell.

In any case, give much thought to this aspect of your personal color preference. If your tendency is toward very intense color, realize the limitations this will impose upon you in today's portrait market. But also consider that you may be the forerunner of the trend of tomorrow. In reference to this whole question I urge you to read with particular care David Leffel's remarks regarding what he calls "subtractive" use of color in Chapter 14 of this book.

Mastering Color

Color, by virtue of the subjective reaction it evokes in every individual, cannot be governed by rules, precepts, or directives—at least not when it comes to its use in painting. To me, color is a viable, elusive presence that defies description, yet is unmistakably a force to be reckoned with—maybe something like love. All of us love somebody or something. But *how* we love is entirely up to us. There are many ways to express love. The same with color. No two painters express it alike, and that's as it should be; otherwise all paintings would emerge the same.

This long preamble has been offered merely to admonish you not to seek formulas or recipes for the use of color, since none exist. In the following section, I'll offer some possible color combinations for painting general skin tones. But these are mere guidelines to help establish a starting point from which to strike out your own.

For now, let me strongly advise that you make color your tool, not your master. Feel free to subdue it, exaggerate it, invent it. It's there like raw clay from which you, the sculptor, must mold the statue. If you timidly try to simply match color precisely you'll end up *rendering* a portrait, not creating it. And a color camera can probably do better.

Some General Skin Tone Mixtures

The key to this section is the word *general*, for I wouldn't think of making specific directives on how any skin should be painted, since each skin is different. Even more so, each is strongly affected by the light that strikes it at any particular time. So take these suggested mixtures as a basis from which to build your color combinations to meet the specific situation.

Suggested color combinations for Caucasian (white) skin:

Yellow ochre and white

Cadmium red and white

Cadmium orange and white

Venetian red, yellow ochre, and white

Same as above, with a touch of chromium oxide green

Burnt sienna, cadmium red, white

Same as above, with a touch of ultramarine

Burnt sienna, alizarin, white

Same as above, with a touch of ultramarine

Cadmium yellow medium, cadmium red deep, white

Same as above, with a touch of blue or green

Cadmium scarlet, raw sienna, white.

Suggested color combinations for dark skin:

Raw sienna and raw umber

Ivory black and cadmium red

Ultramarine blue, burnt sienna, Indian red

Raw umber, Venetian red, black, blue

Cadmium yellow medium, cadmium red deep, gold ochre, burnt sienna

Suggested color combinations for Oriental skin:

Yellow ochre, white, chromium oxide green, with a touch of Venetian red

Alizarin crimson, yellow ochre, with a touch of blue or green

Yellow ochre and white

Lavenders in the shadow areas, violets for the lips

Color in Backgrounds

Portrait backgrounds are also made up of color, but usually this color is duller than that found within the head and figure. The general trend is to keep background color fairly neutral and toward the green, gray, or brown side. A vivid background might intrude and take emphasis away from the main attraction—the subject.

One approach is to contrast the background color *temperature* with that of the figure. If the skin tones are warm, the background is cool, and vice versa. Some portraits are bright and high in key all over, backgrounds included. But even here, it would be more useful to reserve the brightest tones for the figure.

Choosing Colors for the Subject

Certain subjects, by virtue of all the aspects we have already considered, may call for a specific overall color scheme or for individual color accents. You can determine this during the planning stages by arranging costume, background, light, etc. Or you can decide this during the actual stages of execution by inventing or changing the existing elements to suit the color demands.

Either way works, but the best way is to combine both methods. Prior to painting arrange all elements as closely as possible to the desired color concept. This way. you'll have less to alter during the actual progress of the portrait. This combination of approaches makes attainment of your color goals that much easier and more practical.

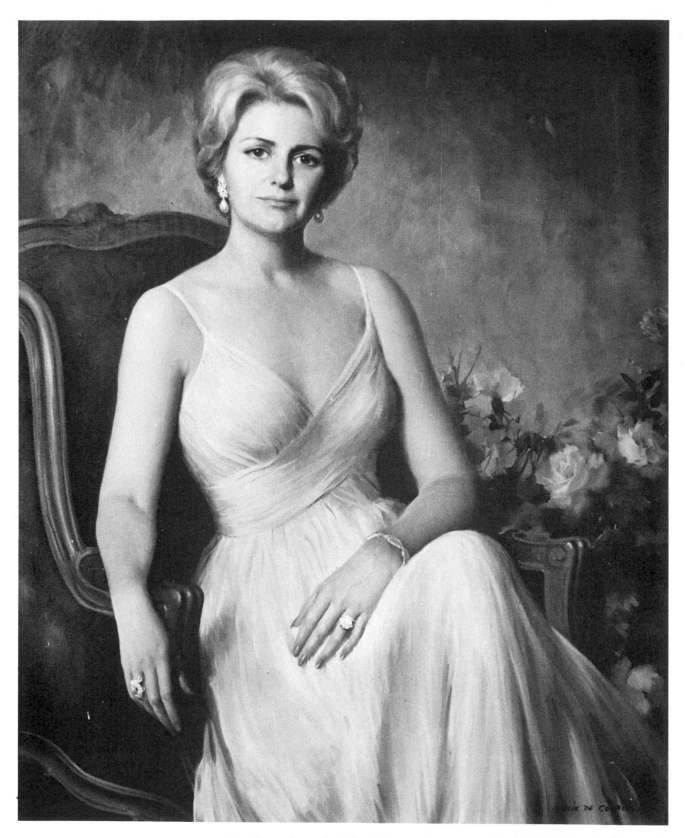

Mrs. Blanca Suarez by Felix de Cossio, oil on canvas, 46" x 36" (117 x 91 cm), collection Mr. Diego Suarez. This is a splendid example of the tight technique of painting, in the very best sense of the word. The artist makes certain to soften enough edges so that the total effect isn't harsh, but all the elements are clearly delineated, and the transitions between the planes are extremely smooth and subtle. Notice the amount of detail in the jewelry. In the hands of one less skilled than de Cossio, this might have focused too much attention upon the hands. But through skillful use of design and contrasting values, the eye is immediately drawn to the subject's very attractive face, as the artist intended.

CHAPTER SEVEN
Materials

The physical tools used to create good art are as important as the mental and emotional attributes of the artist. Without materials, the artist could not execute his vision. Care must be taken that neither factor is neglected in favor of the other. Both must be used with concern, intelligence, and good judgment.

Colors

Oil paints come in so called "student" and "professional" grades. The former are cheaper but may contain certain adulterants, driers, stabilizers, extenders, reducers, diluents or other inert materials to render them weaker in pigment and possibly less permanent than the higher-priced grades. I have painted with all brands and all grades of colors, and I have yet to determine any significant differences between any of them. These days, even the student-grade colors meet the minimum requirements established by the National Bureau of Standards and will probably outlive your grandchildren. However, if you're inclined to anxiety, buy only the top of the line of any of the better-known domestic or imported brands. These are Grumbacher, Permanent Pigments, Shiva, Rembrandt, Winsor & Newton, Weber, Bocour, or Blockx. Most manufacturers will provide you color charts and information as to the permanence of individual colors.

Canvas and Other Surfaces

Most oil painting is done on canvas which comes in linen, jute, cotton, duck and now in synthetic fiber form.

Linen, for a variety of reasons, offers the best surface, but is becoming somewhat more difficult to obtain. The trend for many manufacturers is to concentrate their effort on the cheaper, more popular cotton canvas, and many art stores now carry this surface exclusively.

Because of rising prices, some artists buy raw linen or cotton and prime it themselves. This results in considerable savings. Another reason for doing it yourself is to obtain a particular texture you desire. The glue for sizing, as well as the lead white, gesso, or titanium white for priming can be bought raw or ready-mixed.

For those who are really lazy, there are available prestretched cotton or linen canvases. You should check the type of priming used on any roll or prestretched canvas be-fore considering its purchase. Some are single-primed instead of double-primed, and many today are primed with acrylics instead of the lead white that most serious artists seem to prefer.

The better-known manufacturers of canvas are Fredrix, U.S. Art Canvas, Grumbacher, Winsor & Newton, and Weber.

Wood stretchers for canvas are easily obtainable in various lengths and widths.

Besides canvas, you can paint on so-called canvasboards, which are a cheap combination of cardboard and cloth and are less permanent than canvas.

There are also boards of compressed wood (hardboard) available in sheets in lumber yards. Some of these are quite adequate for painting (you have to size and prime them yourself) and are widely used. The Masonite Corporation makes a board called Standard Presdwood, which offers a smooth, stable surface.

Other possible (if questionable) surfaces for oils include plywood, paper, metal, and various manufactured wallboards used basically in construction.

Brushes and Knives

Brushes for oil painting are basically made of bristle and sable. The former are stiffer, the latter, softer and more pliable. Bristle and sable brushes come in several shapes:

1. *Rounds*—cylindrical brushes that taper to a point.
2. *Flats*—flat brushes with longer bristles.
3. *Brights*—flat brushes with shorter bristles.
4. *Filberts*—long, flat brushes with an oval shape.
5. *Blenders*—fan-shaped brushes for blending or fusing.

Brushes come in varying widths. Many artists prefer to work with large brushes only, eschewing the narrow brushes for their tendency to make one's work picky and fussy. I don't place much credence in this contention. Most professionals I know use whatever brush is handiest, and I've seen artists paint an entire picture using just one brush.

Knife painting allows you to paint thickly and more smoothly, since the blade can cover larger areas and leaves the paint passages free of the marks of the hair of a

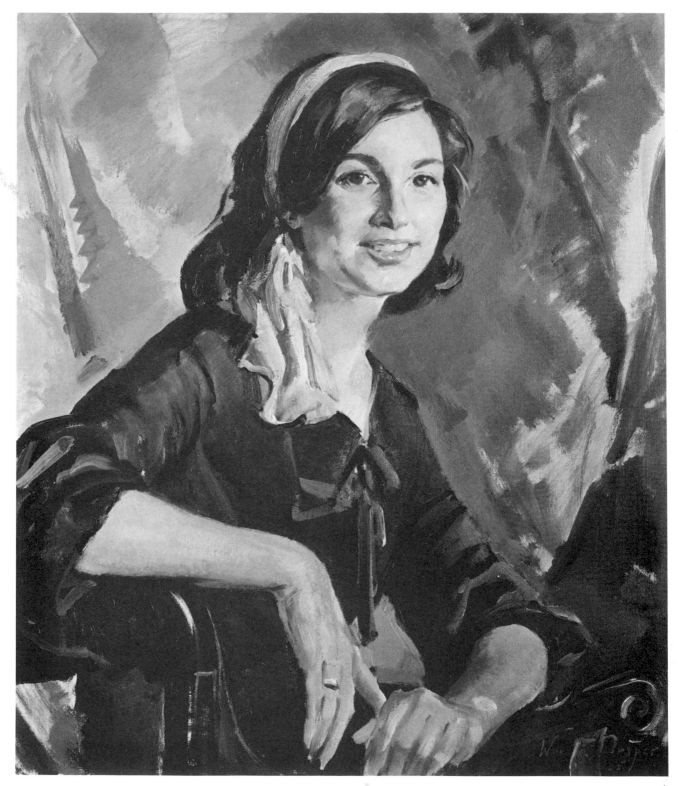

Sandra Goldberg (above) by William F. Draper, oil on canvas, 30″ x 25″ (76 x 64 cm), collection the Goldberg family. Note how the artist arranged the various elements to add interest to the portrait. The light head scarf provides a contrast against the dark hair, and the dark foulard at the neckline repeats the shape of the scarf and directs the eye down to the light triangle formed by the sleeve and hands. While it appears quite casual, all this is deliberate and planned. An artist such as Draper is constantly pressed to come up with intriguing new designs for the continuous flow of portraits he is commissioned to paint.

Mrs. Harold B. McSween (right) by Marilyn Conover, oil on canvas, 40″ x 30″ (102 x 76 cm), collection Mrs. McSween. There is no one method of painting portraits. Conover employs a kind of dry, scratchy, Impressionistic technique of broken color and distinct texture. Passages are scraped down with a knife, and a mosaic-like effect is achieved. Contrast this with the liquid, painterly approach of Kinstler, the smoothly blended technique of de Cossio, and the dash and bravura of Draper. No one can tell you how thickly, thinly, tightly, or loosely you must work. The answer will emerge from within yourself after intensive study, trial and error, and introspection.

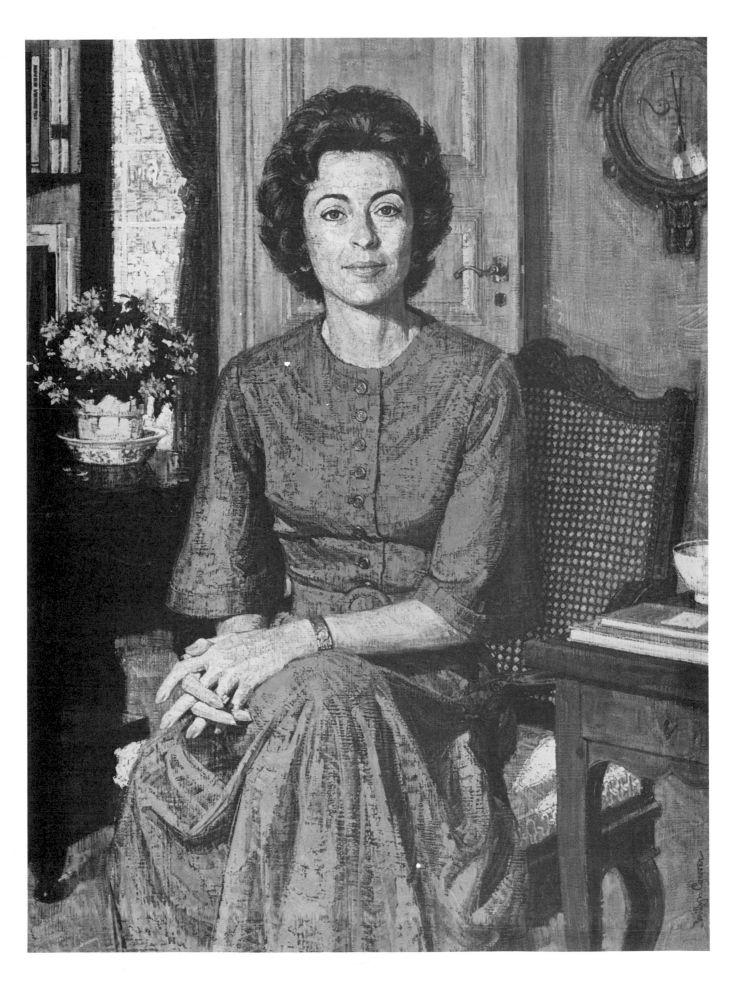

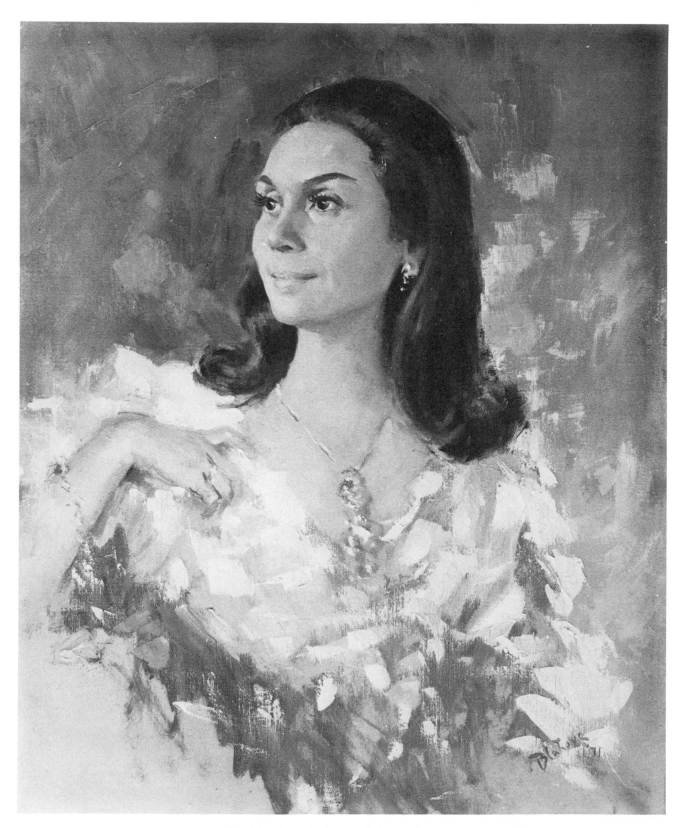

Graciela Rivera *by Marcos Blahove, oil on canvas, 26" x 20" (66 x 51 cm), collection Ms. Rivera. In this sparkling portrait of the Metropolitan Opera coloratura, Blahove shows what can be accomplished in a vignetted portrait. Although areas are left unfinished at the bottom of the canvas, the impact of the vivacious subject comes through and leaves no doubt as to her physical and emotional essence. Contrast this with the de Cossio painting of Mrs. Suarez (page 50), in which all the elements are thoroughly realized. It once more proves that a successful portrait can be approached from any number of directions, and that the restrictions imposed upon the artist are bounded only by his good sense, daring, and imagination.*

brush. The knife is also used for priming canvases.

Brushes are made by Delta, Robert Simmons, Winsor & Newton, Grumbacher, and Langnickel.

Easels

For your studio you'll need a sturdy easel that rolls, tilts in all directions, and moves up and down.

For outdoor or location painting, you'll need a good folding easel that's easily portable and which won't buckle, snap, or shake. The so-called French easel serves this purpose nicely.

Mediums, Varnishes, and Solvents

Most painters employ some sort of painting medium to make their paint flow more smoothly or to achieve certain effects. There are traditional mediums, self-concocted mediums, and experimental mediums, some of which have generated quite a bit of controversy.

A current tempest in the artistic teapot concerns the highly disputed Maroger medium, devised by the late art scholar and researcher, Jacques Maroger, who came up with a medium allegedly based on a formula employed by the old masters. Essentially, this is a mixture of linseed oil and mastic varnish which is then "cooked" to a jellylike consistency. Its proponents claim it permits a manipulation of colors unobtainable with any other medium. Its detractors condemn it as impermanent and a threat to the lifespan of the painting.

Of the artists interviewed in this book, only David Leffel paints with the Maroger medium. However, many painters today, both young and established, swear by its benefits. This medium is also used to tone canvases.

More traditional painting mediums are raw linseed oil alone; linseed oil mixed with turpentine; linseed oil, turpentine, and damar or copal varnish; stand oil or sun-thickened oil with turpentine and damar or copal varnish. However Frederic Taubes, whose copal mediums are made by Permanent Pigments, stoutly claims that copal is the medium of the old masters.

Retouch varnish is widely employed to bring up areas gone dry between painting sessions. Since experts warn not to apply a permanent varnish to an oil painting until six months to a year after its completion—in order to allow the paint to dry thoroughly—many portrait painters spray the portrait with the lightweight retouch varnish for temporary protection before releasing it to the client.

The heavier final varnish is usually made up of damar resin and turpentine.

The Palette

This can be either wood, glass, plastic, or paper. There are palettes that are hand-held and those that are affixed to a table or some other stand set on wheels or casters for easy mobility. There are advantages and disadvantages to each type of surface. The wooden palette is not as easy to scrape off as the glass. Artists usually allow the mounds of paint to build up around its rim and merely clean off the center mixing area between sessions. When the mountains of paint grow too high around the perimeter, the artists scrape them away, oil the palettes down with linseed oil, and begin anew. Some artists like the wooden palette for its middle tone which, they claim, gives them a better indication of how the paint mixtures will look when placed on the canvas.

The glass palette is easy to scrape clean with a razor blade, and those who use it clean their palette after each session. The glass can be either clear or opaque. If it's clear, you can slip white or toned cardboard underneath it, depending upon whether you like a white or a toned base on which to set out and mix your colors.

Paper palettes are disposable, and some artists who don't like to take time off to squeeze new paint or clean mixing areas keep tearing off used sheets and beginning anew. Another trick is to prepare several palettes full of color at the start of the session, then switch from a dirty one to a clean one as the first gets messy. Paul Burns and Clyde Smith are two artists that follow this routine.

It's generally best to use a larger rather than a smaller palette so that you won't run out of mixing room too soon.

Mirror

Many artists keep a mirror mounted on wheels handy in the studio. They use this mirror to check the proportions of their painting from a different angle. It also serves to double the distance from viewer to painting, which is particularly useful in a small studio. A third use of the mirror is to arrange it at such an angle that the subject can see herself being painted from beginning to end. This, some artists find, keeps the sitter entertained and less likely to fall asleep.

Screens and Draperies

A tall, folding, three-panel screen of some neutral color is used by many artists to provide a background; to cut down unwanted illumination; and to change around the look of the studio in order to lessen the chances of repeating oneself.

Most painters also keep a stock of clothes and draperies of various hues, textures, and tones to create instant backgrounds of desired shade and color. Pastel or assorted colored papers can also be employed for this purpose, as can an item called background paper which comes in wide widths and various colors and is used by photographers to achieve seam-proof backgrounds.

Other Equipment

Additional equipment you may require are: cups for mediums; brushwashers; paintboxes; rags; a mahlstick (to steady your hand); a reducing glass (which does exactly what it implies—reduces images); a staple gun or hammer and tacks for stretching canvas; canvas pliers; masking tape to mark the location of the easel between sessions; a so-called "blue glass" which removes all color when you look through it, so that you see the image in tone only; stretcher keys to tighten a sagging canvas; and atomizers to blow retouch varnish.

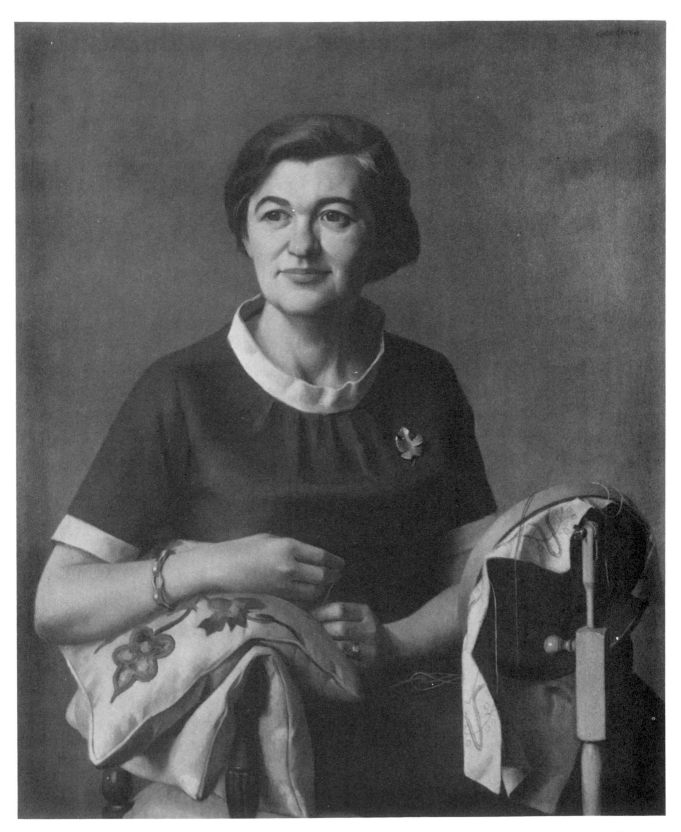

Mrs. Patricia Farrow *by Ray Goodbred, oil on canvas, 36" x 30" (91 x 76 cm), collection Mr. and Mrs. Farrow. The concept of flattery in the portrait is easily resolved by professional artists of high purpose and integrity. Most clients want to be shown as they are, not as some vague, idealized person. This fine-looking subject must have been pleased indeed with the character and individuality the artist managed to impart in her portrait. Had Goodbred failed to portray honestly her distinctive features, the result would have been insipid. How many times have you heard an ineffectual portraitist say: "I paint people as I see them, not as they are." This is the excuse of those who can't or won't capture likeness.*

CHAPTER EIGHT

Painting Methods and Procedures

In this final chapter of the first section of the book, I'll discuss some of the problems—technical and otherwise—that you might encounter in painting a woman's portrait. I'll also suggest some possible solutions. Additional suggestions may be gleaned from the two sections of the book in which six professional portrait painters articulate their concepts and approaches and show, step-by-step, how they put these theories into practice.

The Problem of Flattery

Flattery becomes a problem only when you make it one. The first thing you must face up to is that 90% of your subjects—be they nine or ninety—want to be *presented in the best possible light*. This doesn't mean deviating from the truth—it means *making the truth as attractive as possible*.

The remaining 10% will *demand* to be *flattered*, which does connote altering and embellishing the truth. Here is where you must decide your direction as a painter. If you refuse to flatter, you may lose some commissions. If, on the other hand, you consent to perform corrective work, then you compromise yourself as an artist.

In reality, no choice exists at all. You simply must decide that as an artist you're committed to truth, and this truth transcends all other considerations. However, you don't have to become a fanatic who feels compelled to trumpet his integrity from the rooftops by turning his subjects into Lady Draculas. Look at portraiture as you do upon dressing. The reasonably intelligent person dresses to make himself as attractive as possible without sacrificing good taste, or inviting ridicule, or calling attention to himself.

That's the way to approach portrait painting. By all means, minimize the subject's bad features and stress the good, but don't meddle with her essence—her individual physical, emotional, and spiritual self.

Achieving a Likeness

Achieving a likeness is for some artists a snap; for others—it's a burden. Often this has nothing to do with overall ability. Some carnival hustlers who paint "portraits" at fairgrounds can achieve a photographic resemblance within minutes. This deeply impresses innocents, but it certainly shouldn't awe anyone who values the deeper qualities of a portrait. Not that likeness isn't important, because it is. However, it's not always a facility that can be attained and kept unwaveringly consistent. If, after a reasonable period of study, you find that you still have trouble with likenesses do give serious thought to whether you should become a portrait painter. You can still go on painting portraits, but possibly you shouldn't make this your specialty. There are many excellent artists who fall into this category. They paint portraits, but not on commission. If likeness is for you a hit-or-miss proposition, commission portraiture is not for you.

Maybe with lots of practice you may improve your average, but it's been my experience that those who are good at getting likeness shine at this skill from the very beginning—even before they've learned to be good painters.

Use of Photographs

More portrait painters than care to admit it make extensive use of the camera. It's one of the worst-concealed, unspoken secrets of the trade, and you might as well face the fact that one day you too will have occasion to paint portraits from photos. The way to approach this is to be perfectly relaxed and unselfconscious about it. If for some reason your subject can't or won't pose in person, take as many black-and-white pictures of her as you can. Have them developed in a commercial studio (not at the local drugstore), select the best shots from the proofsheet, have them enlarged as big as possible, pin them to a stand or rack, and go to it.

In addition, shoot a roll or two of color transparencies (not prints) and use these as color *guides* to hair, eyes, costume, etc. Remember that color photography is generally unreliable (there are too many variables present); never, never slavishly copy or render a color or a black-and-white photograph! The use of photos in portraiture is intended as merely a guide, never as the end in itself. A good approach is to treat the photograph as you would the subject herself. You, not it, are the one who must decide how the finished portrait will emerge.

Edges

Some people claim that there is no such phenomenon as an *edge* in nature—merely loosely or tightly bound clusters of

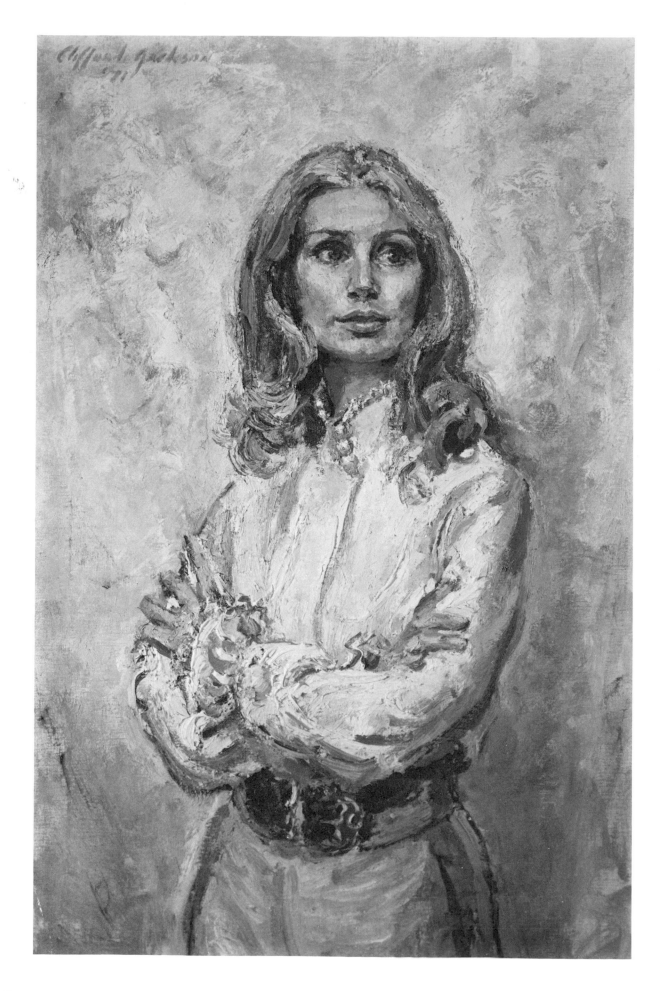

particles which, when pressed closely together, *seem* to produce a sharp line or edge.

Artists who paint realistically fall into two basic categories—the soft-edge painters and the hard-edge painters. Which is best? Neither. The best is to hew a middle course—paint some edges hard and some soft.

The next logical question is—when to do which? I can't honestly answer this question, since no rules apply to either situation, despite the fact that some "experts" postulate directions. I can only advise you to follow John Sargent's suggestion as passed along to me by Ray Kinstler. The Old Man is purported to have told a student: "Watch your edges . . ." This can be interpreted to mean that edges must be carefully considered and evaluated, advice with which I heartily concur.

Do remember, however, that of the two, you're better off leaning toward the soft edge. An edge can cleverly be made to *appear* sharper by placing two contrasting colors or values next to each other.

All the artists I interviewed agreed with me that edges should not be consistent but "lost and found" throughout the picture. They also concurred that this decision process must evolve out of the painter's instinct, not out of some book of painting rules.

Textures

Like edges, the beauty of textures in a painting lies in their variety. An all-rough painting is as tedious as an all-smooth one. A smooth area broken up by a rough brushstroke or two adds tang and spice to a portrait. A good general rule is to paint thick in the lights and thin in the shadows, since shadow is essentially veil-like in character.

The masters achieved a striking variety in their work by glazing extensively and piling up thick impastoes in selected passages. Another good approach is to define the actual textures found in the subject's skin, hair, and clothing, and to consciously indicate these with some bold, decisive strokes of the brush, knife, or other implement. Rembrandt scratched in sharp lines with the wooden tip of his brush handle. He would use anything at hand to achieve the effect he was after. Don't hesitate to do the same. If your thumb will serve to strike a telling passage, by all means use it! A match end, a hairpin, a crumpled piece of paper, a rough bath towel—whatever you use, make it work for you. The only thing that counts is how the picture looks at the end, not what you used to construct it.

Mrs. Berner by Clifford Jackson, oil on canvas, 36″ x 24″ (91 x 61 cm), courtesy Portraits, Inc. Jackson paints in a pure alla prima *technique, piling on paint heavily and emphasizing the texture of hair, skin, and clothing. This results in a painting in which color sparkles and shimmers in small, jewellike patches. Although his sense of construction is firm, Jackson concentrates on the aspect of painting, subordinating line to tone and color. Note how distinctly he models the subject's hair so that it assumes an almost sculptural quality. Compare this technique with some of the smoother and thinner styles displayed in the book and see which is more advantageous for expressing your goals.*

Alla Prima Technique

Painting *alla prima* means working direct, seeking to place the correct tone and color from the very first stroke. It's essentially a wet-into-wet technique in which the artist tries to retain a single cohesive layer of paint rather than painting in stages—waiting for one coat to dry before going on to the next. Most modern-day artists paint in the *alla prima* technique, which is more conducive to today's hurried, impulsive style of living.

Underpainting and Overpainting

The opposite of *alla prima* is the underpainting and overpainting technique. In this method, the picture is built up in successive stages or layers, and these paint layers are deliberately isolated from one another. A painting executed in this technique may proceed through the following stages:

TONED GROUND. A color is laid over the white primed surface to provide a middle tone. (A toned ground may also be used in *alla prima* painting.)

GRISAILLE. The head and/or figure is rendered in shades of monochrome only, usually gray. No color as such is employed. This allows the artist to solve the problems of tone without considering color.

OVERPAINTING AND GLAZING. Once the forms are established in monochrome, the painter can proceed to lay in the colors. This can be done in two ways—painting in opaque color or glazing. The former is self-explanatory. The latter means applying one or more *transparent* layers (or glazes) of color so that the underlying color or colors show through.

Glazing is done by diluting a color with medium or varnish to a thin, watery consistency and smearing it over the painting surface with brush, sponge, rag, or finger. The resulting effect may be compared to looking at an object through sunglasses or filters, or draping flesh in some filmy material such as silk.

Some Technical Notes

1. Instead of moving color around on the canvas, some artists place a brushstroke and *let it stay*. They refine by placing additional brushstrokes over each other, never by sloshing the paint around.

2. Some artists mix the color right on the palette and then place the mixture *as is* onto the canvas. Others, prefer to do all the mixing on the canvas itself.

3. Some artists cover a large area of the canvas in one enormous swoop. Others put in dainty little strokes that cover a small area at a time. Both methods work.

4. Some artists charge a brush with lots of color and slap it onto the canvas. Others transfer a little bit at a time from palette to surface.

5. Today's paint is manufactured so that it retains a kind of buttery consistency. The old masters used paint that was runnier and more wash-like. You can make your tube color

more fluid and "wet" by adding painting medium to it. To make your tube color even more crisp and solid, let it stand on a piece of tissue until it drains off the oily vehicle in which it was ground. Or you can mix it with specially ground whites instead of the standard whites. Such whites are manufactured by leading makers and are available under trade names: Permanent Pigments Texture White Underpaint, Winsor & Newton Underpainting White, Grumbacher MG White, Shiva Underpainting Textural White, and Talens Underpainting White.

6. Many artists prefer to mix a desired tint from primary colors rather than obtain it ready-made from a tube. This applies particularly to greens, browns, grays, and violets.

7. If you show the teeth in a smiling mouth, don't outline each tooth and don't make them too white or else you'll wind up with a toothpaste ad. The same for whites of eyes—keep them down in value.

8. Always remember the softness of the texture of hair. If you paint it to appear solid and dense as stone, you're asking for trouble.

9. Eyelashes aren't meant to be seen in a portrait—don't, for heaven's sake, indicate each one as an individual little hair.

10. If your subject has a network of wrinkles—indicate a few. Don't paint each and every one as sharp as a crevice. Wrinkles are basically soft, so treat them with tenderness and affection.

11. The white highlights in the iris—despite propaganda to the contrary—can be easily left out. Also, don't paint the color of eyes a too-vivid blue, green, brown, gray or what-have-you. Above all, don't listen to people who claim the color of their eyes changes with whatever they wear. You know better than that.

12. Don't fuss with ears. There is nothing particularly intriguing about the dizzying variety of hills and convolutions of the human ear. Paint ears as simply as possible, concentrating on the often interesting color they present.

13. Colored fingernails are likewise a trying sight. Leave out the polish or at least minimize it.

Setting Up

Having analyzed, diagnosed, lit, and posed your subject, you must now be in an ideal position to paint her. This means having all your tools ready and easily available and eliminating all possible nuisances and disturbances that might shatter your or her concentration.

First, depending upon the acuity of your vision, you must select a spot from which you'll see her in perfect focus. Some painters begin their portrait from far away and zero in closer and closer as it nears completion. Others prefer their subject literally nose-to-nose with the canvas. Still others like to maintain a considerable distance throughout.

Here are a few specific suggestions about setting up and actually starting the painting.

1. Pick a spot most favorable to you; then mark the floor with tape in case you wish to move your easel about and later resume the original position.

2. Have the palette (assuming it isn't hand-held) comfortably nearby and well lit so that you don't have to stoop or reach out each time you mix a color.

3. Squeeze out sufficient paint so that you don't have to stop every few minutes to replenish your palette. Some artists prepare several palettes at the very start. Make sure you have extra tubes of all your colors handy so that you don't suddenly run out of a necessary color. Do the same with mediums, varnishes, etc.

4. Have enough brushes handy so that you don't have to clean them too often.

5. Have an extra canvas stretched in case of some freak accident. I know of one enthusiastic painter who jabbed a brush end through his canvas in a moment of (artistic) passion.

6. Make sure there's a washroom handy.

7. Put all clocks out of sight. (Watching the minutes drag by tends to make sitters either drowsy or edgy.)

8. Turn off or muffle your telephone. Nothing is as jarring as a sudden loud ringing of the bell.

9. Unless you enjoy a coffee klatch atmosphere, discourage visitors. The presence of an outsider can be most disturbing.

10. If you decide to play music, determine your sitter's tastes so that she isn't forced to hear two hours of Wagner when she's a Johnny Cash freak, or vice versa.

11. If you converse, keep the topics light and impartial. Avoid politics, religion, gossip, and ethnic jokes.

12. If you use a mirror to let the subject follow the progress of the painting, make sure she can't see herself at the same time. This invariably leads to grimacing and posturing.

The Preliminary Sketch

Some artists do all their technical planning in their heads and then proceed immediately to the painting. Others like to work out the problems of proportion, composition, tone, and color in physical terms. The latter, having resolved the analytical and diagnostic stages of the portrait, like to view the results of their decisions on paper or canvas. They might begin by making numerous drawings of the subject as seen from various angles and in various poses. Ray Kinstler showed me a book he had filled with line sketches of a subject. He finds most helpful.

Another step might be making one or several *tone* sketches executed in any medium. These help work out problems of light and dark as well as familiarize the artist with the planes and forms of the subject's head and figure.

A third preliminary might be making a *color* sketch in which problems of color are confronted.

Having done one or more of the above, the artist may then begin executing thumbnail sketches in which he roughly resolves the placement of the head, figure, and other objects (if any) within the framework of the painting. By moving these elements around freely within the square, circle, or rectangle, he is certain to arrive at a composition

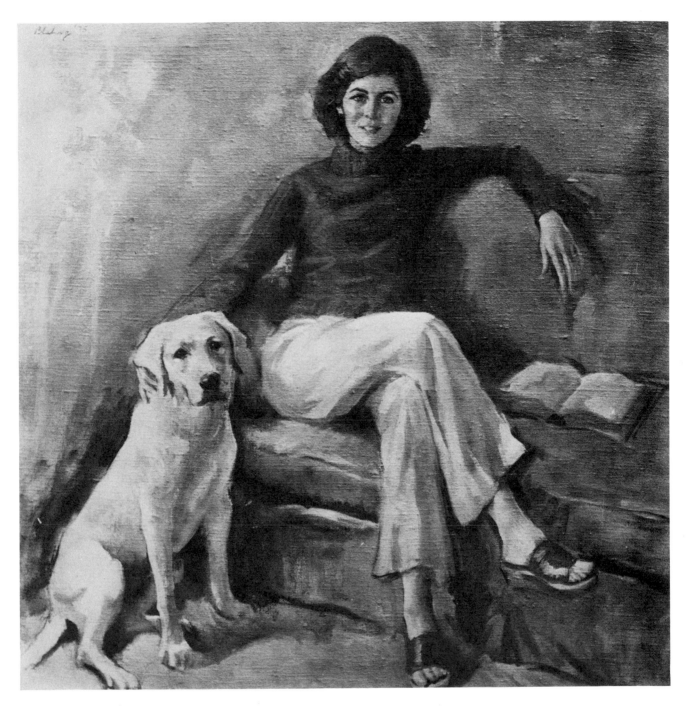

Miss Diana Reuter *by Marcos Blahove, oil on canvas, 24″ x 24″ (61 x 61 cm), collection Dr. and Mrs. Frederick A. Reuter. Within this small painting, Blahove has encompassed a lot of visual information. The picture gives no hint that the figure is perhaps one-third actual size. Part of the reason for this is the artist's ability to include only such pertinent details as promote the illusion of reality. Knowing what to leave out is one of the most important considerations in painting. In response to this problem, many artists proclaim: "Only that which is necessary . . ." Of course, your concept of what's necessary may not jibe with your neighbor's. However, just as in writing, brevity is not an undesirable goal.*

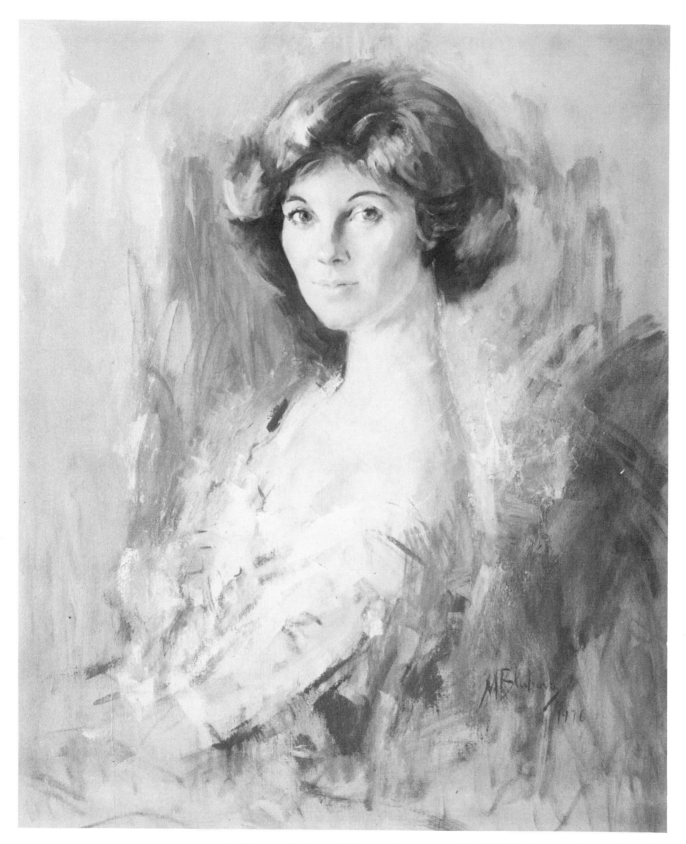

Gail Rogers by Marcos Blahove, oil on canvas, 30" x 24" (76 x 61 cm), collection the artist. Knowing when to stop is another tortuous challenge that plagues almost every painter. This is a decision that's particularly painful to the beginner who suffers attacks of anxiety in seeking a conclusive solution. In this one-session study, the artist stopped far short of what may have been extended for days on end. Despite its somewhat "unfinished" look, the portrait tells me all that's necessary about its very attractive model. One way to confront this problem is to stop when you feel you've captured the essence of your subject without fretting about the many refinements you might have added.

that seems appropriate to the portrait's goals.

A final preliminary step might be to execute a detailed pencil or charcoal drawing in the actual size the portrait will be painted, then transfer this so-called cartoon to the canvas. This used to be a common practice but is seldom done these days when spontaneity and impulse prevail over precise, meticulous preparation. Norman Rockwell was one of the few contemporary artists to follow such a procedure.

One method of transferring such a full-sized cartoon to the painting surface is to compose the original drawing on tracing paper, slip a sheet of transfer paper underneath the cartoon, and retrace every line on the canvas.

Another method is to make a drawing to scale, photograph it, slip the photo into an opaque projector, focus the image to desired size onto the canvas, and trace the drawing from this image.

Painting the Portrait

The actual procedure you employ to execute your portrait must of necessity be based on your personal choices and decisions. Painting has been described by David Leffel as a continuing process of solving problems, and each of us must arrive at these solutions through his own resources. However, here is a general guideline to help you along this always difficult route. Assuming you have settled in your mind or in a drawing the proper placement of the various elements within a composition, proceed to place the figure onto the canvas. You can do this with a cartoon or directly with charcoal or paint, and it can be as sketchy or as precise as you elect.

Most artists today draw with brush and paint, and most settle for a rather loose sketch composed of lines designed to serve as a map or general outline of contours, angles, curves, and patterns. One way to help achieve the proper proportion of the various components and their correct relation to each other is to use a series of imaginary plumb lines so that you can check whether an eye lines up with an elbow and so forth.

Another useful device is to place a dot where lines cross on this map; then run imaginary lines from these important junctions to other such junctions. This is yet another check of the correct distances, proportions, and relationships of the angles and masses to each other. Having resolved this stage, do remember that drawing and painting are a simultaneous process, and that you'll constantly be refining your drawing as the portrait progresses.

Now you are ready to indicate the masses. Most painters work from dark to light, and they execute the second stage of the painting by blocking in *all* the shadows, not necessarily in actual color, but certainly in proper tone. Having concluded this stage, usually the next step is to put in all the halftones. A good method is to mix the precise hue and value of these halftones and try and place them correctly at once.

The fourth stage is to place in all the lights—also in their exact shade and hue. Most artists feel that in oil painting lights should be painted more heavily than shadow areas—however this is not an absolute imperative.

Having laid in the darks, middletones, and lights, the time comes to fuse or blend the edges lying between these areas. The degree to which you do this must remain strictly your own province. Some artists prefer to show this transition in a series of turning planes; others opt to let the three areas float smoothly together.

The final step is to place highlights and reflected lights where you think they belong.

Naturally the background and the other elements outside the figure must be attended to as well, and these can be painted in the same order as the head and figure—from dark to light, blended, and touched with highlights and other refinements.

This, very basically, is one way to paint a portrait. I've described it in only the most primitive terms, since you may elect to go in a totally different direction. After all, it's not how you go but whether you get there that counts.

What to Leave Out

Remember at all times that you're painting a *portrait*. So no matter how exciting the furniture, the gown, the flowers, the draperies, or the pet Siamese may appear, subdue them to the main subject of the painting—your sitter. Unless you're specifically commissioned to paint an interior or a landscape with the figure, leave out all extraneous elements and employ them as merely background for the chief attraction.

Use the principle of *selective focus* to concentrate on the face by forcing the viewer's eye to linger there for a significant moment before allowing it to go wandering to less important areas.

Knowing When to Stop

Many artists don't know when to stop the portrait. The tendency is always to cock a self-critical eye and try to improve the effort. Ending the painting is a value judgment that imposes much self-examination and introspection. Anyone serious and honest about his art—painter, writer, composer—questions his validity as a creative person each time he steps into the arena.

When to stop?

It takes enormous discipline to take a stand and say to yourself: "There, I've done all I could this time out. Next time, I'll strive to do more."

Until the artist convinces himself that his life is an ever-evolving process and that he is an eternal student who grows with each painting, he'll turn into an anxiety-ridden neurotic who can never put his brush down and go on to new experiences.

The time to stop the portrait is when you feel you've given it all you've got and that you've captured at least some of the *essence*, if not an exact replica of your sitter. Time alone will reveal when successes outnumber failures, but do remember that without failures, there can be no successes.

COLOR
GALLERY

Miss Kustyah of Java (detail) by Charles Baskerville, oil on canvas, 24″ x 30″ (61 x 91 cm), collection the artist. This exotic young lady has served as secretary of the Indonesian Mission to the United Nations. She is painted in local costume and in an environment suggesting her native land. People of nonwhite races have a tendency toward more sallow, less reddish complexions. The hair often exhibits bluish highlights because of its intense blackness and shiny texture. Note how liquid and moist the eyes appear. Dignity, pride, quiet amusement, and awareness of her rare beauty show in the somewhat enigmatic expression. Altogether a most sophisticated portrait by a skilled, incisive artist.

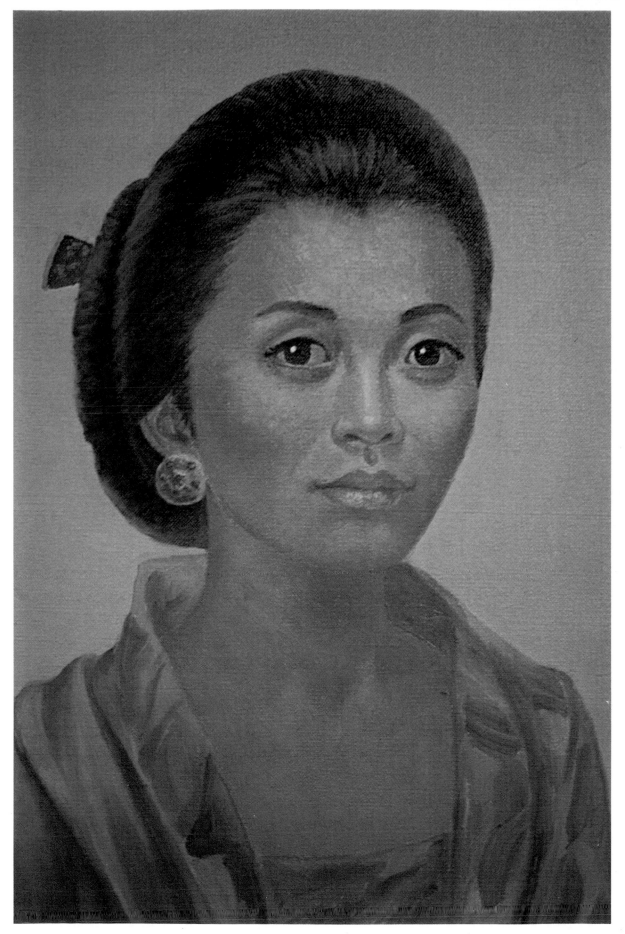

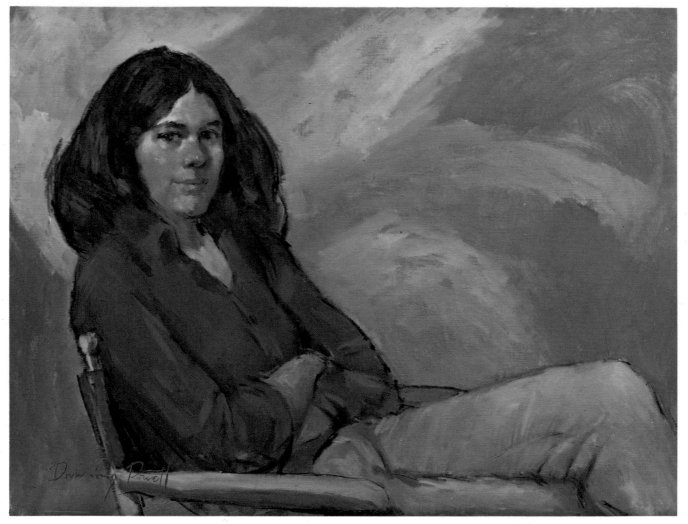

Maureen (above) by Dunning Powell, oil on canvas, 40″ x 30″ (102 x 76 cm), collection Mrs. Carole Fowler. Powell outlines his forms and treats the inner areas in a loose, painterly fashion. The face is a pleasing contrast of warm reds and cool green-gray halftones. Shadow is kept fairly high in value, except in the dark hair. The loose treatment typifies the contemporary approach to realistic painting. Our eye has been trained to accept such shortcuts, and the artist capitalizes upon this to work in a rapid, bold technique while still achieving likeness and the illusion of fidelity. The red shirt is the predominent color, yet, because of Powell's clever use of design and color balance, it doesn't take interest away from the face.

Jackie (right) by Clifford Jackson, oil on canvas, 22″ x 16″ (56 x 41 cm). The overall cool treatment of skin, blouse, and background lends a pleasing sense of unity and cohesiveness to the portrait. With a minimum of color variation Jackson has painted a sensitive, subtle study of a pretty, thoughtful young woman. It isn't necessary to load a painting with bright, contrasting colors to achieve interest and stimulate a positive reaction. Experience teaches that by understating, the result can be equally, if not more, satisfying. Like condiments in cooking, color can be used sparingly for most gratifying effect.

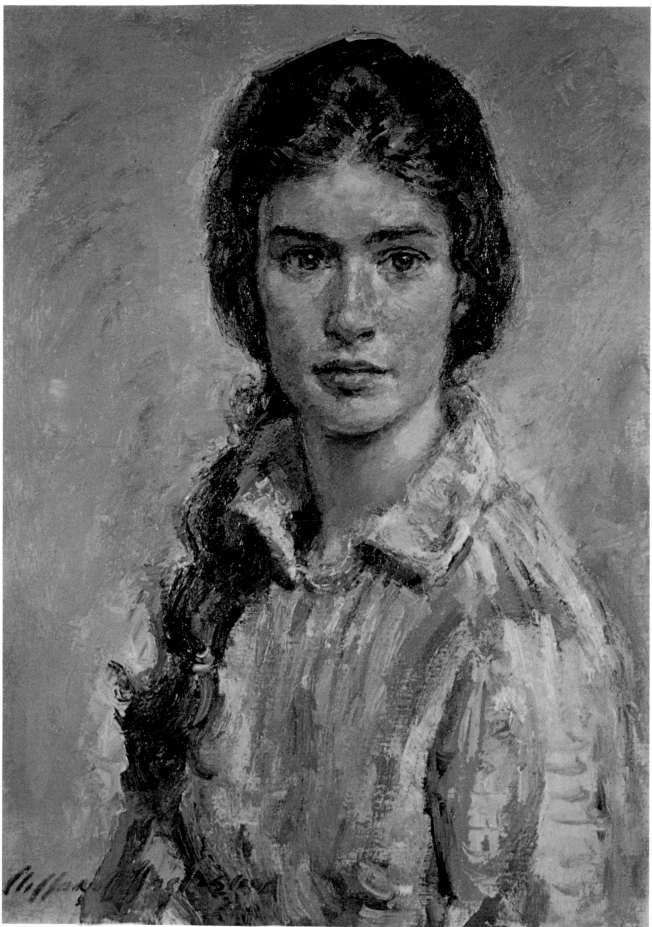

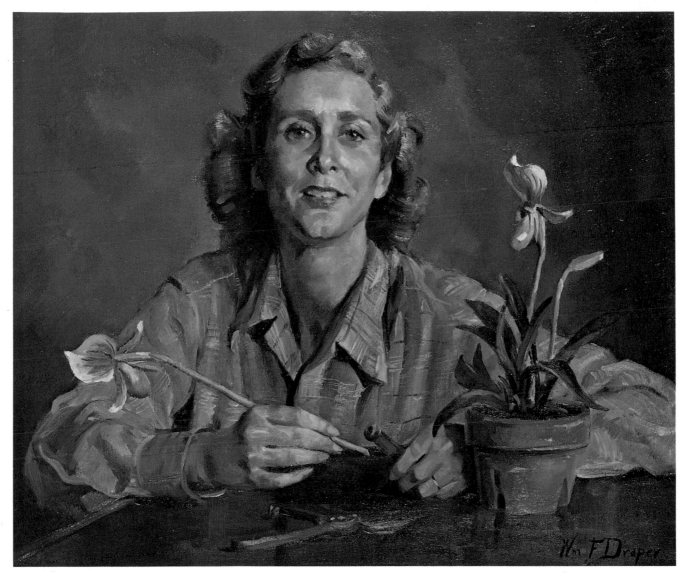

June Newby (left) by Paul C. Burns, oil on canvas, 34″ x 28″ (86 x 71 cm), collection Mr. and Mrs. Newby. Burns chose a dark background and costume to set off the subject's high complexion and dash of blond hair. Had he painted her strictly according to the old master technique, he would have shown the head partly veiled in shadow, a device which he chose to disregard. The light tone around the bridge of the nose is particularly striking, and the lips are positively luscious. This is a good example of how to combine high and low key in a single painting. Accents approximating those in the hair and skin are repeated in the material of the chair. It all adds up to a tour de force—the kind of portrait artists have great fun painting.

Mrs. August Belmont, Jr. (above) by William F. Draper, oil on canvas, 24″ x 30″ (61 x 51 cm), collection Belmont family. Draper painted this portrait in stronger chiaroscuro than he exhibits in most of his work. The head is modeled in bold planes, and the rounded, sculptural result more than justifies the artist's approach. I particularly like the way the musculature of the cheeks is handled to display the rather broad smile. It takes enormous confidence to paint a commissioned portrait in such a free and dashing fashion. It's a tribute to both the artist's skill and the client's tolerance and eclectic taste.

Lea by Everett Raymond Kinstler, oil on canvas, 24″ x 20″ (61 x 51 cm), collection Mrs. Kinstler. This was obviously painted in a single session—or no more than two—but the result is stunning! Kinstler demonstrates his deep knowledge of craft as we almost follow his brush racing across the head. With a splash here, a line there, he quickly establishes the main masses of the head and adds a few highlights to round out the forms. I don't know how many actual colors were used in this painting, but it might have been only three or four. The lights bristle with impasto. The painting reminds me of Sargent's best efforts when he dashed off his personal studies between his elaborate commissioned works.

Joan Wiggins by Peter Cook, oil on canvas, 38″ x 30″ (97 x 76 cm), collection Mrs. E. W. Dedhan. A sensitively handled portrait of an adolescent girl, this was painted in the kind of light artists seem to prefer for women. The mood is quiet and serene, the colors pale but not weak. I particularly like Cook's treatment of shadow in the white dress. He avoids the deep marks a less experienced painter might have included for dramatic contrast. Cook chose a more natural approach which sustains the portrait's integrity and lends truth to his statement. Having the sitter look away from the viewer lends the portrait an entirely different character than if she had been staring us straight in the eye.

Adele Bernard (above) by Clyde Smith, oil on canvas, collection Mrs. Bernard. Almost abstract in design and daring in its courage to move part of the head out of the frame, this is a fine example of the contemporary approach to portraiture. The color is bright and snappy, and little effort is made to lose or veil any of the elements in shadow or mystery. The modern way is to hide little or nothing. This approach works marvelously when the artist paints in a bold, free, unhampered fashion. But if he hesitates, fumbles, or consciously tries to force such a style—chaos results.

Toddy (right) by Richard L. Seyffert, oil on canvas, 24″ x 20″ (51 x 61 cm), collection the artist. Seyffert first underpainted then glazed this intimate study of a pensive subject. The design is most striking, and the hands are painted with exceptional skill. Blues mark the halftones in the chin, neck, and hands, and the paint is thickest in the highlight on the forehead. Most artists paint thick in the lights and reserve the thinner layers for the darker areas of the picture. A nostalgic, evocative mood in this portrait is particularly moving and engrossing. Color, design, and pose have combined to give us a thoughtful, penetrating look inside a person.

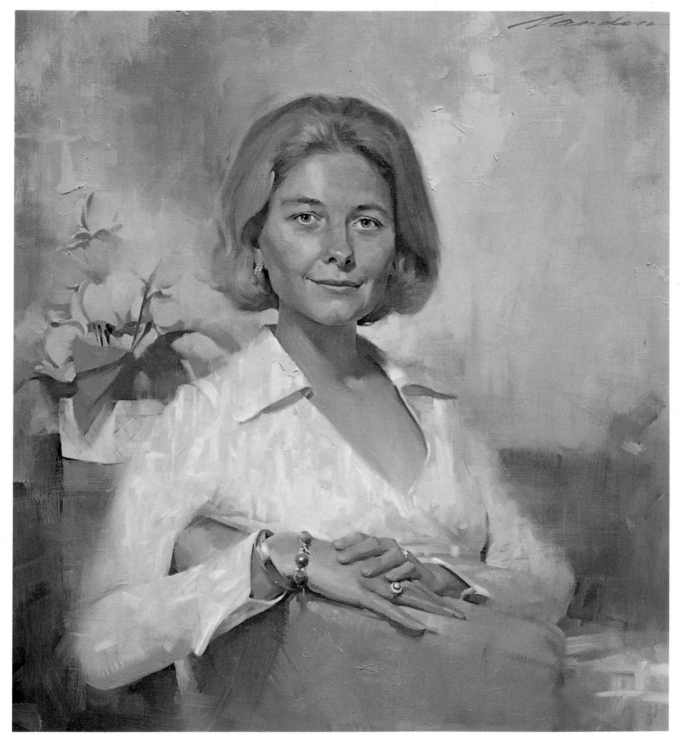

Mrs. Richard Horn *by John Howard Sanden, oil on canvas, 30″ x 27″ (76 x 69 cm), collection Mrs. Horn. Sanden is a master of the commissioned portrait. He achieves perfect likeness, his color is gracious and never intrusive, and his design complements the intent of the painting. Many factors are required to paint portrait after portrait and always end up with a satisfactory product. Sanden has trained himself to be consistent, and his discipline, resourcefulness, and competence come through time after time. He paints in a fairly high key, his backgrounds are usually on the light side, edges are often washed into the backgrounds, and passages of abstract color are spotted here and there for added interest.*

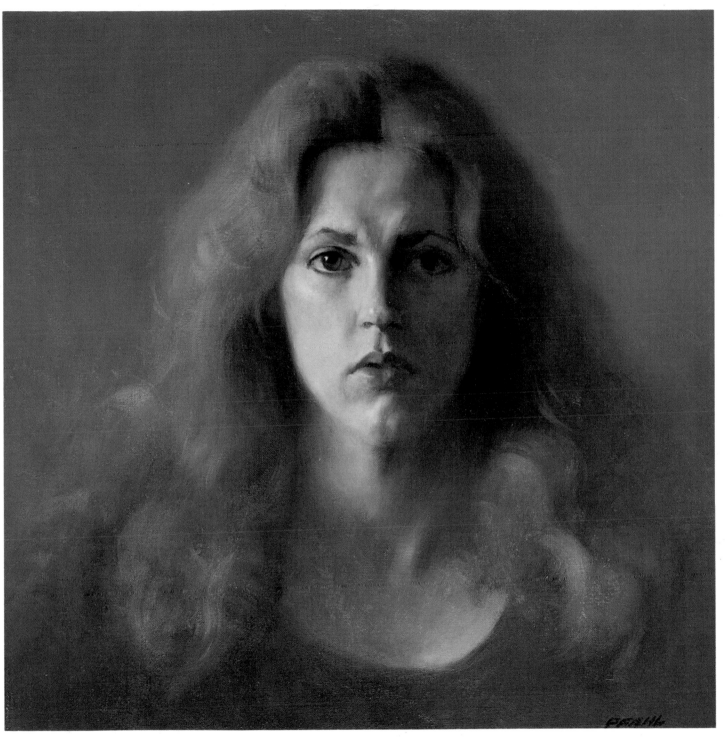

Jay by Charles Pfahl, oil on convas, 16″ x 16″ (41 x 41 cm). Like David Leffel, Pfahl too uses the Maroger medium. His technique is studied, deliberate, and unhurried, with a minimum of apparent brushstrokes and planes that are even and smoothly integrated. This results in deep, carefully worked-out paintings in which color is cool and subdued, draftsmanship is superb, and value gradation is subtle and extensive. Note how softly the hair is painted. It projects a character as real as life. The face is almost evenly divided into light and shadow, but so apt is the transition between these two areas that they emerge in ideal balance and relationship. Pfahl is one of the finest young painters around, with a future as unlimited as he himself cares to make it.

Portrait Mid-Stage: Detail. The portrait is shown here in mid-stage. The general ash color of the hair is already indicated, and the facial tones are placed but not yet fully articulated. Mrs. Duke's fair coloring is accented by a rather vivid reddish-orange area at the cheek, accenting her deep-set dimple. The eyes are an unusually deep blue. Cool tones predominate in the areas where the skin tones turn and round off the form. Note how softly and subtly Baskerville has painted the lips.

Finished Portrait: Detail. Note how the coloring has evolved from beige to pink. A pale yellow blouse has been introduced, and the highly individual hairstyle is shown in its interesting cut and design. Lights have been introduced throughout the face, a background has been put in, and the artist has decided to show the lobe of the left ear. A strong reflected light marks the right edge of the face.

Finished Portrait: Detail. Note the subtle, cool halftones surrounding the mouth. Baskerville paints in a very thin technique that doesn't allow distinct changes of value or hue. No brushstrokes are evident, and in places the texture of the canvas is quite obvious. See how softly the hair fuses into the left temple. Were this edge hard, the effect would be unnatural and garish. Note the detail in the eyes: the bottoms of the irises are lighter, and catchlights are placed at the edges. This is designed to promote the illusion of roundness in the eye.

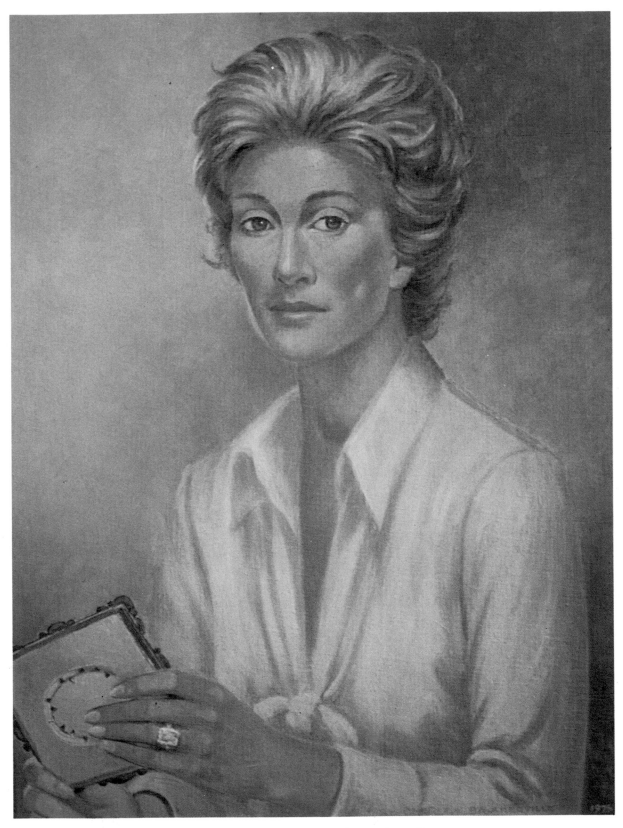

*Finished Portrait. **Mrs. Angier Biddle Duke,** oil on canvas, 24″ x 18″ (61 x 46 cm). Note that the eyebrows are not as black as is often (erroneously) shown in paintings of women, and that the effect of eyelashes is present here but they haven't been painted as individual little hairs. The little picture or mirror is primarily a device to enhance the portrait's design. Its light color matches the general high key maintained throughout the painting in which the deepest dark is perhaps the edge of this small frame. Baskerville never goes really dark— his tendency is to paint light, bright, happy portraits. (To see steps of this demonstration in black and white, refer to pages 94-97.)*

Portrait Mid-Stage. *The face, hair, sweater and background have received a measure of color indicating general shadow, halftone, and light. At this stage the artist is seeking to establish these elements in fairly accurate hue and value, with room to adjust, refine, and correct. The relationship of the features is still fairly vague—something to be resolved later. The background, however, will remain pretty much the same to the end.*

Portrait Mid-Stage. *The painting has progressed considerably and is much closer to completion. The hair is fairly well worked out but will become somewhat cooler and darker in the finished portrait. The eyes and mouth have been worked on extensively and have assumed their basic character, shape, and expression. Details of the sweater and necklace have also been added. The shape of the face is still to be corrected, and the planes of the face will need some blending and relating. At this stage the artist is essentially striving to achieve accuracy of likeness and to model the forms to perfection.*

Finished Portrait. Irene *(right), oil on canvas, 24″ x 20″ (61 x 51 cm). The highlights have been carefully placed in the lower lip, the tip of the nose, the forehead, and right cheek. The thick brown hair has been touched with blues to cool down some of the color and to provide natural high accents. The bottom of the chin picks up some warm reflected light from the sweater. A cool brownish halftone marks the left side of the forehead where it fuses with the hair. The bright red lipstick forms what is probably the warmest spot in a portrait that is essentially neither warm nor cool overall. (To see steps of this demonstration in black and white, refer to pages 104-109.)*

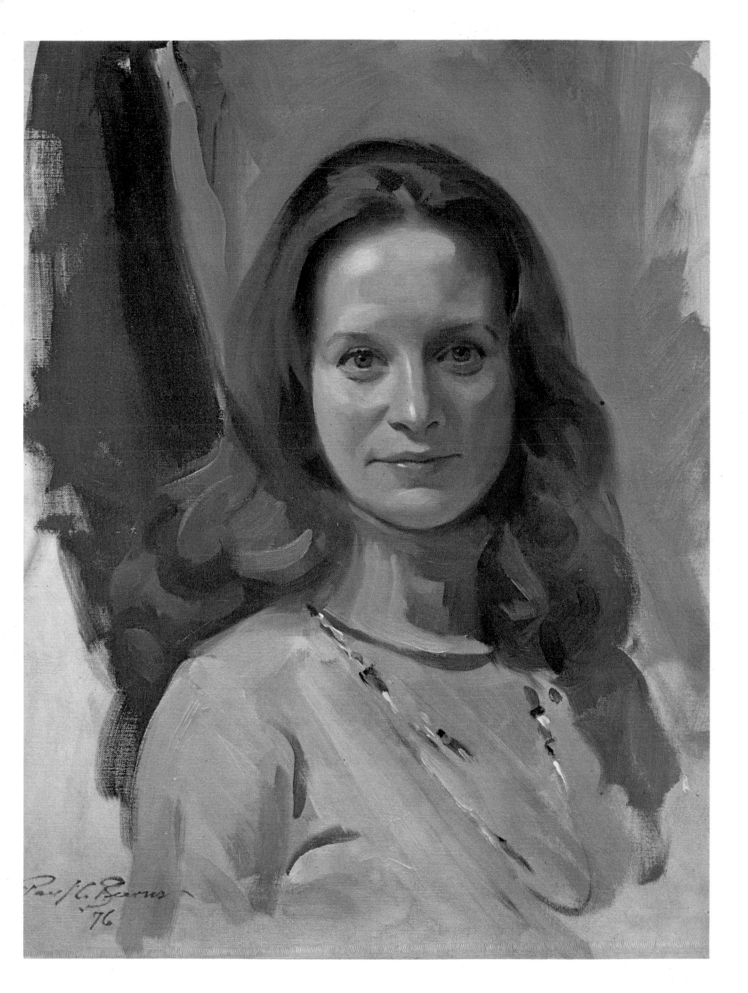

Portrait Mid-Stage. *In this rather early stage of the portrait, an overall bluish tonality is present. The individual hues have not yet been indicated with any degree of accuracy or finality, and the only touch of warm color is present in the face, neckline, and arms. Soon Cook will begin piling on the color in its correct hue and value, but at this stage it's all rather scattered and pale, as the artist probes for solutions to design, proportion, and drawing problems. This is a valuable insight into the way Cook builds his picture.*

Finished Portrait. Lynn Fraker, *oil on canvas, 30" x 24" (76 x 61 cm). Although still basically cool in tonality, the richness of color is now apparent in the sitter's fair complexion, bright blue eyes, and light brown hair. The arms of the chair provide a contrasting green accent. A highlight is made possible by the ring on the left hand and the edge of the locket. The overall coolness may have been motivated by the subject's personality or by Cook's tendency to paint cool portraits. Artists tend to lean to one or the other side of the color spectrum. (To see steps of this demonstration in black and white, refer to pages 116-119.)*

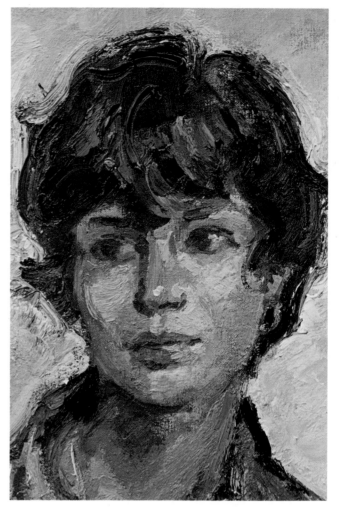

Portrait Mid-Stage: Detail. *Jackson builds his portrait by piling on strokes of bright color in Expressionistic fashion; thus the bright blues in the hair, the strong yellows in the forehead and neck, and the reddish-brown passage under the chin. It all seems very disorganized at this stage, but Jackson knows exactly what he is doing. All the elements will fall into place at the conclusion of the portrait.*

Finished Portrait: Detail. *Note how skillfully everything has been coordinated from the apparent disorder. Strong blue reflected lights mark the contours of the face at left and right. Cool gray-brown halftones have pulled the planes of the face together. The earring adds a warm gold-orange touch. The hair seems to snap and crackle with its crisp blackness. Blues mark the "whites" of the eyes, a characteristic often seen in brunette women. A slash of orange underlines the tip of the nose and the cleft of the upper lip. Likeness and character have been achieved.*

Finished Portrait. Mrs. J. Incorvaia *(right), oil on canvas, 50" x 30" (127 x 76 cm). The violet-pink suit complements the subject's rather dark complexion and black eyes and hair. The colors of the suit are slashed in boldly and thickly. At times, Jackson squeezes paint right out of the tube onto the canvas, à la Van Gogh. Such bold, uninhibited technique seems to demand color, and Jackson is primarily and essentially a colorist. His palette runs to 26 colors, and he seems to have used most of them in this vivid, exciting painting. (To see steps of this demonstration in black and white, refer to pages 125-129.)*

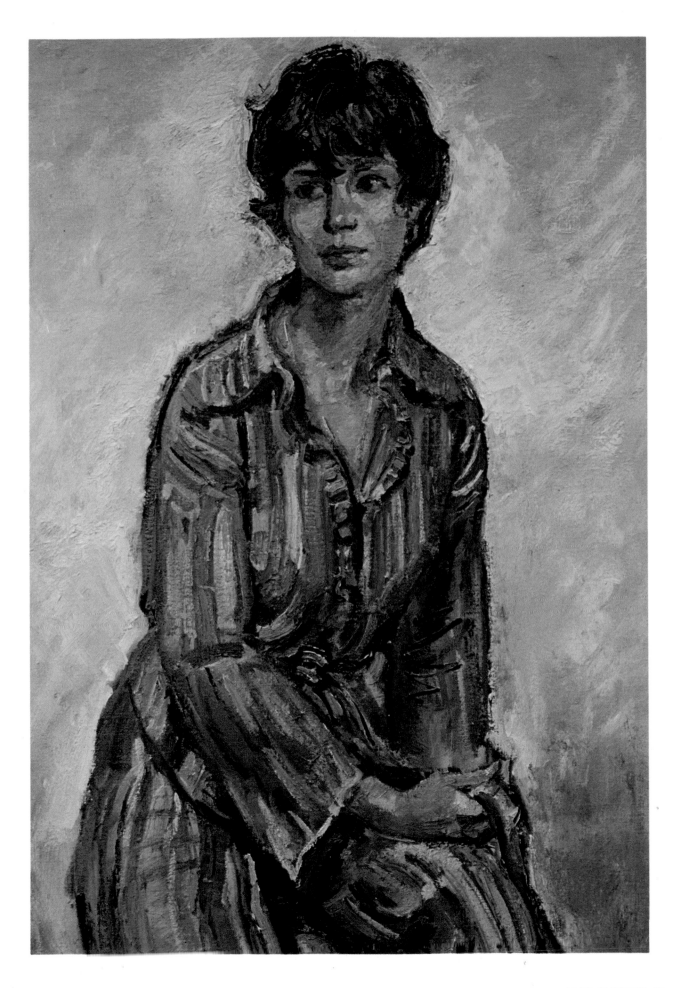

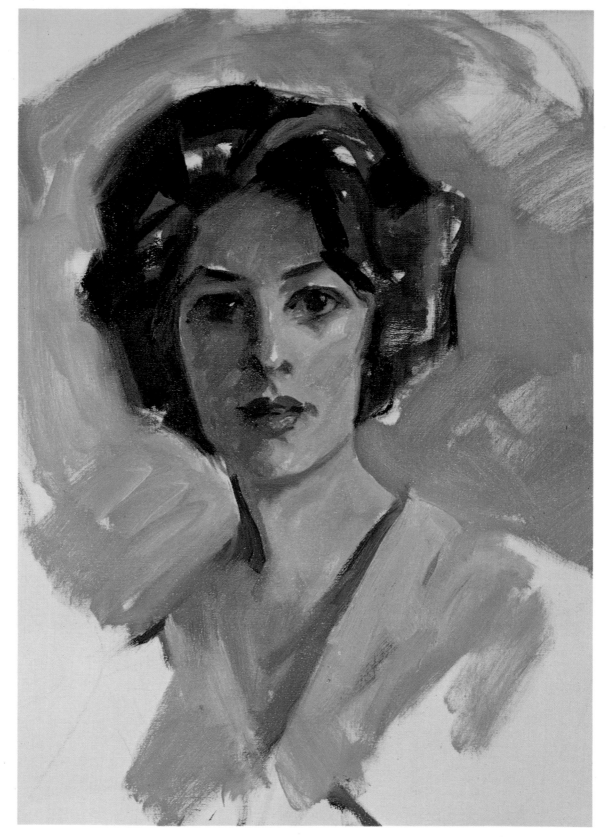

Portrait Mid-Stage. *At this point the colors have been placed in appropriate areas in hues approximating those in the finished portrait, the blouse will become somewhat paler, and the hair will pick up more reddish accents. Note how Kinstler contrasts warms with cools by adding green accents to halftones at the left corner of the mouth and under the left eye. The reflected light at the right edge of the face is a fairly light, cool blue. The "whites" of the eyes are not white, but a grayish medium tone.*

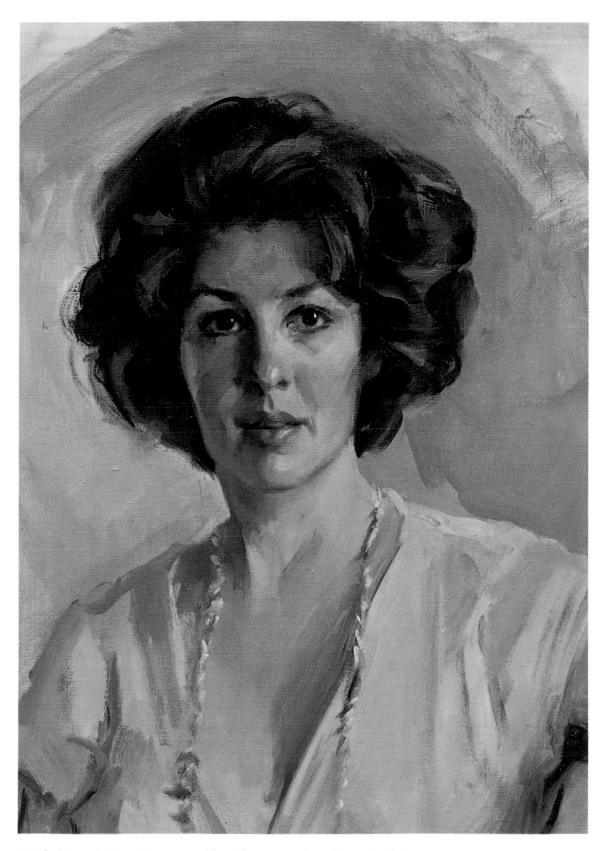

Finished Portrait. Mrs. Albert Kennerly, *oil on canvas, 23″ x 19″ (58 x 48 cm). A strong green accent marks the angle of the cheek at the left. Warm oranges and yellows shape the tip of the nose, the forehead, the cheeks, and the chin. Kinstler uses reflected lights effectively in the chin to produce the effect of roundness. Blue and brown accents are spotted in the hair. Note how simply Kinstler painted the left earlobe—a touch of warm color and we accept the ear without question. Kinstler handles color as well as anyone painting today. (To see steps of this demonstration in black and white, refer to pages 136-139.)*

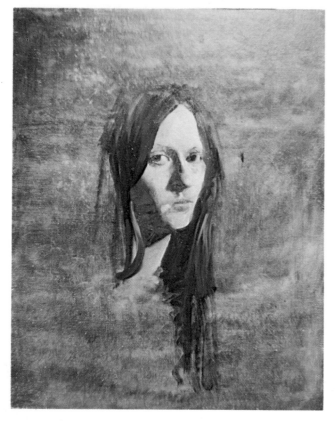

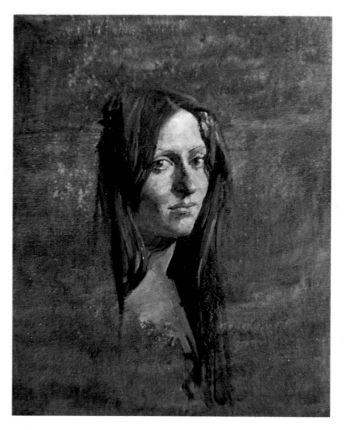

Portrait Mid-Stage. *The color of the toned board serves Leffel as a medium value on which to build the darks and lights. Greens and blues serve as the base for the model's dark-blond hair. The shadows are placed in cool, neutral shades, and Leffel makes no effort at this stage to place the actual hues. He is painting in tone only, trying to resolve the problem of values.*

Portrait Mid-Stage. *Warm reds are introduced in the nose, lips, cheeks, and eyelids, but the general coloring is still basically cool. Leffel's approach dictates such cool color—it's inherent in his style, personality, and attitudes toward art and painting. Those who employ the Maroger medium all seem to fall into this category, for reasons not very clear to me. However, in this case, it's particularly fortuitous, since Brett possesses a pale, ivory complexion.*

Finished Portrait Brett *(right), oil on panel, 20″ x 16″ (51 x 41 cm). The background has gone considerably darker and warmer. The hair is now closer to its natural sandy hue, and more warmth has been added to the skin tones. I particularly like the way Leffel has handled the reflected light in the right jawline—its pale olive contrasts intriguingly with the red of the cheek just above it. The half-smile and rather bemused expression are just right, and the lights in the skin seem to glow. The total effect is quite appealing and charming. (To see steps of this demonstration in black and white, refer to pages 145-148.)*

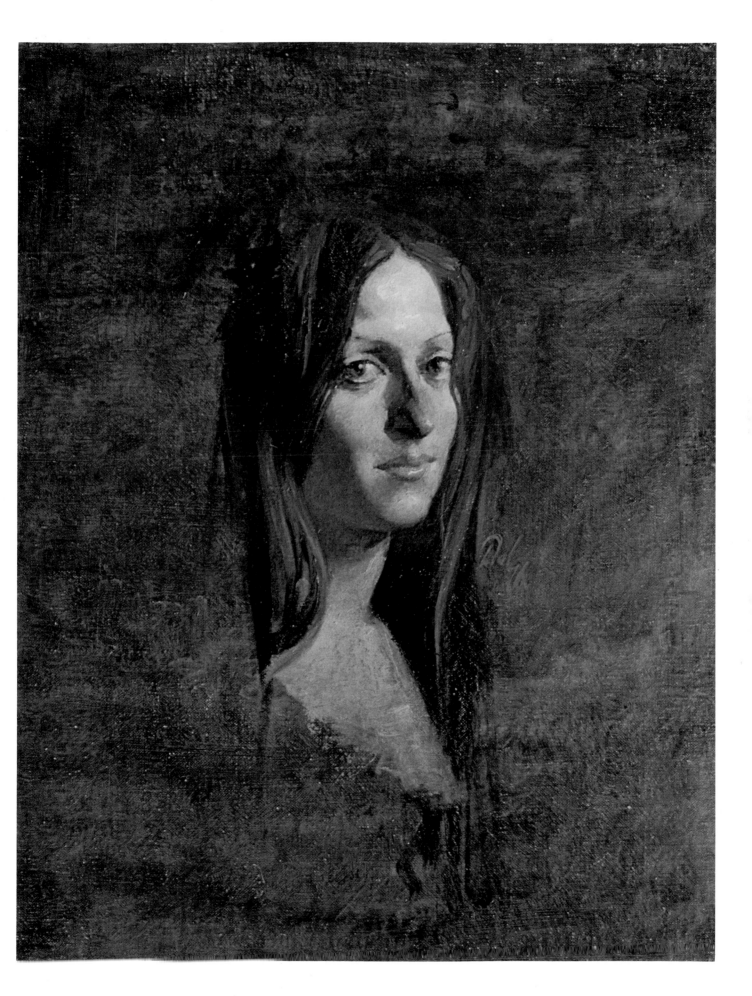

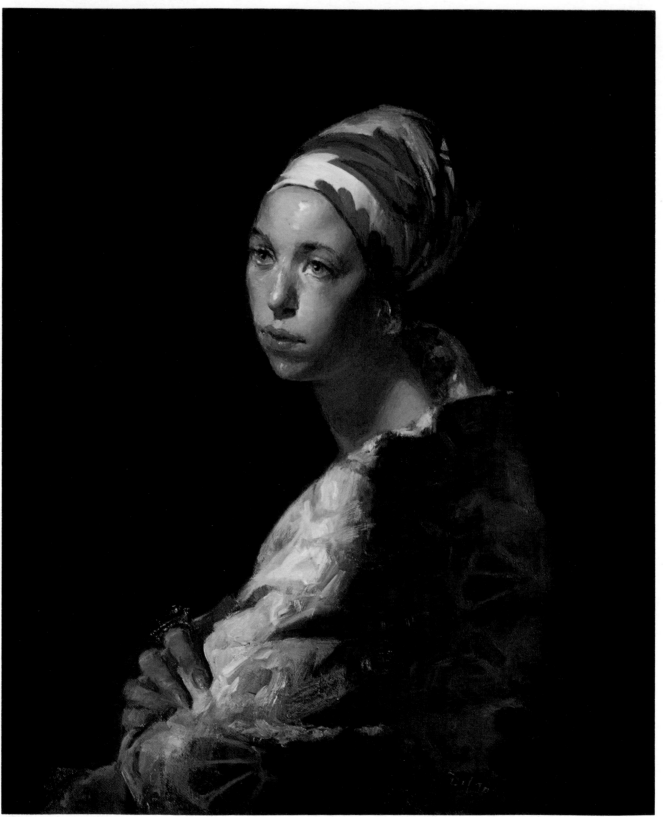

Girl in Turban *by David A. Leffel, oil on canvas, 24″ x 30″ (61 x 51 cm), collection Mr. and Mrs. Jack Dunne. Among contemporary artists, David Leffel comes closest to the traditions of Rembrandt, Vermeer, and Velásquez. In this remarkable painting, we are overwhelmed by the depth and richness of color. Warms and cools are balanced. Highlights round off the forms. Edges are alternately soft and hard. Note how effectively Leffel sets off his figure against the dark background. This can be disastrous unless the transition is skillfully realized. The ring adds a dramatic color accent, and the folds of the brocaded costume are slashed in in firm, powerful strokes. It's one of Leffel's proudest achievements.*

ARTISTS
AT
WORK

Charles Baskerville at Work

A highly decorated veteran of both World Wars, Charles Baskerville lived in his native North Carolina until the age of eight but still retains traces of soft Southern speech patterns. Young Baskerville studied at Cornell University, the Art Students League, and the Académie Julien in Paris. He has traveled extensively and painted such distinguished persons as Prime Minister Nehru of India, the King of Nepal, the Duchess of Windsor, and a host of noted society, business, and government figures.

In addition to his portrait painting activities, which included a stint as official portrait painter of the Army Air Force during World War II, Baskerville has executed many important murals for such locations as the conference room for the Joint Committee on Military Affairs of the House of Representatives and the Senate, the S.S. America, Princeton University, and the homes of Mrs. Merriweather Post and the Viscount and Viscountess de Sibour.

Baskerville has had twelve one-man shows and has exhibited at the National Gallery of Art, the Corcoran Gallery, and the Metropolitan and Whitney Museums. Early in his career, he wrote and illustrated for the then fledgling New Yorker magazine.

Baskerville tries, whenever possible, to arrange a preliminary meeting with his sitter. "I do this because I wouldn't paint someone I found repulsive," he reasons. At this initial encounter Baskerville looks for an expression about the eyes and mouth —the individual quality the sitter projects. To him a woman emits an impact and a dash upon entering a room. The artist must preserve this impact in mind and value it as a guide to the ultimate portrait.

He feels strongly that a harmonious rapport must evolve between the artist and sitter; otherwise, the portrait will suffer. He looks for the best in the subject, but he won't flatter for flattery's sake. If an artist likes people—as Baskerville does—and if he respects and esteems the individual he is painting, this will enhance the portrait to such an extent that the results will far outweigh anything possible with photography or other means of portraiture. It's this interaction of two persons working toward a single goal that makes people stop before the finished painting and say: "Yes, you've captured the essence of _____."

In certain instances, Baskerville senses that the sitter wants to be portrayed as is—warts, wrinkles, and all, and he proceeds accordingly. He has gone so far as to paint a woman with her eyes out of focus without complaints from the subject or her family. To Baskerville, it all depends on the sitter's character.

As part of his painting procedure and an aid in the rapport he establishes with his sitter, he uses a mirror placed behind him so that she can follow the development of the painting. This helps to keep her interested, relaxed—and animated.

Baskerville paints both his commissioned and noncommissioned portraits the same way. "My style is dictated by my nature, and I can't control it. I paint in a high key and in bright colors, always. I've had a marvelous, privileged life. I reflect my happiness in my work."

Baskerville feels that the goals of a portrait are to put down the physical likeness of the sitter and hopefully to capture individual personality. The first is achieved by careful attention to drawing, color, and proportion. The second comes from the chemistry and rapport that flows between the artist and sitter.

Unlike most portraitists, Baskerville doesn't set his fees by the size of the painting. Therefore he is free to vary the dimensions of his portraits to suit the situation. One consideration is where the picture ultimately will hang. A good size that will fit into most situations is 30″ x 24″ (76 x 61 cm), but Baskerville has painted a double full-length portrait just 13″ x 12″ (33 x 30 cm). His tendency is to paint his heads somewhat under lifesize, but this is instinctive, not something consciously perpetrated.

Generally, Baskerville prefers a simple background composed of varied tones of neutral color. He occasionally sets up screens and draperies behind his subject, but he avoids the dated effect achieved by precisely delineating the folds and breaks of material. At times, particularly when he paints on location (which he seldom does now), he includes familiar objects found in the sitter's home such as masses of flowers or even pets.

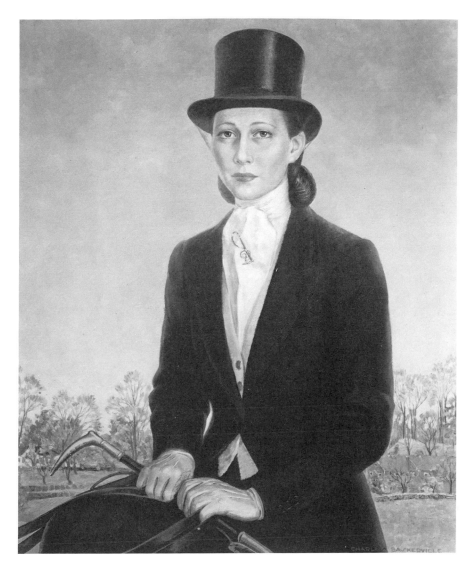

Mrs. R. L. Parish by Charles Basker-
ville, oil on canvas, 36″ x 30″ (91 x 76
cm), collection Mrs. Parish. It's inter-
esting to compare this portrait with
Seyffert's of Linda Fay (page 27).
In both, the subjects wear formal rid-
ing attire, yet the treatment couldn't be
less similar. Baskerville's elegant
horsewoman sits confidently holding
the reins, her eyes fixed firmly upon us.
She is obviously quite conscious of her
status and direction in life. Seyffert's
younger subject presents the inquisi-
tive, reflective expression that exem-
plifies the yet unformed personality.
Consideration of your sitter's status,
position, and age should play a signifi-
cant role in the way you approach the
portrait.

Baskerville prefers simple, casual dress for his sitters. He has done his share of
formal portraits, but he welcomes the current tendency toward informal attire.

He has no preferences for particular poses. He posed Eva Gabor (page 34)
sitting down and then changed the portrait to make it appear as if she were in
motion. He doesn't object to standing poses except that they may tire the sitter. He
did a number of tinted drawings of full-length figures which were exhibited in
New York and which brought him a number of desirable commissions.

Many of Baskerville's portraits are painted full-face, which presents the hazard
of seeming to flatten the form. He concedes that the three-quarter view lends
more form to the face, and this is the way he chose to paint his demonstration
portrait of Mrs. Duke (pages 76 and 94). This pose allowed him to show her very
deep dimple and the receding planes of her face.

Baskerville normally paints his portraits in a standing position; his coffee table
serves as a model stand to elevate his sitters and to provide him with an eye-level
view. He likes to leave enough air in his portraits so that his subjects don't appear
trapped by the frame. He also points out that the artist can indicate the height of
the individual by the placement of her head in the rectangle of the frame. It's a
factor he always considers in composing his portraits.

In conjunction with his preference for light, solid-colored clothing that won't
overpower the impact of the face, Baskerville does not favor an overabundance of
jewelry in a portrait. His reason for adding the diamond ring in Mrs. Duke's por-
trait was, in his own puckish words: "Just to kid myself along. . . ."

If his sitter is so fashion conscious as to insist on a dated look, Baskerville will

reluctantly go along with it. However, if due to excessive makeup or garish hair color the woman's appearance simply disturbs Baskerville's esthetic sense, he might find an excuse not to paint her.

Baskerville enjoys painting hands and finds them a great aid toward achieving a successful design and characterization. He feels that very few artists can paint hands with skill.

Before the sitter has even arrived, Baskerville has already diagnosed the most advantageous angle of lighting her and has raised or lowered his shades accordingly. All that remains are minor adjustments. Baskerville prefers a light coming from above, which forms an interesting triangle of shadow beneath the nose. This shadow he considers an important element in the face. If the day is particularly dark, he takes advantage of whatever illumination enters through the skylight of his New York City studio. He keeps the window facing the south blacked out at all times, leaning to the consistent north light—as do most painters.

Baskerville never paints portraits outdoors. If he requires an outdoor pose, he'll paint it in his studio and add such elements as gardens or trees. He hasn't painted portraits under artificial lights for years.

Baskerville considers himself essentially a cool painter. He dislikes the crude colors found in some warm flesh tones. His palette of Winsor & Newton colors consists of the following:

Fern Tailer by Charles Baskerville, oil on canvas, 30″ x 25″ (76 x 64 cm), collection the artist. This striking red-haired beauty demonstrates Baskerville's frequent predilection for painting the subject in full frontal view. This is an angle other portraitists tend to avoid, since it's demonstrably more difficult to round off the form when working from this perspective. Baskerville obviously doesn't let this faze him, or perhaps he enjoys the very challenge it presents. In any case, while there is some apparent loss of shadow in this pose, the innate difficulties apparently can be resolved. I recommend that you test this approach until it no longer presents a hardship to you. Confronting and solving problems is one pleasure of painting.

Permalba white	Cadmium yellow pale
(manufactured by Weber)	Oxide of chromium green
Rose madder	Viridian
Vermilion	Cobalt blue
Venetian red	Cerulean
Yellow ochre	Ivory black
Lemon yellow	Raw umber

To get a *basic* flesh tone for a white woman, he would mix Venetian red and yellow ochre with possible touches of oxide of chromium green, blue for eye color and some shadows, and black for receding planes.

For a black woman he might employ raw umber, Venetian red, black, and blue.

For a pale-skinned Oriental person with translucent, golden hues, he would use the same combination as for the Caucasian sitters, except for some additional ochre.

Baskerville wouldn't arbitrarily select an overall color scheme for a portrait. He might, however, use the sitter's costume as a point of departure to guide his color choices throughout the portrait. He prefers to use pale colors painted thinly, in a high key, and applied in small areas at a time. His preference is for imported Belgian or English linen canvas which he occasionally primes himself with gesso. Before commencing a painting, he sprays the primed canvas with a light coat of retouch varnish to render it less absorbent and to make it easier to wipe away unwanted color on the first day without staining the canvas.

At times Baskerville will tone his canvas a kind of pink-beige hue that he calls his "sunburned" color. He finds this tone easy on his eyes and warm in those areas where it shows through between the canvas interstices.

He has painted on panels on occasion, and a number of paintings executed directly on wood in Morocco in 1931 still retain their freshness of color. His medium is a 50% blend of linseed oil and turpentine. He uses various sable and bristle brushes, but employs a knife only to scrape out unwanted areas.

He seldom executes preliminary studies for portraits and rarely uses photographs except as a guide to costumes for those subjects who feel themselves too busy to pose. Baskerville is deeply resentful of such a high-handed attitude. He feels that unless a painting is executed totally from life, the artist becomes not a portraitist but a manufacturer of likenesses.

He finds that as his career progresses he tends to go ever softer in his treatment of edges. He points out how the vertical edges of the arms in his demonstration

portrait are blended noticeably into the background. Nor does he allow his textures to grow too complicated. He has always painted in a very thin manner which comes naturally to him. He applies the paint in small dabs in a pure *alla prima* technique and tends to regard sloshy, bravura techniques as uncontrolled.

Baskerville is not completely sure that a final varnishing of a painting is of any benefit. He does apply retouch varnish between sittings, which usually run from four to six two-hour sessions. He retains a mental image of the sitter and gets a lot of the costume painting done between these sessions.

A natural, unselfconscious painter, Baskerville makes no attempt to invest himself or his work with any sense of mystique or mystery. He chats easily with his model and treats the entire procedure as the enjoyable experience it should be.

When the portrait is nearing its conclusion, Baskerville is more than happy to listen to the comments of the sitter or her family and friends. He feels that no artist knows when to stop, and that an outside opinion often is helpful to prevent him from noodling and picking excessively at the picture. Baskerville himself finds it helpful to put the portrait aside facing the wall and to gain a fresh perspective of it the following morning. He likes to keep the painting around a few days to let it "mature" in his studio, but too often the subject snatches it away too soon to allow this to happen.

Didi Kelley by Charles Baskerville, oil on canvas, 36" x 24" (91 x 61 cm), collection Mrs. John Prosser. The artist's extensive experience as a mural painter is very much in evidence here. The stylized bird and foliage create an interesting counterpoint to the penetrating characterization of the very handsome subject. Baskerville contends that in the first meeting every woman projects an impact that the artist is wise to incorporate into the portrait. This special sense of identity comes across strongly here as we look deep into the sitter's eyes. A first impression often becomes the basis for a portrait, and it's something the artist must strongly consider.

Step 1. *Baskerville stretched a 24″ x 18″ (61 x 46 cm), canvas and framed it before beginning any actual painting. Some artists find this helpful, since it allows them to see the picture in its total dimensions right from the beginning. He used no preliminary drawing in any other medium and sketched in the face alone, leaving the other elements for later. Unlike some painters, Baskerville doesn't work all over the canvas at once, but concentrates on one area at a time. All this mapping was done with a neutral color, placing the features and determining proportions as quickly as possible. A light tone of skin color was then introduced in the shadows and in some of the halftone areas. A darker tone was employed to mark a characteristic feature of the subject—her prominent cheekbones.*

Step 2. *The artist corrected his drawing somewhat by broadening the face and cutting down some of its length. The mouth was drawn in, the nostrils and upper lip defined, and the general symmetry of the features reinforced. Till now, Baskerville had done little actual painting and had spent his time working out the problems of proportion and relationships. This can be related to building a solid house. The individual aspects that make the structure attractive and outstanding can't be added until the foundation is firm and correct.*

Step 3. *Now the serious business of painting has commenced. The face is nearly filled with skin color tones. The approximate color of the irises has been put down, and a degree of modeling executed on the nose, the chin, the jawline, and the left and right cheeks. Mrs. Duke's deep dimple is also indicated, and a heavy shadow accent is added below the left jawbone. The lips have been fully filled in, and a dark note has marked the eye sockets. Spots of canvas have been left blank where the lights will be placed, but so far everything is being left tentative with room for modification and change.*

Step 4. *Further modeling has been carried through all over the head, and for the first time the character of the sitter comes through most decidedly. The additional color laid in has brought the overall tone up in value, fusing the divisions between shadow, halftone, and light. The first tones have been introduced into the hair to indicate its general hue and rather springy character. Note that Baskerville has wiped away the contours of the neck. By spraying his canvas with a coat of retouch varnish before beginning to paint, he is able to wipe away areas in the beginning stages of the portrait without staining the canvas. See how smoothly the planes of the face have been fused. Baskerville paints thinly and in small, deliberate strokes.*

Step 5 *(above). Here he brings the head to near-completion before proceeding with the balance of the portrait. He has further modeled the form of the head and filled in all areas next to the hair so that the finishing touches of highlights, reflected lights, etc., can be placed during the concluding stages of the portrait. The hair has been further developed, and the line of the jaw and chin has been resolved. The planes around the upper lip, chin, and eyes have been turned, and lights have been added in the forehead, left upper lip, nose, and lower lip.*

Step 6. Mrs. Angier Biddle Duke *(right), oil on canvas, 24" x 18" (61 x 46 cm). Baskerville painted in the blouse and background in the final stages of the portrait. A reflected light was placed on the right jaw and cheekline. Also, the hair was given its highly individual character, and catchlights were placed in the eyes. A strong highlight marks the tip of the nose and the top of the forehead. A touch of mystery is introduced in the little framed picture or mirror which Mrs. Duke holds, and we wonder what scene or subject it represents. Baskerville used the hands and frame to keep the painting from being too soft all over and to give an interesting diagonal to the design. In his words, he added the diamond, "to kid myself along." There is a gracious air of elegance about the portrait, but its sense of playfulness keeps it from being at all solemn. The likeness is uncanny. (To see selected steps of this demonstration in color, refer to pages 76-77.)*

Paul C. Burns at Work

A native of Pittsburgh, Paul C. Burns studied art at the Pennsylvania Museum School of Fine Arts, the Pennsylvania Academy of Fine Art, and the renowned Cape Cod School of Painting.

A former magazine illustrator, Burns made a propitious transition to portraiture which now consumes much of his artistic time. Equally skilled in oils and watercolor, Burns teaches, exhibits, and executes portrait commissions in his New Jersey studio and on location. His female sitters have included Mrs. John Rodman Wanamaker; Mrs. Benjamin Fisher; the writer Charlotte Adams; Mrs. Jack Button; and Mrs. Edmund Martin, the wife of former chairman of Bethlehem Steel Corp.

A member of the American Watercolor Society and the Allied Artists of America, Burns has shown at the National Academy of Design, the National Arts Club, the Chicago Art Institute, and the Corcoran Gallery. He has won awards from the Wilmington Academy of Art, the National Arts Club, and the Hudson Valley Art Association.

Meeting his sitter for the first time, Burns may ask her to stand under one of the three main sources of light that illuminate his studio. In this light he can study her general appearance. If he senses a certain tenseness emanating from her, he may invite her to sit and engage her in light conversation until she feels more relaxed. This affords him the opportunity to examine her in a less strained atmosphere, since experience has taught him that sitters frequently tighten up emotionally (and therefore physically) when preparing for a portrait.

To achieve a favorite ambience in which the sitter will interact naturally and harmoniously with him, Burns may also put on music appropriate to his model's age and cultural status.

Unlike some portraitists, Burns doesn't fix a firm first impression of his subject, but rather envisions the process of getting to know her as a continuously evolving experience.

Having ascertained how much time she can afford him, he is prepared to make certain adjustments should this time prove to be limited. He may take a number of photographs (Burns is a skilled photographer) to help him progress with the portrait between sittings. Given his choice, however, Burns prefers painting from life; as a former illustrator, he knows how badly photographs can mislead the unwary painter. Shadows appear much darker than they actually are, as do red and warm tones. If compelled to work from photos, Burns will employ three prints—one light-toned, one medium-toned and one dark-toned. This combination will allow him to "read" into the shadow areas.

Burns refuses to flatter his subjects merely for the sake of vanity. He considers this an affront to his integrity as an artist. He will, however, employ light constructively to veil the sitter's less attractive features or to embellish her most attractive ones.

To the question of how he would treat a sitter suffering the signs of aging, Burns responds: "If you look at a face from three feet away, you see all the lines that are there. But I paint it as if I were nine or ten feet away. I half-close my eyes and apply the principle of diffused light such as Renoir or Gainsborough might have done . . . using a flatter light along with simplification."

Burns isn't apt, like some, to probe the sitter's personality in order to incorporate her emotional traits into the portrait. Instead, he relies upon his instinct and training to guide him in the choice of the physical aids he might employ to portray these inner traits—perhaps using distinct folds in the background for an assertive personality, or a generally paler color tonality for the quieter woman.

Burns concedes that he would be more likely to paint with greater abandon when executing a noncommissioned portrait. He might experiment more, let his brushstroke emerge broader and juicier, possibly leave the painting more unfinished, and concern himself less with the sitter's likeness—a factor he considers a requisite in commissioned portraiture. However, both commissioned and noncommissioned portraiture share the common factor of being fine art, each with its different if equal purpose. To Burns, the ideal is to incorporate some of the looser,

Mrs. Macksoud *by Paul C. Burns, oil on canvas, 30″ x 25″ (76 x 64 cm), collection Mr. and Mrs. Edward Macksoud. Burns prefers a simple, uncluttered background for his portraits. In this it's not possible to determine the colors, but the background and suit are close enough in value so that the lighter tone of the face stands out against them. If you squint, the only elements that will pop out of the picture are the head and narrow patches of the blouse. This is the principle of selective focus—consciously forcing the viewer's eye to look at the areas we wish to stress. It's a principle that should prevail in the way we select a subject's dress as well, unless we deliberately want to direct attention away from the face.*

freer qualities of the noncommissioned portrait into the commissioned one, while still satisfying all of the sitter's requirements.

The goals of a Burns portrait, whether commissioned or not, are:

1. *Likeness*—which the sitter deserves

2. *Proportion*—correct drawing and the proper placement of shapes.

3. *Value*—the natural gradation of lights and darks.

4. *Color*—the differences between colors and their relationship to each other.

5. *Composition*—the advantageous positioning of the head, hands, figure, and other elements of the painting within the framework of the canvas.

In addition, the portrait must display a unity, a harmonious "oneness" in which an overall and simplified sense of unity prevails. Nothing extraneous should detract from this feeling.

Burns admires and aims for the "point of focus" established by such masters of portraiture as Titian and Velásquez. Since the human eye is capable of concentrating only on a small area at a time, Burns uses light to benefit from and exploit this factor of limited focus. He leaves out details that the eye wouldn't see when looking at the model's face.

These days, the size of commissioned portraits is predicated on fees—a difference of inches may mean additional thousands in price. Barring this factor, Burns' favorite portrait would run 36″ x 30″ (91 x 76 cm)—a size that he feels is most comfortable, is appropriate for most walls, carries nicely, and doesn't get lost wherever it may ultimately be displayed.

Burns likes to leave sufficient "air" around his portrait heads and figures. Being conscious of good composition, he wouldn't think of cutting off an arm arbitrarily at the bottom of the picture. He will normally position the top of his sitter's head between three and five inches from the top of the painting.

If at the start he is unsure of the exact size of the finished portrait, he'll leave enough canvas around the stretchers so that the ultimate dimensions can be adjusted at the conclusion.

Burns predetermines the mood of his portrait by several factors: (1) the sitter's personality, (2) the setting in which the portrait is painted, and (3) the place where it will be permanently displayed. Each of these considerations obviously dictates a particular mood, and it's the combination of the three that will point the direction the portrait's mood should take.

When it comes to costume, Burns lets the sitter take the initiative. He might ask her to bring two or three outfits to choose from, but he feels that she will naturally select a mode of dress that best suits her spirit and essence. Although the trend today is toward informal attire, Burns welcomes the chance to paint a woman in a regal ballgown, à la Gibson or Boldini.

Unless the portrait is to hang in some aerie where it will be viewed from below (in which case he will paint her *larger* than life), Burns normally paints his sitters lifesize, which represents a head approximately 9½″ long.

When it comes to backgrounds, Burns leans toward simplicity. He'll put up screens and draperies and then paint his background as is. Unless it seems to go dead, he will stick to this original plan. This background might be painted as a general tone or mass, or distinct objects may be introduced if deemed appropriate.

The artist has no preference in poses—he likes them all, but does point out that a standing pose might prove tiring for the subject. If he does paint his subject standing he might provide her with a high stool to rest against and represent the pose as standing.

When it comes to selecting a pose for the sitter, Burns looks for one that will show her off to best advantage. He might move himself or her about until the lights and shadows, the colors, and the curves and angles of head, hands, and figure all strike his eye as ideal for that particular individual. At times the subject will casually strike a pose that seems so attractive and natural that Burns will adopt it for the painting. While arranging his own working position, Burns will be on the

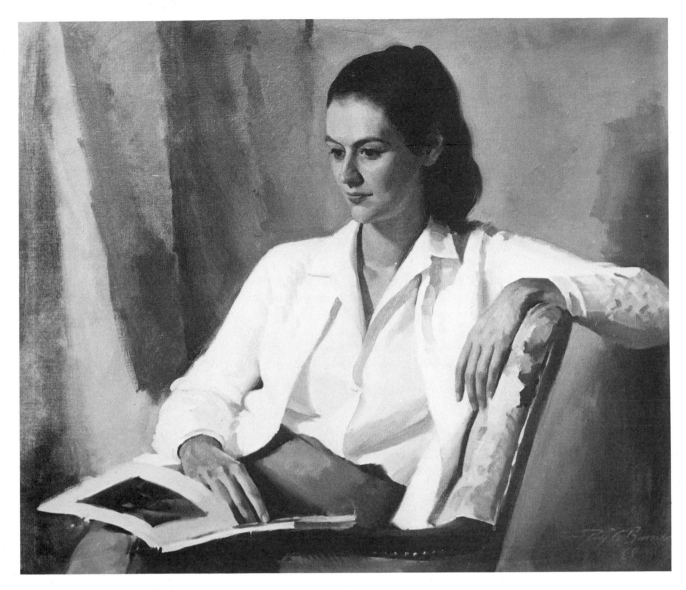

alert to choose a viewpoint from which this sitter will appear at her most attractive. He wouldn't, for instance, paint a heavily jawed woman looking up at her from below, since this would merely accentuate an already dominant feature.

Burns generally feels that the aspect of the artist's physical viewpoint isn't sufficiently stressed in portraiture. His most usual method is to paint standing up, with his subject seated on a model stand. By painting in the standing position, Burns is able to move back from his easel to obtain a good view of the background and to study the figure from some distance for proper perspective. The model stand permits Burns an eye-level view of the model. However, there are exceptions. If, for instance, a woman has a distinctively heart-shaped face, this desirable feature would best be served by painting the sitter from a somewhat elevated angle rather than from the frontal, eye-level view.

Although he has painted some female profiles, Burns will more often than not paint his sitter at a two-thirds, three-quarter, or nearly (but not quite) full-face angle. He prefers that the head be turned enough so that one ear at least is hidden from view.

Women often wonder why Burns asks them to smile when posing—at least at the beginning. He feels that most sitters tend to freeze into a rather rigidly set position which robs them of all verve and animation. He therefore urges them to smile or even laugh, and just as the smile or laugh is *settling*, he catches the play of muscles around the mouth and fixes this action in his memory to be held there throughout the duration of the portrait.

Michèle by Paul C. Burns, oil on canvas, 30" x 36" (76 x 91 cm), collection of artist at Portraits, Inc. Since light attracts and dark repels, painting a subject in clothing lighter in value than her face poses some risks. To counteract this tendency, Burns painted the sweater and blouse as simply as possible and introduced solid, deep modeling into the face where he wants our attention centered. This casual, informal approach is very much current these days, but Burns occasionally welcomes the challenge of painting a woman in a ballgown. Can you ascertain any difference between the technique in this portrait in comparison with the one preceding and the one following? One of the three is noncommissioned.

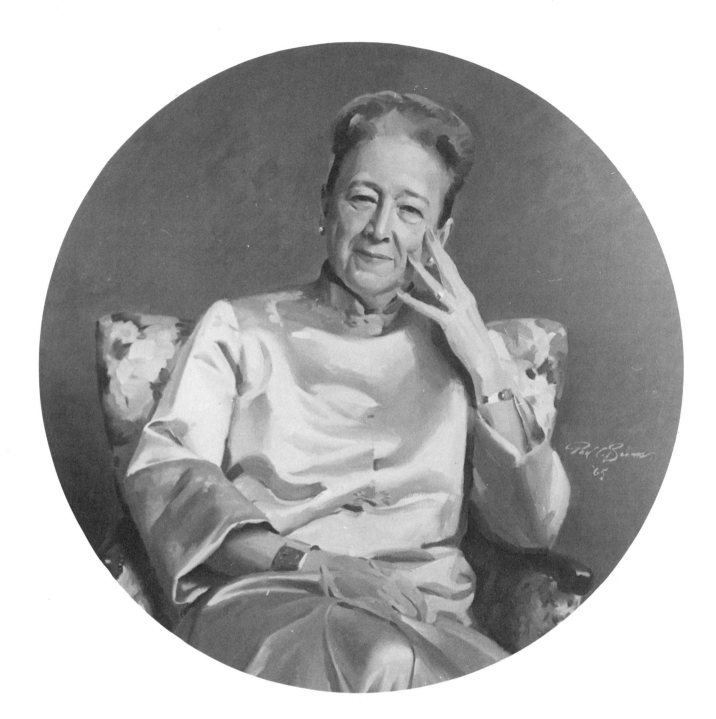

Charlotte Adams by Paul C. Burns, oil on canvas, 32" (81 cm) diameter, collection Mrs. Adams. Burns paints the lines in the face as if he were viewing them not from three, but from nine or ten feet away. He tries to portray the subject as if she were bathed in the diffused light Renoir or Gainsborough might employ. In this handsome study of a middle-aged lady, he has painted her honestly but in the best possible image she might present. Note how skillfully the shiny texture of the mandarin coat is handled. By showing the rather sharp breaks of this material Burns achieves an authentic image of the fabric. Such accurate interpretation lends fidelity and verisimilitude to the portrait.

Such items as jewelry and cosmetics—if overdone—are minimized by Burns. He might diplomatically suggest to a sitter that she remove the excess, but if she insists on retaining it, he will go ahead and paint her—rouge, chokers, false eyelashes, and all. Burns does caution the beginner to avoid painting the edge of a lipsticked mouth too sharply.

As for artificially tinted hair, Burns laughingly admits that he would welcome the challenge to tackle an electric-blue or a carrot-hued topknot.

If the model wears glasses—even those with a strong enough prescription to create a distortion of contours when viewed through the lenses—Burns will paint them as is, since they constitute an integral part of that person's image. Occasionally a sitter may request that he paint her without her glasses, a request to which he will, naturally, accede.

Like many artists, Burns enjoys painting hands and will include them if at all possible.

Burns feels that light is the portraitist's most creative tool; he therefore takes lots of time to illuminate his subjects' faces to greatest advantage. He might bathe

a youthful sitter's face in stronger light to stress its handsome construction, or in select situations he might use a direct, almost harsh light for the strong shadows needed to bring out the form. He likens his use of light to that practiced by Sir Joshua Reynolds, a noted painter of women.

Burns prefers daylight, but if forced to work under artificial light, he is aware of its discrepancies and adjusts accordingly. He enjoys painting portraits outdoors where he might incorporate the dappled effect of sunlight or a stray bird into the composition. Like other former students of the legendary Charles Hawthorne of the Cape Cod School, he was exposed to painting in sunlight by that instructor whose name pops up in so many of my conversations with American artists.

Burns is inclined to a warmer rather than a cooler use of color. His normal palette of Winsor & Newton colors is:

Flake white	Indian red
Cadmium yellow pale	Burnt sienna
Yellow ochre	Alizarin crimson
Raw sienna	Black
Cadmium orange	Ultramarine deep
Cadmium red medium	Permanent blue deep

He employs the same palette for all his portraits—men and women and persons of various skin hues. The basic colors he would use for a Caucasian sitter might include burnt sienna warmed with some cadmium red or cooled with alizarin, plus white and a touch of ultramarine blue.

For a black woman he would mix ultramarine blue and burnt sienna, then add a touch of Indian red.

For the ivory Oriental skin he might mix pale tones of alizarin and yellow ochre and some light blue and green shades.

Burns likes and tries to attain in his portraits the subtle color gradation employed by the Venetian school of painters. He has trained his eye to be sensitive to color variations, but he does not consciously invent color.

He feels that an overall color scheme is counterproductive to a good portrait, since, to a colorist, it is not the sameness but the *difference* in colors that is stimulating.

Most of Burns's portraits are painted on #111 Rix, a single-primed Belgian linen canvas made by Fredrix. He likes its spring and texture and occasionally gives it a pale tone of silver gray.

His brushes are the longer flats or an occasional sable. He doesn't paint with the knife.

Burns's painting medium is a 50% blend of linseed oil and turpentine. He rarely does preliminary studies, but proceeds straight into the portrait, employing a direct *alla prima* technique in which the paint is not laid in too thickly; edges are handled in a soft fashion for atmospheric effect, and textures are not stressed.

Burns uses Vibert retouch varnish to bring up areas gone dead between sittings. He usually requires two or three sittings of one and one-half to two hours duration, possibly spaced out over a couple of weeks.

A trick Burns employs to keep the colors wet between sittings is to place the canvas overnight into a refrigerator. The same method will preserve the paint on his palette in a workable condition for up to three days.

Burns makes his own decision as to when he has achieved a likeness. He tries to have the portrait approved as quickly as possible. He knows he has finished the painting when the urge to sign it comes over him, which usually happens a day before its actual completion.

The final step is to back up 20 feet, then come in progressively closer and look for and add the remaining minor refinements.

Step 1. *Using brush and paint, Burns draws in the general outline of the face, neck, hair, and shoulders. He spots the eyes and mouth and makes some indication of the direction of lights and shadows. A line in the background marks off the area where a deep shadow will fall behind the right side of the subject. The drawing is rough and sketchy, but it provides the artist with the information he requires regarding placement, proportion, and the relationship of the various elements in the portrait.*

Step 2. *Now Burns goes over the whole face with color, covering the underlying guidelines but affirming the answers he has learned from them. He has put in the shadows in the general areas they will occupy in the complete picture. A halftone turns the forehead as it angles back into the hairline, and the wide collar of the turtleneck sweater is painted in. The background is simplified into three general areas. The hair is indicated as a unified dark mass, since Burns has assigned it to the category of shadow, and his procedure is to paint from dark to light.*

Step 3. *Now the process of modeling commences. The edges between shadow and halftone are blended and run into each other. This modifies the stark darks of the shadow and lends a feeling of cohesiveness to the whole. We can see the head beginning to turn, to round off. Strong lights are added in the right temple, forehead, and top of the cheekbone. The hair is divided into halftone and shadow areas, as is the sweater collar. By squinting, you can begin to detect the beginnings of likeness, as the individuality of the subject's bone structure begins to emerge.*

Step 4. *Now Burns has corrected some of the statements he established before. He has broadened the forehead, added to the right jawbone, built up some of the hair on the top left, and marked off the bottom of the right jawline. The process of drawing, redrawing, and correcting goes on throughout the portrait. Burns has also now placed the features with some accuracy. He has mitigated the deep shadow on the left side of the face and set the eyes and the slash of the mouth where we begin to see the trace of a smile. He has placed the sharp shadow beneath the lower lip where the model's rather jutting chin begins. The character of the sitter's features has not yet been fully established, but hovers elusively, waiting to be "nailed down," as artists tend to describe this effort.*

Step 5. *Now the painting assumes a blocky, sculptural quality as Burns establishes the distinct planes of the face and head. The brushstrokes are evident in the cheek, middle forehead, chin, and in the light area trailing down from the junction between the right eye and the bridge of the nose. The light area on the right top of the forehead is reinforced, and lights are added to the nose to lend it a three-dimensional appearance. The lips are refined, and a strong light is placed on the lower one. The tops of the upper eyelids are put in. Resemblance comes nearer as the form is rounded off with halftones and brought forward with lights. A degree of modeling is achieved in the hair.*

Step 6. *Additional halftones are used to lighten the hair on the lower left side of the head. The bottom of the collar is shown, and the dark cast shadow is placed on the left shoulder. The strong shadow beneath the chin is put in. Lights are heightened in the sweater, the forehead and the hair on top. The hair at the subject's right drifts off into the background shadow. The reflected light thrown by the sweater is indicated below the chin, and the shadow at the left temple is strengthened once again.*

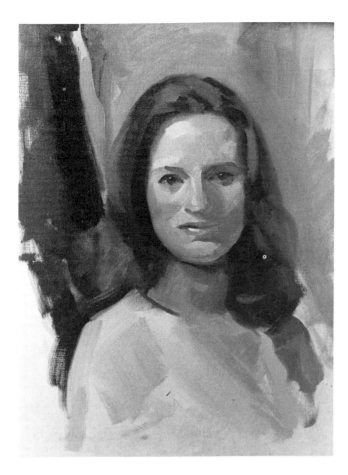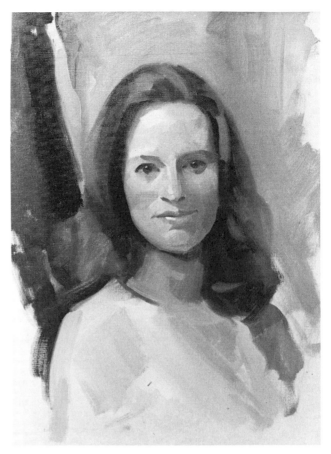

Step 7. *Now Burns goes after likeness with complete commitment. He paints the eyes with some degree of detail, adds catchlights, and indicates the shadows of the nostrils. The corners of the lips receive subtle darks to show the smile. The right cheek and the light beneath it on the right upper lip are reinforced. The modeling of the left temple and of both eyebrows is refined. The shadows beneath the lower eyelids are delineated. The shadow area in the left cheek is more clearly defined. The portrait is entering its concluding stages.*

Step 8. *At this point in the painting, the differences between the stages become more subtle and less apparent. The foundation has been firmly established, the form has been made to turn, and the color has been put in thickly enough to convey the artist's intentions. Now areas of hair in front are touched with additional highlights. The upper lip is altered slightly to give it more accurate shape. The total tonality is brought up slightly, and the right temple is marked with slight touches of reflected light. The left nostril is articulated somewhat more distinctly.*

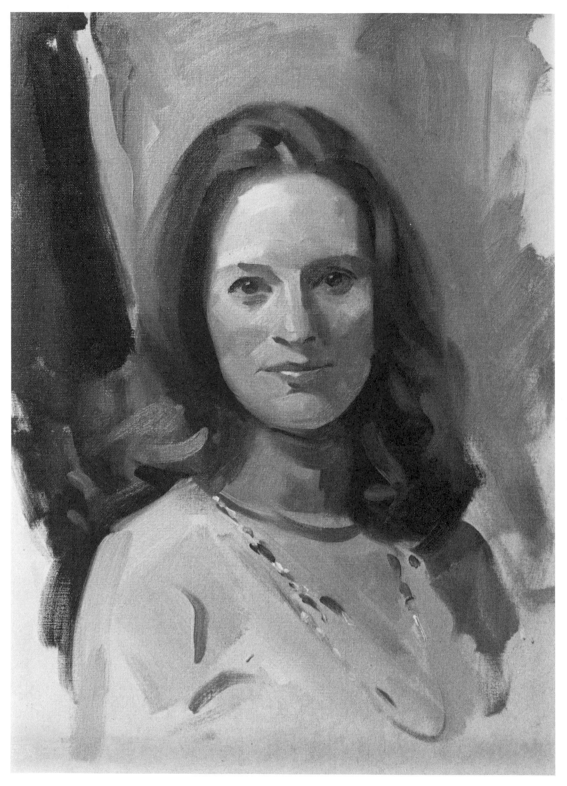

Step 9. At this almost final stage the necklace is put in, and the sweater collar is modeled with more detail. Lighter areas are put into the hair to reveal its thick, flowing texture. The bottoms of the eyelids are indicated, the part in the hair is shown, and the lower lip is rounded and more sharply outlined below. The two significant folds in the sweater at the arm and breast are defined. The folds of the upper eyelids are delineated, while the chin has been shortened slightly. Burns could have stopped right here, since he has captured the likeness and essence of his very attractive sitter, but he has chosen to go on, since some additional refinements remain.

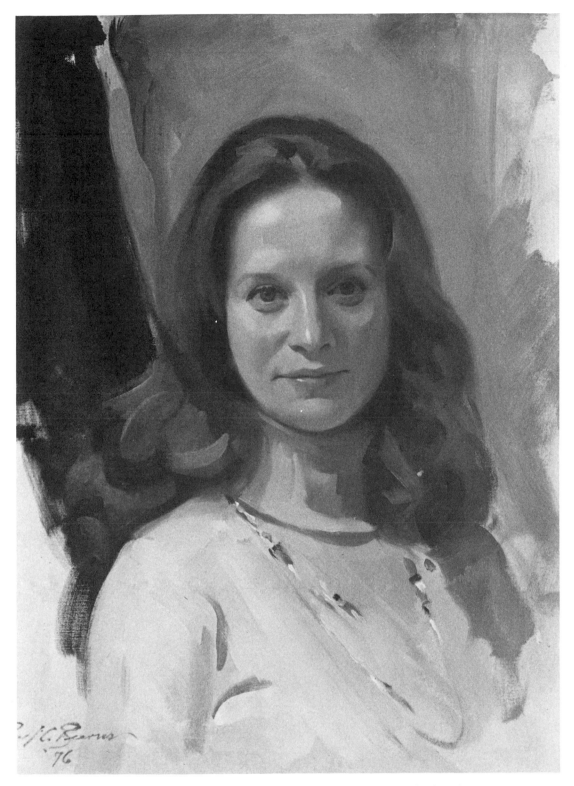

Step 10. Irene, oil on canvas, 24″ x 20″ (61 x 51 cm). Note how Burns has fused and softened the planes. The left side of the nose flows smoothly into the frontal plane, and all lights, middle tones, and shadows come together without sharp breaks. The forehead turns smoothly, the lips are round, soft, and shiny, and the eyes sparkle with animation, even though Burns has covered up the catchlights. The skin of the face flows gently into the hairline, and the outline of the hair has been altered slightly with the subtle divisions within the forehead skillfully articulated. Work has also been done on the ribbed character of the collar. The total effect is a striking portrait of an attractive young lady whose wit and intelligence shine through her handsome features. (To see selected steps of this demonstration in color, refer to pages 78-79.)

CHAPTER ELEVEN
Peter Cook at Work

Born in New York City, Peter Cook has lived near Princeton, New Jersey most of his life on a family compound composed of several houses, tennis courts, gardens, and farm acreage. Cook was graduated from Princeton University where he helped coach the hockey team, a sport with which he has been enthusiastically involved. He studied art with Leon Kroll, Gifford Beal, Harry Rittenberg, Arthur Lee, and his father-in-law, John Folinsbee, himself a distinguished American painter.

Cook has taught painting at the National Academy of Design, of which he is a member; in New Hope, Pennsylvania; in Clearwater, Florida; and in Princeton. He has participated in national exhibitions and has received the Pulitzer Traveling Scholarship, the President's Prize of the Clearwater Art Museum, the Century Association's Medal of Honor, and numerous other prizes and awards.

His paintings hang at Princeton, Rutgers, and Temple Universities and at the United States Supreme Court and in a large number of prestigious personal and institutional collections. Like most artists featured in this book, Peter Cook is represented by Portraits, Inc. of New York City.

Cook tries to meet his sitter prior to the initial painting session. He will ostensibly consult with her about her costume or arrange for them to dine together, but all the time he will be discretely studying her while she's relaxed and unaware of his scrutiny. It's been Cook's experience that when he first walks into a subject's house carrying his paraphernalia, she will tend to freeze and grow tense. To offset this, Cook will pretend to fuss with his easel or squeeze out paint for an hour or so in order to minimize the sitter's ordeal.

If, despite all his efforts the sitter still fails to relax, Cook pretends not to work on the portrait and chats about anything but the painting. This way, the portrait becomes less of a threatening presence and more like a third person attending a meeting of individuals. Often, Cook will ask his wife, Joan, to join the session. He finds that her pleasant, amiable manner helps put the sitter at ease.

During the first day of painting so much must be accomplished and so many problems resolved that time races by swiftly. Often the sitter is amazed when the day's session is over. Cook finds that the more resolved on this important first day, the better the portrait is apt to turn out.

He also feels that the artist must decide immediately, preferably within the first half-hour, upon one *general* aspect of the sitter. This aspect must be general enough to include more than the single expression a photograph offers, and it certainly must include the feeling of animation. Rather than flatter, Cook perfers to portray a sitter's best aspect. Experience has taught him that people who commission portraits don't really want to be changed, embellished, or slicked up in any way. If the portrait is executed with sufficient skill, no flattery will be necessary. If not, no flattery will help.

If for some reason Cook gets off to a bad start, he won't hesitate to make a fresh start—although over the years this happens ever more seldom.

He is resolved to paint as honestly as possible at all times. Since he finds old people very interesting to look at, he will paint an elderly woman just as she is—wrinkles, folds, and all—knowing that an honestly painted portrait will show a person at her best, regardless of age.

To convey the emotional traits of a sitter, Cook will employ light, background, color, and design. To emphasize a vivid personality, he might employ vivid colors and dramatic lighting. Or, he might show a gentler soul in soft, feminine clothing. However, Cook warns of the dangers inherent in trying to paint the sitter's character. Sometimes, he points out with a smile, it's the sinner in us that's most attractive, not the saint. . . .

Cook has distinct responses to some of the problems encountered in commissioned portrait painting. Working with strangers, as is mostly the case, the painter must devote sufficient time to divesting himself of the tensions and constraints that arise naturally from such a confrontation. On the other hand, a certain amount of "good" tension accrues when one is striving to do a good job under pressure. This tension can be exploited to good advantage by the artist by allowing it to bring out the best in him.

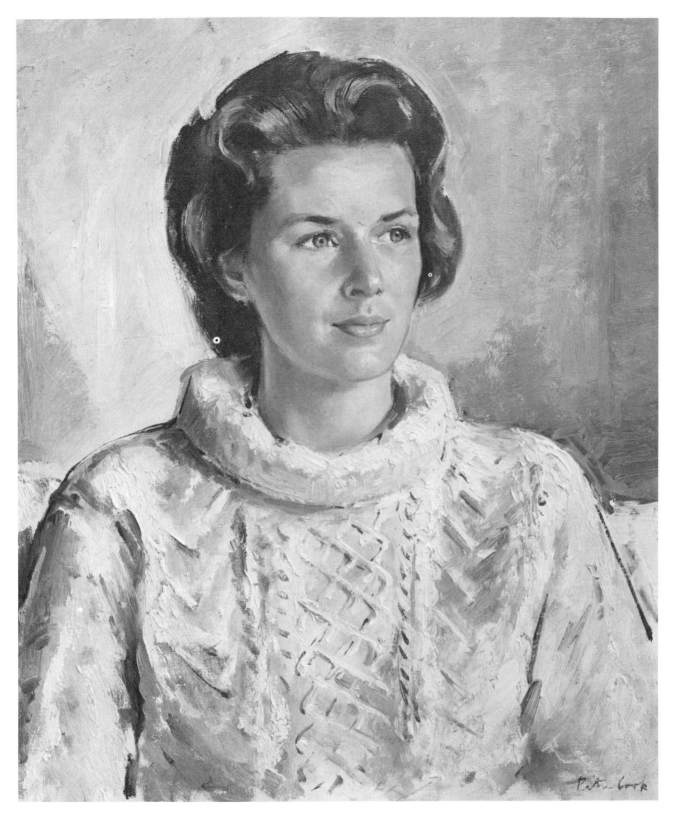

Mrs. Robert Morrell by Peter Cook, oil on canvas, 24″ x 20″ (61 x 51 cm). Cook is partial to the three-quarter view, since it lends form to the head. He often lets his sitter fall spontaneously into a pose that seems natural and comfortable for her. He prefers side illumination and, as in this painting, generally prefers soft, even light for a woman's portrait. To achieve the textural differences between the ribbed sweater, the hair, and the skin, Cook paints alternately thin and thick areas, using a distinct brushstroke in those passages where an impasto will mimic the rough quality of the material. The painting is generally high in key and seems cheerful and optimistic.

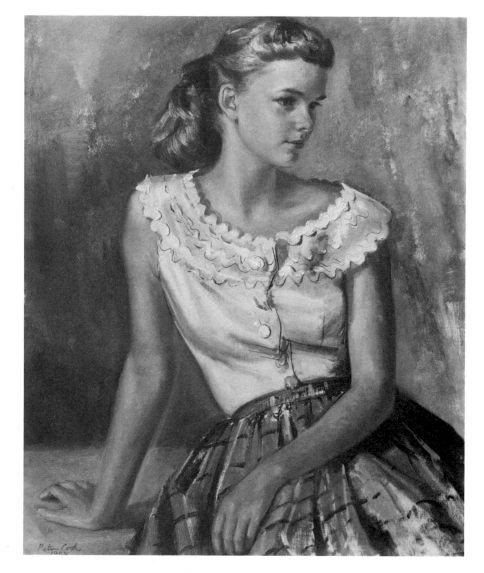

Peggy by Peter Cook, oil on canvas, 30″ x 24″ (76 x 61 cm) collection Admiral and Mrs. Joseph Dodson. Note the treatment of edges here. The outlines of the right arm are fused extensively into the background, while those of the left are almost severely marked off. This is not accidental but deliberate, as is the purely linear treatment of the front of the blouse and the rickrack across the bodice. Cook varies the sharpness of his edges to achieve a change of intensity of line throughout the portrait. He works on the premise that the human eye can only take in one or two edges in a single glance, and he arranges his edges accordingly. Painting all edges consistently soft or hard in a picture robs it of its flavor and visual interest.

Cook also points out that he might tend to finish his commissioned portraits more completely than his noncommissioned ones, since some people, in all innocence, might ask why a certain area of canvas had been left uncovered. Most of Cook's clients, however, are apt to be knowledgeable about art.

To Cook, the goals of a portrait are to produce a fairly tangible image of a personality and to give the illusion of a body in space—not merely to provide a satisfactory likeness.

Many factors enter into the realization of these goals, not the least of which is the *mood* of the portrait. Cook feels that in every painting—whether portrait, landscape or figure—the artist creates a world, an atmosphere in which the subject exists, and that everything within this world is permeated with a mood. He particularly admires the portraits of Eugene Speicher in which an almost religious spirit prevails. To Cook, the moods of Speicher's paintings are more real than the people he painted. These moods possess a sense of existence and stability, of solemnity and graciousness. In his own works Cook seeks to vary the mood to fit the subject.

Another factor to consider in planning a portrait is its size. Like all professional portraitists, Cook paints portraits of various sizes based on fee. But given his option, he would rather paint big pictures and feels that his best portraits have been these showing the subject in three-quarter length. He modifies this assertion with the opinion that—as in all other portrait considerations—the subject should dictate the size of the picture, and that some persons are better portrayed in small paintings. He sees small value, however, in a full-length portrait since little can be gained by showing a person's feet. Incidentally, Cook likes to leave lots of "air" in

his portraits since, in his words, he always seems to be "running out of space."

Cook paints people lifesize, which helps him achieve the illusory effect he is after, which is to convey the feeling that the subject is right *there*. To him, painting her larger than life means to render her forbidding. Painting her smaller than life makes her seem remote.

Cook usually suggests that the sitter bring three outfits from which they can then select the costume that would best suit the portrait. He prefers simple, casual dress which is more fun to paint and which allows the painter greater insight into the subject's character by not concealing her behind complicated accoutrements. He notes that the rare occasions on which he is asked to paint formal attire is when parents insist on having their children painted all gussied up, particularly older parents with young children.

Cook isn't didactic about posing his sitters. He prefers to have them strike a natural, relaxed pose on their own. He has no preference for the sitting or standing pose, but he does find a standing pose most attractive in a young woman who might otherwise slouch in her seat. In any case, he sees to it that the sitter is comfortable and relaxed in whatever pose she ultimately assumes.

Since Cook likes to maintain an eye-level view of his subject, he will accommodate his painting position to hers—if she sits, he'll sit; if she stands, so will he. Incidentally, when working without the model present, Cook always paints standing. He has abandoned the use of model stands because he found that they somehow made his sitters anxious, especially the older ones.

Cook has painted portraits from every angle, but he prefers the three-quarter view because it lends more form to the head than the strictly linear outline of a profile.

He finds hands something of a challenge since most people seem incapable of holding them still. He feels that if an artist elects to show hands, he should have a very good reason to do so, and that their presence in a portrait must be explained.

Cook uses no screens to create background tone or color but instead uses the values of the background to bring out the forms in the figure. In a sense, he creates his own backgrounds, inventing colors at will to serve his demands. If painting on location, he might include flowers or some other objects identified with the subject. But usually he uses existing elements, shifting them about freely to achieve his ends. His rule of thumb for backgrounds is that they possess less contrast of tone and color than the head and figure. Thus, no dark in the background would be as dark as those found in the head and figure, and no light would be as light. Although Cook reserves his strongest darks and lights for the subject, he would not hesitate to exaggerate factors in the background and place its darkest darks as contrasts against the lightest lights in the face.

Cook prefers to paint a sitter pretty much as she presents herself to him. If she wears eyeglasses habitually, Cook will paint them in, since he considers them a part of her personality and her total look. If she wears jewelry, he will paint that also. In fact, he enjoys the challenge of painting jewelry and might use its lines as a part of his design. If she wears heavy makeup or has artificially colored hair, he will not delete it, but with all of these things—eyeglasses, jewelry, cosmetics and dyed hair—he will exercise artistic license to subdue them if he feels this is best for the total painting.

Cook paints essentially in a high key. Since an oil painting will darken in time anyway, he compensates for this phenomenon by using lots of white, as much as a pound tube for a 24″ x 30″ (61 x 76 cm) portrait.

He considers light the painter's most valuable tool and prefers side to overhead illumination, which seems to him less natural. He likes a single source of light—preferably natural—which he uses as his principal means of dramatizing the sitter's personality. He generally uses a softer light for female sitters.

He dislikes painting under artificial light and seldom paints portraits outdoors. His preferred light source is a window. If the portrait should require an outdoor setting, Cook will paint the sitter indoors then add the background later.

Cook paints in generally cool colors, using blues and greens to cool the flesh

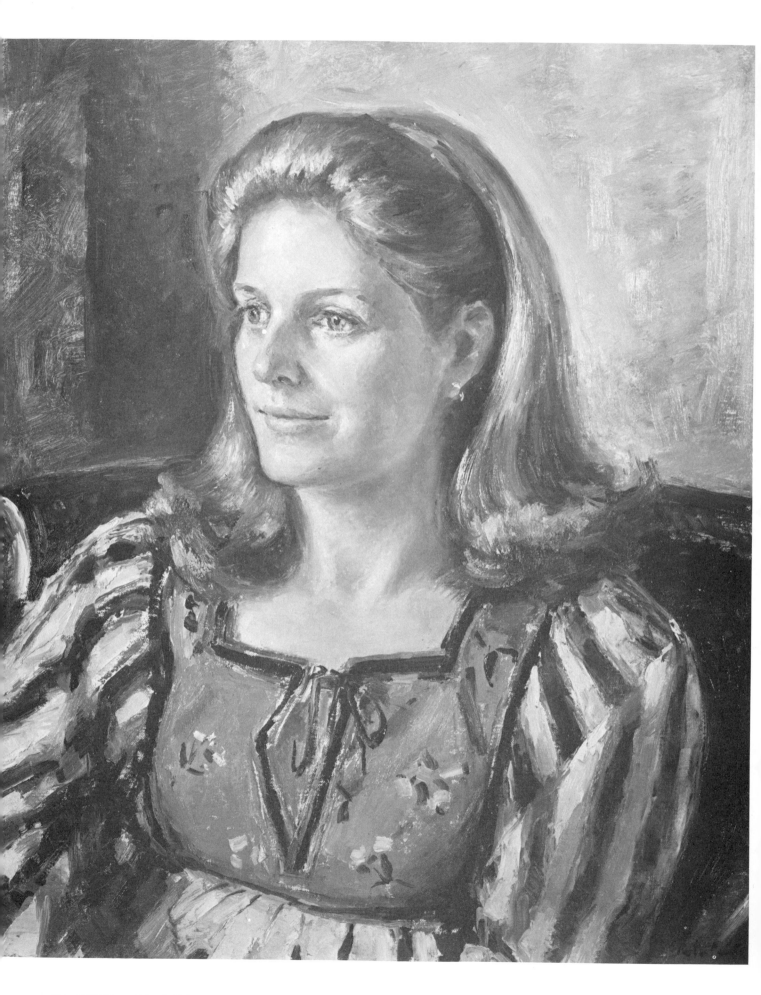

tones. He deliberately leans toward the cooler shades, since he is aware that red tones tend to grow even redder with time.

Cook's palette consists of the following colors in the Rembrandt line:

Zinc white
(he finds titanium white too stringy and fears the poisonous qualities of lead white)
Cadmium red deep
(he feels the more commonly used cadmium red light bleeds through too much)

Alizarin crimson
Cadmium yellow medium
Gold ochre
Burnt sienna
Ivory black
Permanent green light
Cerulean blue
Ultramarine blue

Although this is a rather limited, generally transparent palette, Cook has no hesitation about exaggerating, subduing or inventing color as the need arises.

Cook suggests some possible color mixtures for various-hued complexions.

For the *basic* white complexion: cadmium yellow medium, cadmium red deep, and white cooled with blues and greens.

For the black skin: cadmium yellow medium, cadmium red deep, gold ochre, and burnt sienna.

He likes a double-primed Winsor & Newton canvas, in the Herga or Winton texture, and works directly on this surface without toning. On some smaller commissions, particularly those of children, he might paint on Masonite panels to get brighter effects. He prepares his own boards, usually priming them with gesso.

Cook's brushes are long flats, round and flat sables, and a regular housebrush for backgrounds. He finds a knife useful for laying in whites, since it doesn't pick up any of the underlying colors. It is also helpful in painting patterns. His painting medium is made up of one-third turpentine, a bit more than one-third of damar varnish (homemade), and the remainder linseed oil.

His usual portrait painting time consumes three sittings, with lots of painting between the posing sessions. He limits the sittings to three because he has found that people tend to grow tired of the whole process if it extends beyond that time. To keep the procedure brief, Cook has disciplined himself to make up his mind quickly. He wastes no time on preliminary sketches or studies but pitches right in.

He finds photographs distracting and never works from them. Instead, he forces himself to observe, to form a mental picture of his sitter, and to get it down as swiftly and as accurately as possible.

He considers the treatment of edges the entire "secret" of modeling. Losing and finding edges in those places where the contour turns round the form is to Cook what painting is all about. He has no theories regarding edges and works only from instinct and feeling, with the full knowledge, however, that the human eye can only take in one or two edges at a time before shifting its focus.

Since he works in the *alla prima* technique, he will glaze only occasionally, and then only to bring down some passage in tone.

By varying his brushstrokes and paint thickness, Cook achieves the tactile quality he is after. He avoids the use of retouch varnish, since this represents to him an additional layer of skin which cannot be penetrated. He also finds that retouch varnish tends to create spotty areas.

Cook's method is to draw in the outline with the brush in gray; he paints in the shadows with burnt sienna, blue, and white and then loads up these shadows with additional color. He attempts to keep the painting as wet as possible between sessions and will often place the canvas outdoors in the winter to do this.

Before releasing the portrait to a client, Cook will keep it a week or ten days to make sure it has dried evenly and properly. He advises the client to have the painting varnished after six months or a year so that it can eventually be cleaned without danger to the paint surface.

He relies upon his own judgment to determine if he has achieved a likeness. He stops painting when he is no longer doing anything to improve it.

Lee Tetzeli (opposite page) by Peter Cook, oil on canvas, 24" x 20" (61 x 51 cm), collection the artist. Cook excels at painting young women. He manages to capture the fresh, appealing quality they project through the use of high-key, bright color and natural side light—plus that extra ingredient that can only issue from the artist's inner awareness. Note how loosely and skillfully the hair is handled here. You can almost feel its thick, bouncy texture. The dress is quite busy, yet it doesn't interfere or intrude, since it fits the general feeling of the portrait. Appropriateness is one of the most vital aspects contributing to the cohesiveness of a portrait. How would this subject have looked if posed in a severe black suit?

Step 1. *Very roughly Cook marks in the general placement of the head and figure. He makes no attempt at accuracy of detail—it's merely a sketchy outline intended to serve as a point of departure. Interestingly enough, Mrs. Fraker—who is determinedly athletic—posed with a broken foot confined in a cast, yet none of her discomfort is apparent in the finished portrait. A skilled portraitist such as Cook has learned to deal with various conditions and has sufficient discipline to surmount such hindrances.*

Step 2. *Now Cook turns to color and blocks in the face and hair. He places general shadow areas in the figure and background and marks the neckline of the blouse. As yet, no effort is made to delineate individual features other than a few darker areas indicating where the form dips or turns sharply. For all the apparent sketchiness, however, Cook has established a firm base from which he will veer only slightly. He knows where he is going and, therefore, can afford to take such abrupt shortcuts.*

Step 3. *Here the drawing has been strongly reinforced and a distinct expression indicated. The arms have been drawn in and the thrust of the figure is set. It's all still very rough, but the direction of the portrait has been resolved. Distinct modeling of the jawline appears, and the outline of the hair is pretty much set. Cook has solved the problems of placement and is ready to begin the process of refinement. Elements such as fingers, locket, chair, and background are still not in evidence, but the shapes, proportions, and relationships of the various components are soundly established. Without resolving these decisions, Cook couldn't go on with the portrait.*

Step 4. *The eyes, nose, and mouth are placed with considerable accuracy, and the modeling of the hair and blouse collar is advanced. Likeness is now becoming apparent. Although Mrs. Fraker presents a rather delicate appearance, Cook will seek to show some of her firm will and personality through color, design, lighting, and expression. More of the background has now been included, and Cook masses the darker areas of background against the lighter side of the face and figure to achieve contrast.*

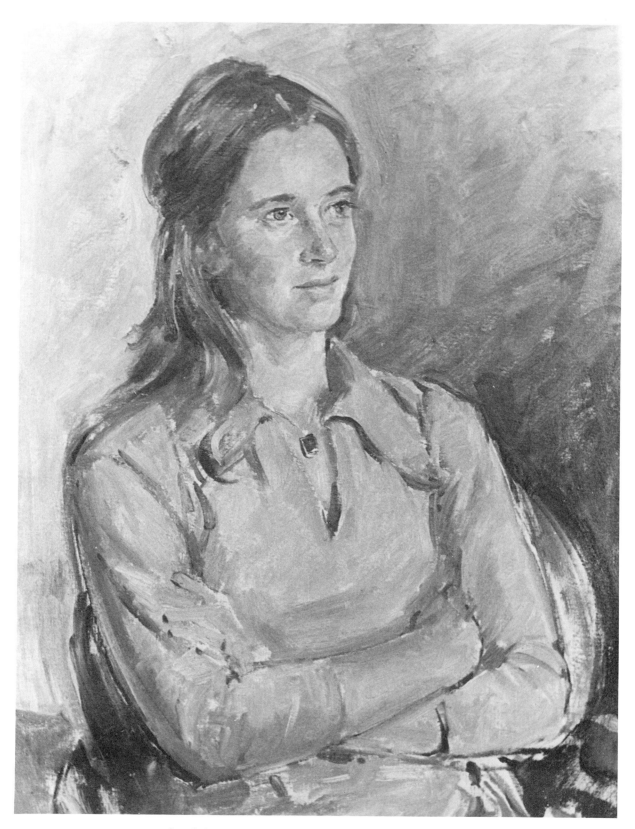

Step 5. *Attention is given to refining planes in the face and figure. The eyes are painted in greater detail, and the mouth, nose, and planes of the cheek are painted with care and concern for accuracy. Note how the left side of the nose has been modified so that it now emerges somewhat broader in the bridge. Subsequently it will be narrowed again. The process of attaining likeness isn't continuous but involves taking three steps forward, then two back. Few, if any, artists never fix, correct, and adjust but sail effortlessly forward without refinement or adjustment. Now the fingers have been marked in, the chair arm has been placed, and the locket indicated. The portrait is ready for its finishing touches.*

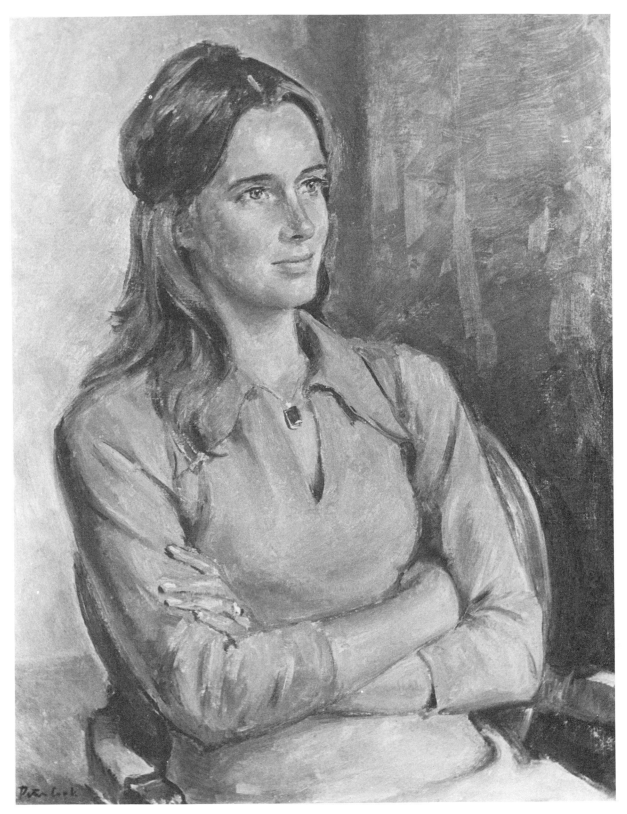

Step 6. Lynn Fraker, *oil on canvas, 30″ x 24″ (76 x 61 cm). All outlines and contours are resolved here. Highlights have been placed in the forehead, the bridge and top of the nose, the eyes, the top of the cheek, the corner of the mouth, the fingers, and the locket. The folds in the skirt and sleeves are marked in, the arms, hand, and fingers modeled, and the arms and side of the chair delineated. The artist has clearly indicated the eyelids and eyebrows and placed a strong shadow beneath the jawline. The subtle musculature of the face reveals the half-smile. Altogether, this has become a very handsome study of a clear-eyed, healthy, resolute young woman. (To see selected steps of this demonstration in color, refer to pages 80-81.)*

CHAPTER TWELVE
Clifford Jackson at Work

A native of San Diego, California, Clifford Jackson spent six years in the United States Navy during World War II. He studied painting with the renowned teacher Wayman Adams and with Hilton Leach in Florida, then earned his master's degree in fine arts and art education at Columbia University. Jackson also attended William and Mary College and the Pennsylvania Academy of Fine Arts and took further art courses in Spain.

Jackson is a descendant of an old American family which included a well-known painter of miniatures and a grandfather who taught painting at the Art Students League in New York. In addition to painting, Jackson is also a skilled professional musician.

He has exhibited at the Norfolk Museum in Virginia, the Town Hall Club in New York City, and the Portrait Gallery in Newport, Connecticut, and has taught art at Columbia University, the New Lincoln School in New York City, and the Old Mill Summer Art School in Elizabethtown, New York. Jackson is currently represented by Portraits, Inc. of New York City.

Jackson's method of getting to know his sitter is to sit her down in a chair and then commence to walk around her like a hunter stalking his prey. He employs no psychological techniques nor character analysis, but merely forces himself to *see* with utmost clarity so that the ultimate portrait epitomizes the person painted.

Jackson believes in gaining a first impression, something he has learned he can trust. He feels that since each of us sees a person in a series of flashes, it isn't necessary for him to look at his sitter continuously for hours. Instead, he feels that his subject's impact should be almost visceral, and by analyzing he would tend to lose a great deal of what is essential and primal.

Jackson doesn't believe in a too-chummy relationship with his sitter, but prefers to maintain a kind of studied aloofness in order to lend an aura of importance to the proceedings. He finds that this is particularly essential with child models.

If it will help to move the painting along, he will converse. However, he won't put on the radio because if the music is bad, it will annoy him, and if it is good, he will grow too preoccupied with it and neglect his painting. Nor does he believe in putting up a mirror, as many portraitists do, to let the sitter follow the progress of the painting. Jackson finds this distracting.

The pose adopted for the portrait will be determined by the sitter's personality and attire. Whenever he can, Jackson likes to get away from the usual sitting pose. He prefers the three-quarter view of the head, unless the sitter happens to be blessed with an unusually attractive profile. Most subjects, he finds, feel they're not getting their money's worth in a profile portrait.

To portray a woman of strong dynamic character, Jackson may employ strong diagonals in the composition rather than curving, more restful lines. For a shy woman, he might have her avert her eyes. Generally he avoids painting a sitter looking straight ahead. He finds such a pose wearing and suggests that the form of the eye is better served by placing the irises somewhat to one side with more white showing. A possible alternative to this, of course, is to have the sitter's eyes facing directly forward but with her head turned à la Frans Hals' *Laughing Cavalier*.

Jackson feels that by selecting the most favorable pose, lighting, costume, and angle for his sitter, the artist best serves the demands of the portrait. He begins by *liking* the subject and holding her in the highest esteem and then proceeds to paint her exactly as she appears from the most sympathetic viewpoint. This process represents to Jackson the highest form of flattery.

If the subject is somewhat past her prime and shows definite characteristics of aging, Jackson brings to mind Rembrandt's portraits of his mother, and Simon Elwes' conception of Mrs. August Belmont, once a raving beauty. In both cases the artists "flattered" their subjects by merely implying rather than cataloging their numerous folds and wrinkles.

Jackson concedes that he might be more innovative in his noncommissioned paintings as compared to his commissioned ones, which are probably smoother and more finished, since clients may not really understand rough brushwork. He would prefer to incorporate a looser, freer approach into his commissioned work

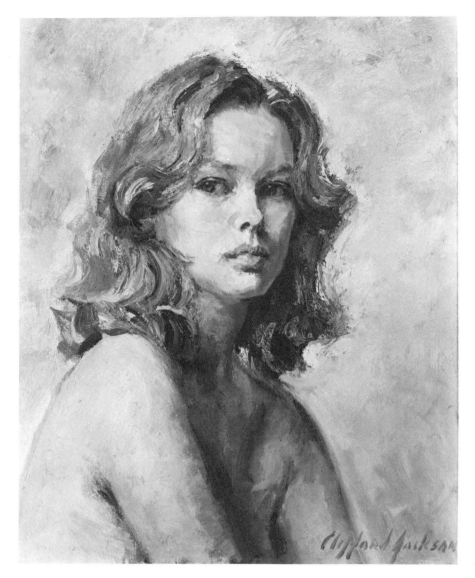

Sandy Dennis by *Clifford Jackson, oil on canvas, 24" x 20" (61 x 51 cm), courtesy Portraits, Inc. In this handsome study of the well-known film and stage actress, Jackson reveals his firm control of the medium and an ability to attain likeness. This is a face that's familiar to most of us, and one glance convinces us that Jackson has captured that pretty lady's essence. Note how distinctly Jackson indicates the divisions between shadow and light in the face. He belongs to the school that believes in putting down a brushstroke and letting it stay on the canvas, rather than moving it about. This leads to a plastic, sculptural quality in which planes turn in a series of angles, much like the facets of a cut diamond.*

and is encouraged by the fact that portraiture is moving away from its traditional formalized concept to a more expressionistic style.

One of Jackson's major goals is that the personality of the sitter come through. This is what characterizes the works of the masters. Although the subjects are often unknown to us, their force emerges from the distance of several hundred years ago. A second goal of course is likeness, which is what the client pays for. A third is the creation of a good work of art.

Jackson likes the full-length or nearly full-length portrait which he finds easiest to paint. He considers the head and shoulder portrait less of a challenge. Since he is an athletic type of painter who roams to and fro quite a bit and wields his brushes with vigor, he paints standing up, with his sitter perched on a model stand so that his view is approximately eye-level with hers. At times, he will arrange the pose so that he is looking down at her from above if he feels that she appears more attractive from a downward angle. Jackson also suggests that painting a subject so that she appears to be looking down at the viewer from a vantage point lends the portrait a psychological note of superiority. He normally paints the head just a bit under lifesize on the premise that we normally see others at some distance, which reduces the size of that person's dimensions in our image.

In selecting the clothing for the portrait, Jackson advises the sitter to bring as many changes of costume as possible so that a choice can be made. He tends to avoid a look, which quickly grows dated; he leans toward simple clothing made of handsome materials. He finds fabric with a nap or definite texture desirable, but

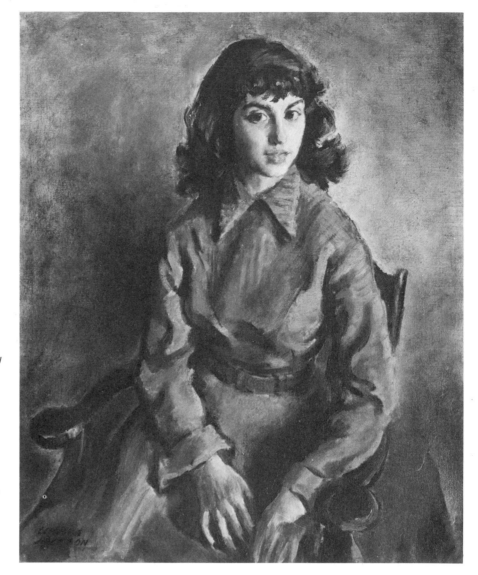

Spanish Girl by Clifford Jackson, oil on canvas, 36″ x 30″ (91 x 76 cm). Due to the subject's somewhat dark coloring, this painting is done in a lower key than the portrait of Sandy Dennis. Jackson doesn't like his portraits to appear too cluttered and therefore leaves sufficient space around the subject's head and figure. The background is mass—combinations of lighter and darker tones. Jackson considers the background as atmosphere which the artist must then infuse with air or life. He prefers to dress his subjects simply; but because of his free technique, he likes fabric that's distinctively textured. A pose Jackson likes is one such as this, in which the head is averted slightly, but the eyes face forward.

would shy away from something with a tedious, mechanical design. Although informal dress is now most common in portraiture, Jackson would love to paint a woman in costume so long as it didn't resemble a theatrical prop.

If the sitter wears glasses, Jackson will paint them in, avoiding, however, an overworked effect and striving merely to suggest their presence. He is careful to avoid the reflections emanating from lenses and paints the sitter without the glasses and then adds touches to indicate them. At times, Jackson finds, eyeglasses even lend a measure of strength to a soft, unformed face.

Jackson is quite vehement about cosmetics. He will urge his sitter as forcefully as possible to wipe away every trace of lipstick and rouge. He finds that powder flattens the face and renders the planes of the face less apparent. Makeup also distorts the true color of skin. If a woman is addicted to oddly colored hair, Jackson will rely upon his color taste to minimize this startling effect.

Jackson determines the mood of the portrait by the personality of the subject. Some women obviously appear more attractive smiling or painted in a high key. Others necessitate a more somber effect that can be achieved by lowering the key and presenting them in a more introspective attitude.

Posing the person and arranging a suitable background are elements contributing to the general mood of the portrait, so Jackson closely supervises the pose he wants his sitter to assume, arranges the lighting, and plans the background. Since he doesn't like his portrait to appear too busy, he leaves a reasonable amount of "air" around the figure. When painting on location, he may incorporate some ob-

jects found in the sitter's home into the background. He generally tries to avoid what he calls the "studio look."

His concept of background is that of atmosphere. He employs the background as a point of departure to which he must supply the air. Describing the effect he is after, he says: "You really want to feel that you can go back around the head." Jackson's backgrounds tend toward the lighter side.

Jackson likes to paint hands if at all possible. He feels the secret to painting hands well is to pose them attractively, so that they appear convincing.

Essentially a colorist, Jacoson paints in a fairly high key, avoiding a somber, chiaroscuro effect. For women, he prefers a flat light as opposed to strong, oblique light. Like most painters, he prefers natural light to artificial light which, he finds, removes all the cool flesh tones in the skin. He might use cheesecloth to diffuse the light coming through a window to cut down the harshness and the blueness of the sky. He tries to avoid the cast shadows and sharp edges a very strong light might produce.

Jackson has painted portraits outdoors and would love to do more. When painting outdoors, he will normally pose his model either in the shade or with the light coming from behind her, since posing her in sunlight tends to cause her to squint. Painting outdoors confines the artist to a certain time of day, if the painting extends to more than one session. Otherwise, the light would simply vary too much to continue the portrait successfully.

Jackson's method of bringing out the coloring of the face is to paint cool highlights on warm skin, creating an interplay of warm against cool. He tries, whenever possible, to incorporate a little cool reflected light into his shadows.

Jackson's palette consists of the following colors:

Titanium white	Cobalt violet light
Blockx jeune brilliant	Cobalt violet dark
(a very pale lemon color)	Raw umber
Cadmium yellow extra pale	Genuine ruby madder
Cadmium yellow lemon	Rose doré
Cadmium yellow light	(a slightly browner pink
Winsor & Newton jeune brilliant	than alizarin and Jackson's
(a pinky-orange)	favorite color)
Indian yellow	Davy's gray
Raw sienna	Thalo green
Cadmium yellow medium	(for emerald tones)
Camium yellow deep	Manganese blue
Winsor orange	French ultramarine blue
Cadmium scarlet	(less dark than regular
Winsor red	ultramarine)
Venetian or Indian red,	Thalo blue
or any of the earth reds	(instead of Prussian blue)
Burnt sienna	Ivory black

This extensive palette, in which there are at least nine yellows, reflects Jackson's predilection toward color. He is essentially and primarily a colorist.

Jackson suggests some *general* color combinations as points of departure for the various human skin tones.

For a white woman he might use a basic tone of cadmium scarlet, raw sienna, and white.

For a black woman of medium tone, he might begin with raw sienna and the greener browns.

For the ivory-skinned Oriental, he would be careful to avoid pinks and look for lavenders in the shadow areas. The lights would tend toward a grayish hue. The lips would be quite violet, with the lower lip often apricot and the upper lip quite blue.

Jackson wouldn't arbitrarily select a color scheme for a portrait. He might, however, create an overall tonality consisting of a predominant color with subor-

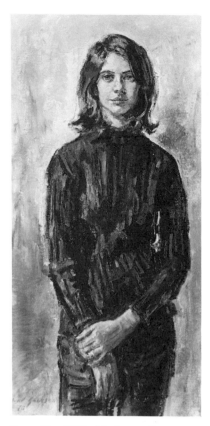

Laurel by Clifford Jackson, oil on canvas, 50" x 22" (127 x 56 cm), courtesy Portraits, Inc. Jackson doesn't stick to conventional sizes in his portraits. He prefers a full-length portrait, which he considers more of a challenge than the more commonplace head-and-shoulders canvas. He also likes to include hands whenever he can. He feels that the secret to painting hands well is to pose them attractively to begin with. Note the bold, rough manner in which Jackson blocks in his masses. There's nothing picky or finicky here. The forms are stated in powerful terms so that the sense of solid flesh and bone underneath comes through unmis-

dinate echoes. He feels that the basic separation of color in a picture is into warms and cools. He prefers his colors intense, since he feels that color is the only excuse for painting. Otherwise, one might do with a photograph or a drawing. He therefore exaggerates, subdues, and invents color at will.

Jackson paints on canvas whose spring he likes as opposed to the rigidity of a board or panel. He prefers a #66 Victor Claessens single-primed surface, which provides him a bit rougher tooth than the double-primed.

He uses the Degas series filbert brushes made by Grumbacher, some rounds, and an occasional flat brush for a crisp accent. He finds himself painting with a knife more frequently these days.

Jackson's painting medium, which he uses very sparingly, is Taubes' Copal #2. He seldom does preliminary studies and most often pitches right into the painting. He seldom tones his canvas, a practice that he finds tends to lower the key of the painting. He never paints from photographs.

Since Jackson likes to paint his picture in "one skin," he employs the direct, *alla prima* technique that entails no underpainting, glazing, or extensive use of retouch varnish. Jackson loves to paint textures, and generally paints in a thick, juicy style which he feels is the nature of oil painting.

Because drawing and painting are synonymous to Jackson, he believes in the concept of the lost-and-found edge based on variation of the intensity of the line. He uses edges selectively to separate two closely adjoining values, thus strengthening an otherwise weak area. Nor does Jackson leave any of his canvas bare, since he believes this to be a potentially dangerous practice—bare canvas may crack or peel in time.

Jackson usually draws in his composition with charcoal, which he finds easier to move around and correct than he would an oil outline. Once he is satisfied with the drawing, he sets it with fixative and then commences to paint.

Toward the end of the portrait, which normally consists of two to three three-hour sittings, when he feels that he has caught the sitter's likeness yet wants to make absolutely sure, he will reserve judgment until he has given it another, fresh look the following morning.

Jackson likes to build to a crescendo and then end the painting. He dislikes ending on a minor note. Therefore he stops painting when he feels he is casting about for things to do such as looking for a smaller and smaller brush, since this may lead him to small, picky strokes. He feels that only the artist reserves the right to stop when he chooses—even if this means striking a slightly wrong note.

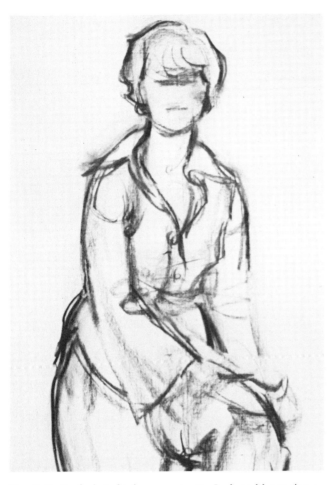

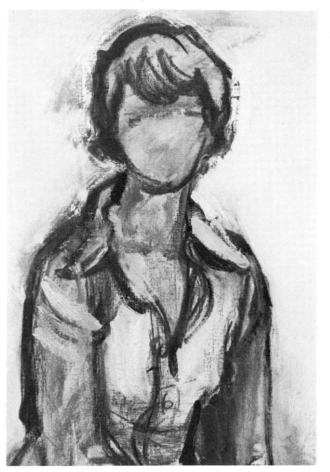

Step 1. *Particularly in his larger portraits, Jackson likes to draw the preliminary step in charcoal. He finds this easier to move around than a painted outline. Having established a fairly comprehensive sketch, he blows it with fixative and commences to paint. In a portrait of this size, it's especially important to get proportions and placement right, and Jackson has given much thought to design and apportionment of the various elements within the picture. A particularly interesting note is the right hand which dangles the sash of the pantsuit*

Step 2. *Next, Jackson blocks in with paint, working the outlines in thick, dark color and painting thinner layers in the inner areas. He has begun to indicate the pinkish color of the suit and some of the general skin tone color here. Jackson works very thickly and lays his colors in so heavily that textures play a vital role in the finished painting. The character of the brushwork is evident in the upper right arm where he has slashed in some lighter color. It's interesting that no trace of facial features is yet apparent at this stage.*

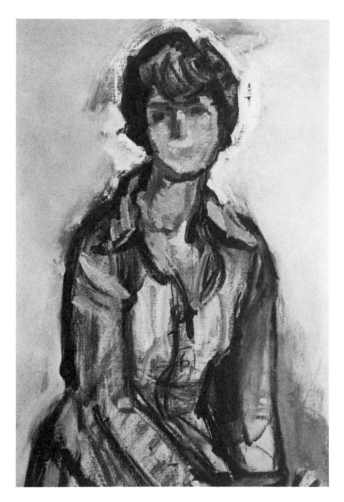 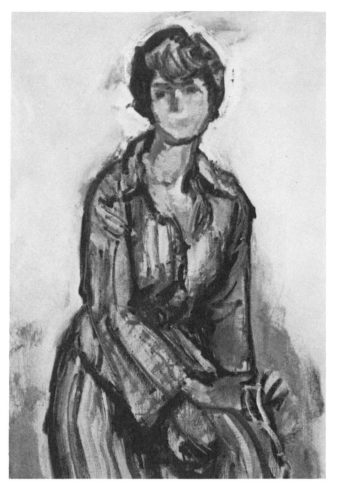

Step 3. *The bold linear pattern of the suit has been placed in strong, vertical strokes. The eyes have been roughly marked, along with a mere indication of the nose. The sitter's dark hair has been filled in in the shadow areas only. Patches of dark outline parts of the lower figure, but there is little contrast of tone higher up in the background. Jackson has rounded off the neck but has ignored the mouth, preferring to do more work in the figure at this stage. Note how this approach contrasts with Baskerville's, who nearly completed the face before even considering the figure. Artists arrive at their goals by entirely different and often strongly divergent routes.*

Step 4. *Jackson contines to work on the figure. He refines the lines of the breasts, adds telling folds in the sleeves, and throws additional tones into the hand and legs. While detail is still lacking—particularly in the head—a likeness is emerging from the other factors present. The sitter is rather slim in the upper body and rounder below the waist, and this characteristic is already unmistakably evident. Likeness isn't confined to facial features alone—bearing and stature also help define the identity of an individual. Jackson exploits this to further his goals for the portrait.*

Step 5. *(right) Now Jackson turns his attention to the face and goes after the aspect of the sitter's eyes, nose, and mouth as the portrait reaches its definitive stages. He models the nose simply, places halftones at each edge of the face to make them recede, accentuates the fullness of the lips, and defines the chin. The black hair is filled in and touched with lighter accents. The sitter's burning dark eyes and vivid coloring come through even in this black-and-white photograph. Accurate likeness is now one of Jackson's prime considerations, as decisions of value, proportion, and design have largely been resolved. The oblique gaze is particularly appropriate to express Mrs. Incorvaia's rather shy, winsome personality.*

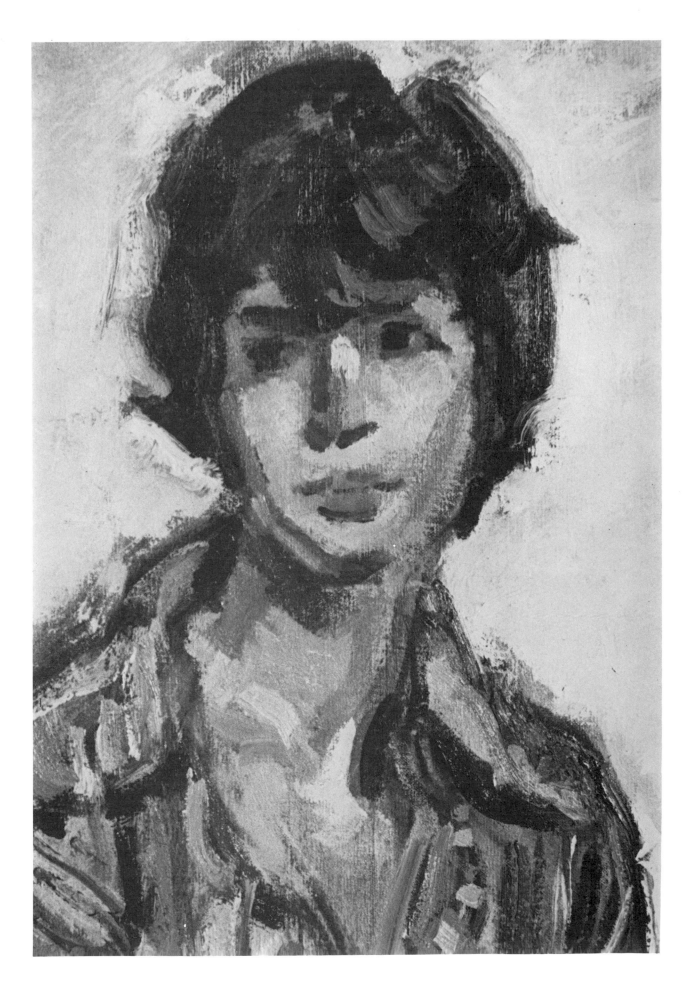

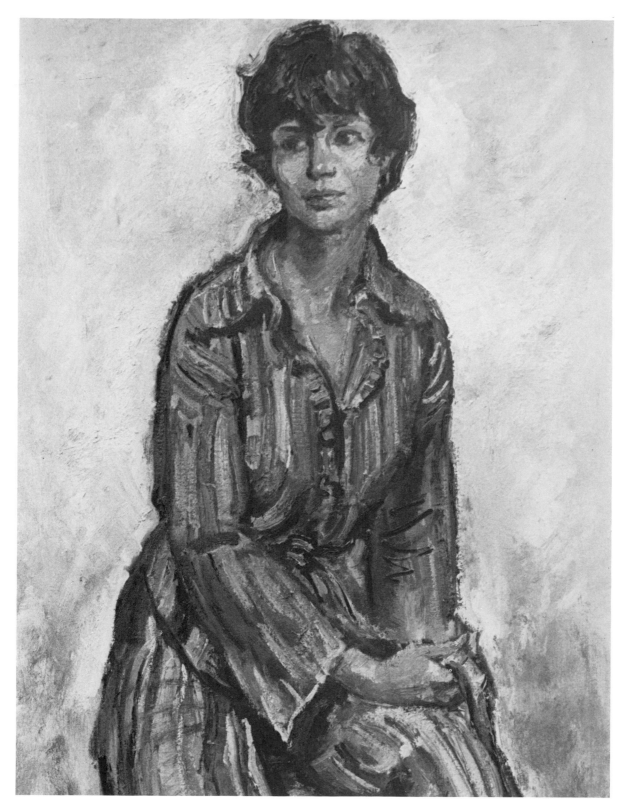

Step 6. Mrs. J. Incorvaia, oil on canvas, 50″ x 30″ (127 x 76 cm). In the finished portrait, much work has been done in the face to refine the features and enhance the illusion of reality. The nose has been carefully modeled, and the planes of the cheeks and chin have been rounded off. The eyes have now assumed their rightful shape, and they turn nicely. In this stage, Jackson went as far as his free-wheeling technique allows to introduce detail and accuracy of form in order to achieve likeness. The hand too shows a degree of care, and its action is clearly delineated. Jackson reserved most of his bravura brushwork for the suit, where the masses, folds, and angles remain simple and bold. Note the use of a rather broad outline which seems to run around the figure. It's a mannerism that works especially well in this slashing, Expressionistic style.

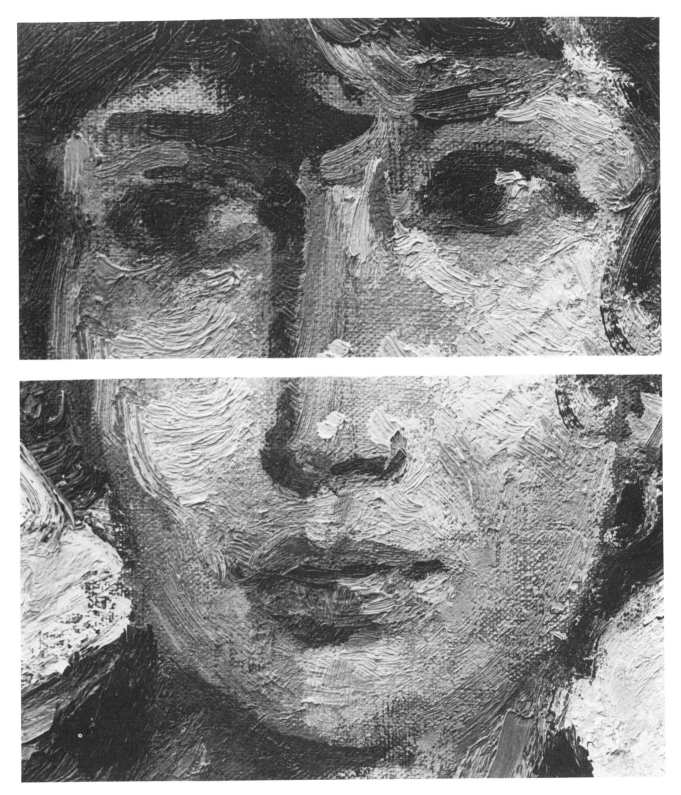

Step 6. Detail *(top). This closeup shows clearly how Jackson uses paint to achieve his goals. Note the density of the brushstrokes along the cheeks and above the left eye. The thickest impastos are reserved for the light areas, a technique which follows the traditional method of painting thick in the light areas and thin in the darker ones. The masters were the chief exponents of this practice, as a close study of any late Rembrandt portrait will reveal. The only difference is that Jackson paints in* alla prima *and employs no glazing or underpainting. Note also that the brushstrokes tend to follow the form.*

Step 6: Detail *(above). Down where the face catches less light, the paint grows quieter and less turbulent. In the left jawbone, in fact, the paint has been applied so thinly that some of the canvas texture shows through. It's this blend of thick and thin passages that lends snap and visual interest to a painting. Note how softly Jackson painted most of the edges of the lips so that they seem to flow naturally into the skin. He saved the sharpest edge for the top left of the upper lip where the strongest light is centered. This is an imaginative application of edge control—using it consciously to achieve desirable contrast of tone or color. (To see selected steps of this demonstration in color, refer to pages 82-83.)*

CHAPTER THIRTEEN
Everett Raymond Kinstler at Work

Photo by Susan E. Meyer

Everett Raymond Kinstler was born and raised in New York City where he now maintains a home and portrait studio. He began as a comic book illustrator for the pulps at age sixteen and soon was swamped with orders. He studied with Frank DuMond at the Art Students League, and with Sidney Dickenson, Wayman Adams, and his favorite teacher, John Johansen. Kinstler ultimately made the transition to portraiture. A great favorite in Washington, he has to date painted from life twenty official Cabinet portraits including those of Ambassador Elliot Richardson and Governor John Connally. Among his more than 500 portraits are such prominent personalities as Secretary of the Treasury William Simon, Astronaut Alan Shepard, golfer Byron Nelson, publisher Charles Scribner, Princeton University President William Bowen, and Richard K. Mellon.

Kinstler is an academician of the National Academy of Design, vice-president of the National Arts Club, art chairman of the Players Club, and a member of the American Watercolor Society and the Century Club. He is the author of Painting Portraits *(Watson-Guptill, 1971) and recently collaborated with Tennessee Williams on a series of color lithographs. He taught at the Art Students League 1969-1974.*

For Ray Kinstler, the process of getting to know the sitter begins with the very first moment of encounter. To him, this process is possibly the most important phase of the portrait. As soon as he meets the person he has been commissioned to paint, a kind of heightened awareness takes over, and he begins to take mental soundings—digging and searching to grasp the essence of his subject. This insight remains at a high pitch throughout the portrait, but is particularly intense during the all-important first hours together. It is so important to him that Kinstler may only simulate painting during the first day's session while he is really trying to find out all he can about his sitter's physical and emotional makeup.

The reason Kinstler stresses this aspect of portrait painting so strongly is his absolute conviction that a portrait is a product of the artist's own personality reacting to the impact of his subject. There is nothing more interesting to Kinstler than portraits of the same person painted by different artists. Today he feels he can bring much more insight, awareness, and sympathy to his portraits because of his own growth and development as an artist and as a human being.

Kinstler feels strongly that one must sincerely *like* people in order to paint portraits successfully. He *has* painted one or two subjects toward whom he didn't feel particularly sympathetic, but this is a rare experience. He is essentially receptive to people, looks for the best in them, and generally finds it. His portraits reflect this attitude.

Although he does gain a first impression of his sitter, he's guarded about accepting it on face value, since long experience has taught him to be wary. He agrees that at some point the artist must make a commitment, and at times this commitment *is* predicated on the first impression.

Kinstler rejects the concept of flattery—he prefers to deal in character and truth. He paints what he sees, but he does see beauty in the astonishing variety of human faces. His fascination with this heterogeneity is based on the sense of character he sees there rather than on mere symmetry of features.

Kinstler points out the difference between portrait painting and illustration, having pursued both professions successfully: "In illustration I painted types. In portraiture I paint individuals."

He objects to what he calls "jobbers," slick portraitists who grind out a well-constructed product guaranteed to offend no one and representing a sophisticated version of a do-it-by-numbers-painting. He quotes his former teacher whom he admires enormously, John Johansen, whose credo was: "A frank error is worth more than a hesitant truth." Mr. Johansen cautioned Kinstler to beware of his facility and avoid slick, clever, compromising painting.

In several instances Kinstler has had the unusual experience of his subjects' husbands berating him for prettifying their wives. He is pleased that his sitters and their families *demand* a truthful interpretation. Thus he finds older women delightful subjects, more interesting than pretty adolescents whose faces are still unformed and unmarked by experience.

Kinstler approaches each new portrait with no preconceived notions. Some-

Marie Louise Snyder by Everett Raymond Kinstler, oil on canvas, 36" x 30" (91 x 76 cm). Kinstler has the uncanny ability to make all his female subjects appear alert, elegant, and distinctively alive. This is a skill particularly appropriate for a painter of portraits, and it stems in great part from the artist's genuine affection for people. I have never seen a Kinstler portrait in which the subject doesn't seem happy, positive, or enthusiastic. This is a trait the artist injects into the portrait and one that represents an extension of his own personality. Kinstler feels strongly that it's incumbent upon the painter to introduce this factor, and he lists it as one of the specific goals he projects for the portrait. The result, as seen in this study, is most pleasing and attractive.

times people's faces undergo startling changes when he begins a portrait of them. In this new situation, the artist and model are no longer observers of a scene but active participants, and the true character of the sitter emerges in the painting.

In executing his noncommissioned portraits, Kinstler follows the same procedure as in his commissioned work, except that he may stop perhaps halfway along the route. Since clients expect and are entitled to a certain product, and because such factors as size and pose enter into the process, the artist is denied the freedom he might exercise in painting for himself. Kinstler eternally strives toward the time when he can dictate the conditions of his commissioned portraits and enjoy the total lack of restraint he now has in his noncommissioned painting. The success of this goal is predicated on his own growing confidence and on his clients' perception of what constitutes a good painting rather than a mere photographic likeness. Kinstler anticipates the day when his commissioned and noncommissioned work will be indistinguishable. Although he is a devoted admirer of Sargent, he values the integrity of Thomas Eakins who painted professional model and commercial client exactly alike, with no concession whatever to status.

Kinstler lists a number of goals attending the painting of a portrait.

1. *Truth*—which he defines as sincerity and integrity.

2. *Artistry*—or the quality of the painting.

3. *The apparent presence* in a portrait of the *personality* of the artist and his ability to bring out the best in the sitter.

4. *Animation*—the feeling of life in the subject.

5. *Craft* displayed by the painter.

6. *Approbation of fellow artists*—the positive response of those whose judgment he values.

Kinstler would like to be in the position to choose the size of the painting without the consideration of fee, which now pretty much dictates the dimensions of a portrait. Aside from the factor of where the painting will ultimately hang, he feels that different people call for various-sized portraits by virtue of their physical and emotional makeup.

Although his direct, *alla prima* style of painting dictates a certain vigor and snap, Kinstler would very much like to be able to vary the mood of his portraits. He considers the lack of freedom to do this another constraint imposed upon the portrait painter. The artist is governed by the client's flexibility as to the concept and type of portrait he can successfully "get away with." Few clients are sufficiently liberated to accept a portrait in which much of the face is lost in shadow or which shows them turned away from the viewer.

Kinstler has done both formal and informal portraits of women and has no preference for either approach. As in all things regarding portraiture, he is generally reluctant to impose rules or recipes. It all depends on the individual sitter.

Kinstler's heads are painted lifesize as a rule. He challenges the contention that women's heads should be painted smaller than men's. He notes that if you include a woman's hair, the total length from the top of the head to the chin is equal to, if not bigger than a man's.

The one concession he does make is to paint the head in a personal portrait a bit smaller than that in an official portrait which will likely hang higher up in some board room or institutional hall. Kinstler paints his heads lifesize because this feels most comfortable to him. Besides, he feels that a smaller head might evoke a tendency to noodle and become picky.

Because of his training in illustration Kinstler tends to create his own backgrounds. In illustration the artist serves as his own stage designer, and Kinstler has carried this practice over into portraiture. To Kinstler, a background is composed not of objects but of atmosphere, and he paints it accordingly. When occasionally working on location, he may include some favorite things found in the subject's home.

Kinstler, whose constant aim is to avoid formula and repetition likes all poses and viewpoints. He would welcome the opportunity to do more profiles like the one of his wife, Lea, on page 70. But he does feel that the frontal view is more challenging since it tends to flatten the form.

He paints standing up, with his subject on the model stand so that their eyes are level. He moves his easel around the studio quite a bit once he has decided on a pose and the portrait commences. With his powers of observation honed by years of experience, Kinstler poses his sitter based on a keen analysis of her physical and emotional traits. He talks to her in order to both relax her and to fully involve her in the process of painting. It is his fervent conviction that a portrait is a mutual process in which total interaction between artist and sitter is absolutely vital. Kinstler finds music distracting. He wants his sitter "eyeball-to-eyeball" with him, in order to converse and be completely involved in the task of creation.

Kinstler helps the subject select an appropriate costume for the portrait. Again, he has no rules for what clothing he prefers except that it shouldn't be so "busy" as to take interest away from the face. Outside of his general preference for simplicity, he has no objections against jewelry.

If the sitter wears glasses, Kinstler will include them in the portrait. He will not ask her to remove them and then paint them in later as many artists do, but will insist she keep them on the whole time. He objects to certain sculptured heads in which the lenses seemed glued to the face. Since the line of eyeglasses can affect the eyebrow and cheek, and since the cheek can affect the way the entire face looks, he is careful to paint the glasses carefully and correctly—just as they sit on the subject's nose.

Mrs. William Littleford *by Everett Raymond Kinstler, oil on canvas, 25″ x 20″ (64 x 51 cm). This portrait should be studied in conjunction with the next one, that of Mrs. Miller, since they represent two approaches to a rather similar situation. Both subjects are described by Kinstler as vivacious, warm, and animated. Both are smiling and posed under fairly equal illumination. Kinstler chose to paint Mrs. Littleford in a dark velvet jacket, which seemed to call for a darker, more formal background. It also effectively set off the subject's light-colored hair. Kinstler painted Mrs. Littleford smiling since, in his own words: "To have painted her not smiling—it would not have been Marian Littleford." Kinstler makes every effort to incorporate the subject's emotional makeup into the portrait.*

The same concept applies to cosmetics. If excessive makeup is a definite part of the woman's image, Kinstler will include it. If her hair is dyed a particularly outlandish color, he might minimize some of the garish effect.

Kinstler is fascinated by the challenge of painting hands and includes them if they can help the compositional aspect of the portrait.

Another danger Kinstler points out as particularly ominous to the portrait painter is that of unvarying light. Locked in, as he normally is, to the confines of his studio, the portraitist confronts the dilemma of constantly painting in the same key and under similar lighting conditions. The tendency to repeat himself looms large, and the artist is hard pressed to avoid monotony. Varying this light drastically also poses problems, since it may present difficulties in achieving a likeness. This can be the case in backlit or deeply shaded illumination.

Kinstler is that rare artist not fazed by artificial light. While he does feel in better control of light during the day, he doesn't automatically opt for daylight. He has encountered north lights which were harsh and some artificial lights—such as in subways—that were attractive.

Kinstler has painted portraits outdoors and would love to do more. When painting outdoors, particularly in bright sunlight, he considers the dangers inherent in this practice and allows his intelligence to take over. He relies upon a knowledge honed by years of experience to make certain adjustments and compensations and negate the washed-out effects and color value distortions bright sunlight stimulates.

Kinstler paints in a medium key and essentially in neither cool nor warm color. He likes "what happens in the middle . . ." those violet and green accents lying between the warm and cool areas of flesh.

Kinstler confesses to a prevailing fault—he gets bored and feels the need to experiment. Thus, while his palette remains basically the same, he is forever testing, substituting, and trying out new colors.

His *basic* palette of Grumbacher and Winsor & Newton colors remains:

Permalba white	Alizarin crimson
(manufactured by Weber)	Burnt sienna
Cadmium yellow pale	Raw umber
Raw sienna	Cerulean blue
Cadmium orange	Ultramarine blue
Cadmium red light	Oxide chromium of green
Light red	Ivory black

He sometimes prearranges an overall color scheme for a portrait and regrets that he hasn't done it more often. He prefers intense color to dull and happily invents, exaggerates, and subdues color to suit his needs. His portrait backgrounds go through phases—dark for a time, and then light. For women, he generally prefers a light background.

Although he likes the spring and bounce of canvas, he has painted heads on panels and would like to do more. He uses Fredrix #125 Kent single-primed canvas whose lead priming and fine tooth he enjoys. His brushes are filberts manufactured by Simmons. Kinstler uses the knife *not to paint*, but only to scrape out a passage. He paints thickly in his light areas and thinly in the shadows and likes the occasional apparent brushstroke—but only if it's subjugated to the subject matter, not if it dictates it.

For his painting medium, Kinstler employs copal, which he uses very, very sparingly if at all. He also uses kerosene. He likes the way it flows, and uses it to keep areas from building up too much. Unlike turpentine or mineral spirits, kerosene leaves a thin layer of film into which Kinstler likes to work.

Kinstler wishes he had more time to devote to the conceptual aspects of the portrait. Were he not so pressed, he would draw and execute many preliminary steps prior to commencing the portrait. He will readily take advantage of any mechanical means that will help him advance his goals and uses the camera with no apology. His extensive training in working from life permits him the luxury of

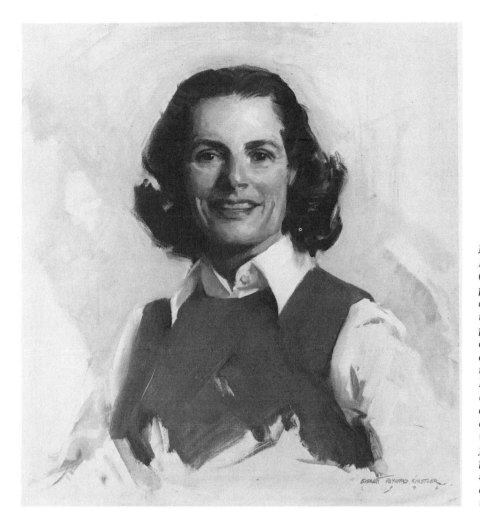

Mrs. John Miller by Everett Raymond Kinstler, oil on canvas, 26" x 24" (66 x 61 cm). Mrs. Miller's portrait was painted very near the same time as that of her friend Mrs. Littleford. Kinstler, therefore, was confronted with the problem of making the two portraits come out somewhat different. Here the approach is lighter and airier, in keeping with the sporty aspect of Mrs. Miller's less formal attire. Also, the lighter background complements her darker hair and coloring. By thus changing the approach to suit the individual situation, Kinstler avoids the formula portrait, a trap many unwary portraitists fall into almost unconsciously. Compare the two portraits and analyze the reasons each one works so well.

working from photographs when necessary. He does caution the beginner, however, that without this prerequisite painting from photographs can prove a deadly trap.

If things go well, Kinstler normally takes four sittings of two and one-half hours each to complete a portrait. In response to a question about his treatment of edges, Kinstler quotes his idol, Sargent, who said somewhat enigmatically to a student: "Watch your edges."

Kinstler feels that this rather terse statement is self-explanatory—he refuses to postulate theories concerning edges and merely advises the student to be acutely aware of them.

Kinstler enjoys the challenge posed by various textures and, in his own words, he actively and consciously "goes after them."

Kinstler's practice is to stretch excess canvas around the stretchers so that he can later restretch it to adjust the placement of the elements in the picture. Occasionally he tones his canvas. He usually begins by drawing with the brush on white canvas in a middletone, and then masses in his darks. He always works all over the whole canvas at once and strives to place the right value in exactly the right areas.

He usually manages to get the "feel" of his subject early in the portrait, and when he senses that he can go no further, he stops.

Kinstler likes to say that it takes two people to make a picture: one to paint it and the other to hit the first over the head to make him stop. Obviously in Kinstler's case this schizophrenic process works to perfection since his portraits look always fresh and alive—never overworked.

Step 1. *Kinstler uses brush and medium-tone paint to sketch in the general outline of his sitter's head, hairline, features, and neckline. This simple guideline would be worthless if he hadn't previously devoted long hours to a thorough, painstaking study and observation of the subject's physical traits and emotional makeup. Kinstler has thoroughly visualized his portrait, and these few basic lines are merely a blueprint for the kind of picture he has already built in his mind.*

Step 2. *Now Kinstler mixes a darker tone and throws in some of the more obvious darks. He is sticking fairly closely to his original linear statement and uses the tone to reinforce his early impression. Mrs. Kennerly presents a general impact of brunette vivacity and high coloring, and this image is reflected in her rather full-blown hair and generous lips. Kinstler goes after likeness from the very first stroke and achieves it as quickly as anyone I know. This ability is basically inborn and is a blessing for those seeking a career in portraiture.*

 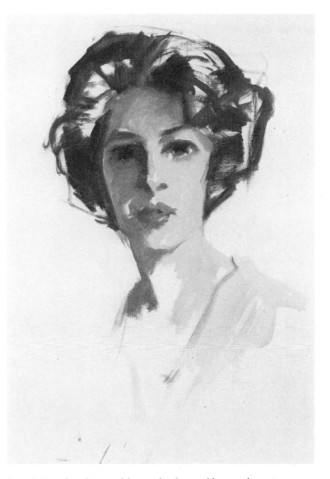

Step 3. *The halftone areas within the face are filled in, with some smaller areas left open where Kinstler anticipates the placement of lights. Some of these decisions will be modified in the finished portrait, but for the present they help Kinstler separate and classify the tonal gradations within the head. He also makes minor adjustments in the hair, which is treated exactly as the face—broken up into light, halftone, and shadow. The character of the sitter's lips is more clearly defined, and the nose begins to assume its final shape. The strong cast shadow thrown beneath the right lower lip is indicated and the form of the eyes further developed.*

Step 4. *Kinstler places additional color and begins bringing together the tones within the head. He decides to test the right side of the head in fuller shadow but leaves a light accent on the right side of the mouth to hint at a smile. The fullness of the lips—a most significant characteristic—is once again intensified, but there is no indication yet whether the mouth will be shown open or closed. The eyes are filled in to show their recession. Tone is added to the neck and blouse to resolve their relationship to the head. Kinstler likes to work all over the canvas at once rather than devote his attentions to one feature at a time.*

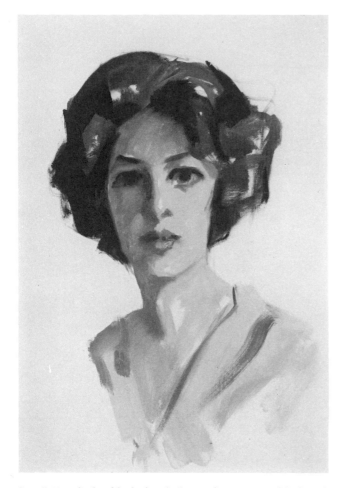

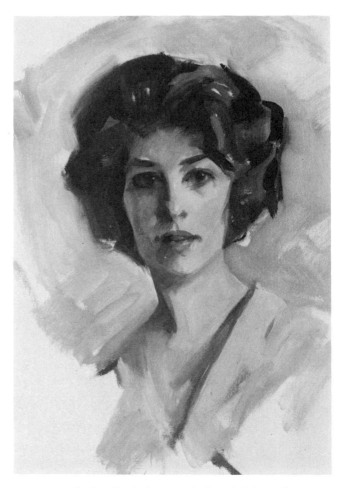

Step 5. *Kinstler has blocked in the hair in big masses of dark and halftone to capture its thick, wavy character. He fills in the neck and bodice and resolves the placement of lights, darks, and halftones in the head and figure. Note that the shadow on the right side of the head has been modified with reflected light along the edge. So far Kinstler hasn't painted in the lights with any significance, but he knows where they belong and is saving this step for later in the painting. The lips, eyes, and nose have been developed a bit further, but at this stage Kinstler's concern is centered on an accurate placement of values.*

Step 6. *Kinstler has decided to open the lips slightly to show a glimpse of teeth. He models the shape of the eyes and adds catchlights at the upper left edge of the irises. The cleft in the upper lip is shown, and the shadow at the right side of the neck is strengthened. Subtle modeling has been executed in the left side of the head to show the musculature of the cheek as it bulges slightly in a smile. A lighter tone is placed just above the left cheekbone. The shadow cast by the blouse is put in, and a background tone is introduced. This stage represents an effort to fuse the values in such a way as to retain form yet add cohesiveness to the portrait.*

Step 7. Mrs. Albert Kennerly *(right), oil on canvas, 23″ x 19″ (58 x 48 cm). By this final stage, many changes have been effected, but the structural stability has basically been retained. Kinstler has lowered the decolletage, expanded the sweep of hair, broadened the face slightly, accentuated the smile, lightened the area above the right eye, brought up the reflected light along the right cheekbone, and added highlights in the forehead, neck, blouse, and bosom. Also, the darkness of the eyes and lashes has been accentuated, and a necklace has been added to enhance design and color. Shadows in the face have been strengthened, and the left corner of the mouth has been darkened to show the plane formed by the fuller smile. A stronger light bathes the bridge of the nose, and lights mark the lower eyelid rims. Finally, extensive work has been done on the blouse, and the background has been fused and expanded. The result is simply super. (To see selected steps of this demonstration in color, refer to pages 84-85.)*

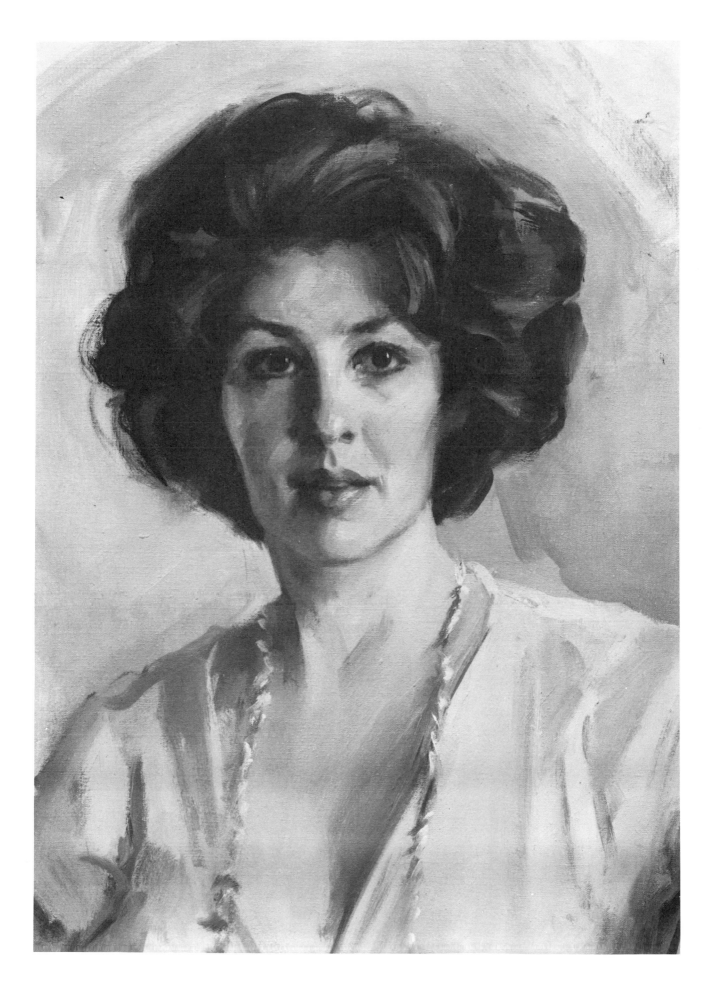

CHAPTER FOURTEEN
David A. Leffel at Work

A native New Yorker, David A. Leffel received his education at Fordham University, the Art Students League, and Parsons School of Design. Upon concluding his studies he became an illustrator, an easel painter, and an art instructor. Leffel has had seven one-man shows and has participated in a dozen or so group exhibitions. His illustrations have been featured on record covers and in Esquire *and* Redbook *magazines. He has been written up by* American Artist, *the* Chicago Tribune, *and* Art News Magazine.*

Prizes Leffel has won include the Ranger Purchase Prize of the National Academy of Design, the Frank DuMond Prize of the Salmagundi Club, the National Arts Club Prize of the Allied Artists of America, and grants and prizes awarded by the Hudson Valley Art Association and other groups, schools, and societies.

Leffel's paintings are included in the collections of Princeton University; the J. B. Speed Art Museum of Louisville, Kentucky; the New York Racing Association; the National Football League; and numerous private collections throughout the nation. Leffel currently teaches at the Art Students League. He maintains a home with his wife, Claire, and two children in New Jersey, and a studio in New York City.

Always controversial in his views on painting, Leffel maintains—unlike the other artists I have interviewed—that it's not necessary to get to know one's sitter to paint a portrait. Getting to know a person is to Leffel a literary experience, while the effort of painting a portrait requires only visual contemplation. Thus, Leffel doesn't probe his sitter's emotional makeup nor does he seek to form a first impression of her. He trusts his eyes alone to briefly analyze her bone structure and to estimate the kind of light that would show her to best advantage.

Leffel never consciously resorts to flattery but concedes that this might be a hidden, underlying consideration in executing a commissioned portrait. He is apt to use light to achieve a favorable presentation of the subject. Since most of his portrait sitters emerge with serious expressions anyway, the prospect of painting an elderly woman poses no potential problems to Leffel. He might even exploit her folds and wrinkles to stress the character inherent in old age.

Since Leffel paints strictly what he sees, his feelings about his sitter don't enter the effort. He contends that if he paints her honestly enough, the sitter's emotional traits will emerge. Character—strong or weak, positive or negative—will be reflected from the musculature of the face, not from some conscious effort on the artist's part to pinpoint a particular trait. If an element doesn't exist in the subject's face, Leffel simply won't paint it in.

In this respect, Leffel echoes the attitudes of a master such as Frans Hals who also restricted his painting to an honest depiction of the model's physiological features. Leffel feels that the essence of the sitter will emerge in a truthful portrayal of her physical attributes, and the artist has enough to do in solving his problems without indulging in psychological research, which causes a diminution of concentration on the main goal—the process of painting.

Leffel does visualize beforehand how the portrait will look when finished. He does this by translating the image of the subject into designs and patterns of light, shadow, and general color.

Leffel's prime goal in painting a portrait—or any kind of picture—is to achieve a good work of art. He doesn't overly concern himself about attaining a likeness; he feels this will come about naturally if the portrait has been skillfully painted. Still, a commissioned portrait imposes this requirement on the artist, and Leffel feels that he is probably freer in his noncommissioned work.

Leffel agrees with the painter and art scholar Maurice Grosser's contention that a kind of invisible power struggle enters into every portrait situation. If the sitter's personality dominates, the portrait will end up the way the sitter envisions herself. If, on the other hand, the artist is the stronger, the painting will emerge a self-portrait of the artist. The ideal is if the two personalities are equal.

Since Leffel generally paints in what can be considered the old master style—with the figures emerging from a dark background—his portraits tend to present a somber mood. In painting a woman or child, Leffel will go higher in key and possibly throw more light onto the features. He will generally use a flat light in a woman's portrait.

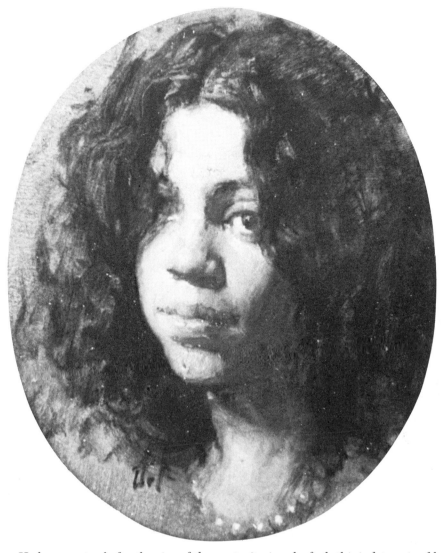

Claudia by David A. Leffel, oil on panel, 11" x 9" (28 x 23 cm). Leffel does nothing to prettify his subjects, but the compelling sense of humanity that emanates from their faces more than compensates for any absence of conventional beauty. There is an essential earthiness here that might be missing in the slick, more finished portrait. Leffel paints deep portraits that convey the passions of the soul and spirit. This is not to say that the more upbeat portraits of other artists are necessarily superficial, for they are not, it's just that each artist must follow his own road in his own way, based on his particular needs, attitudes, and spiritual, emotional, and physical compulsions.

He has no set rule for the size of the portrait, since he feels this is determined by the characteristics of the individual. Some people look better presented in smaller scale; others—those more powerful—dictate a larger painting. However, Leffel is very articulate on the dimensions of the sitters themselves. He never paints a larger-than-life head, since he finds this gross and unreal. He contends that every society maintains a comfortable conversational distance so that in no instance do human beings see each other in any but a below-lifesize situation. Since one of the major problems of painting is attaining an illusion of reality, painting a head smaller than it actually is perpetuates this illusion. To Leffel painting a person small to make her appear bigger is an artistic achievement.

He prefers to pose his models sitting. Most clients wouldn't agree to pose standing, and he feels the areas below the waist are not all that interesting from an artistic standpoint. A seated pose seems to him most natural for the portrait and provides the eye-level view he desires. He also prefers the three-quarter view of the head which he feels displays more character, form, and depth, as well as the most interesting aspects of the face. In his opinion a front-face view tends to become tedious, since it presents a repetitive image of everything—two ears, two eyes, etc. Profiles are desirable only if they are basically striking.

The basic consideration Leffel feels he must resolve is whether to paint the sitter from her left or right side. A variation might be to pose her with her head turned one way and her body another, possibly glancing over her shoulder. Arranging the body, head, and hands to face in varying directions creates movement and action in the pose. Leffel prefers to stand while he paints his portraits and therefore opts for the model stand.

Lizette by David A. Leffel, oil on panel, 7" (18 cm) diameter, collection Dr. Lois Macomber. Leffel paints many of his portraits under lifesize. He shrinks from the oversized portrait which he considers gross. To achieve the illusion of size by painting small is to Leffel an artistic achievement. Leffel's backgrounds are consistently dark, since he paints the head as if emerging from a deep darkness. The mood is generally somber, the expression serious. Although Leffel doesn't probe the sitter's emotional traits and paints just what he sees, his portraits are a tribute to what must be a keen, perceptive, analytical vision.

Jill Gibson (opposite page) by David A. Leffel, oil on panel, 13½" x 11" (34 x 28 cm). Leffel works in strong chiaroscuro—the light-to-dark value relationship lying within a painting. In this portrait, the illumination issues from high above, almost overhead. This creates dramatic contrasts of light and shade, but also makes attainment of likeness that much more difficult, since so many of the subject's features becomes lost in shadow. Few clients of commissioned portraits would agree to such lighting, but those who did would be rewarded with a painting much like those executed by the old masters. Most of those artists who use the Maroger medium tend toward this style of painting, which raises the question whether it's the medium that dictates the technique, or vice versa.

Unless the material of the dress is particularly striking, Leffel prefers informal attire, which he finds more interesting and natural. He leans toward dark garments, since he tends to concentrate his lights on the face and let the clothing serve as part of the background.

Leffel usually paints his portrait backgrounds as a dark mass with no discernible objects. He might set up screens and draperies to achieve this effect or invent the whole thing. He may also include a particularly interesting carving or texture of the sitter's chair. Since he normally tones his boards or canvases a dark color, this serves as an easy point of departure for the ultimate background. He views the background as an extension of the portrait's shadow and color tonality.

Leffel's portrait subjects are given lots of "air" around them, since this too promotes the feeling of reality. He feels that we see people in space, and the "air" makes the sitter appear less cramped.

He likes painting hands, unless the sitter cannot pose them attractively or has particularly unappealing ones. However, he loves to paint jewelry and would paint a heavily made-up woman just as she was.

Leffel is deeply committed to the so-called Rembrandt lighting in which the north light shines down on the sitter from high above (perhaps eleven to twelve feet) but not directly overhead. This light accentuates the areas under the facial planes and makes shadows fall into their proper place. Leffel works under artificial light only when working from photographs. Artificial light tends to affect the shadows adversely, making them too diffuse and not very crisp.

Leffel doesn't paint portraits outdoors, since this would produce an excess of light and weaken the shadow areas, an effect that wouldn't suit his manner of painting. He considers himself essentially a cool painter. His palette of colors has undergone a series of revisions lately. It now consists of the following colors in the Blockx line:

Flake white	Cadmium red light
Naples yellow	Prussian blue
Yellow ochre	Burnt sienna deep
Venetian red	Ivory black (used very sparingly)
Cadmium yellow orange	

This very limited palette of essentially opaque colors serves Leffel's technique perfectly. He believes in using color in what he terms a "subtractive" process, which means employing the least amount of color needed for any particular area. This way, when he wants to emphasize a passage, the small amount of *intensified* color provides a most effective impact, since it stands out so vividly against the other, reduced areas.

An example: he might take out most of the pink in a cheek area, then spot it in over one small area. The cheek will then appear a more vivid pink than had he painted the entire area this intense color.

Leffel finds that by exaggerating rather than subduing it, color can be made to function most effectively. He also invents color, since his method is not to copy slavishly what he sees, but rather to use value and color to provide the *illusion* of reality. This entails taking a color from reality and putting it down in mosaic fashion where it will prove most effective. This means inventing color.

Leffel doesn't consciously plan an overall color scheme for a portrait. Rather, he will reach for certain tonalities in his halftone colors. These might emerge bluish or greenish and, together with the complexion color, form the total skin color. For instance, a person with sallow skin might be painted with a blue, green, gray, or a violet halftone, each of which would modify the original complexion color, resulting in a definite overall skin color tonality.

Leffel separates Caucasian skin into three categories: sallow, ruddy, and orange. He would use yellow ochre and white for the first, cadmium red and white for the second, and cadmium orange and white for the third. Leffel contends that in black skin the shadow areas are more important than the light areas. He might paint these dark darks with combinations of ivory black and cadmium red. He would

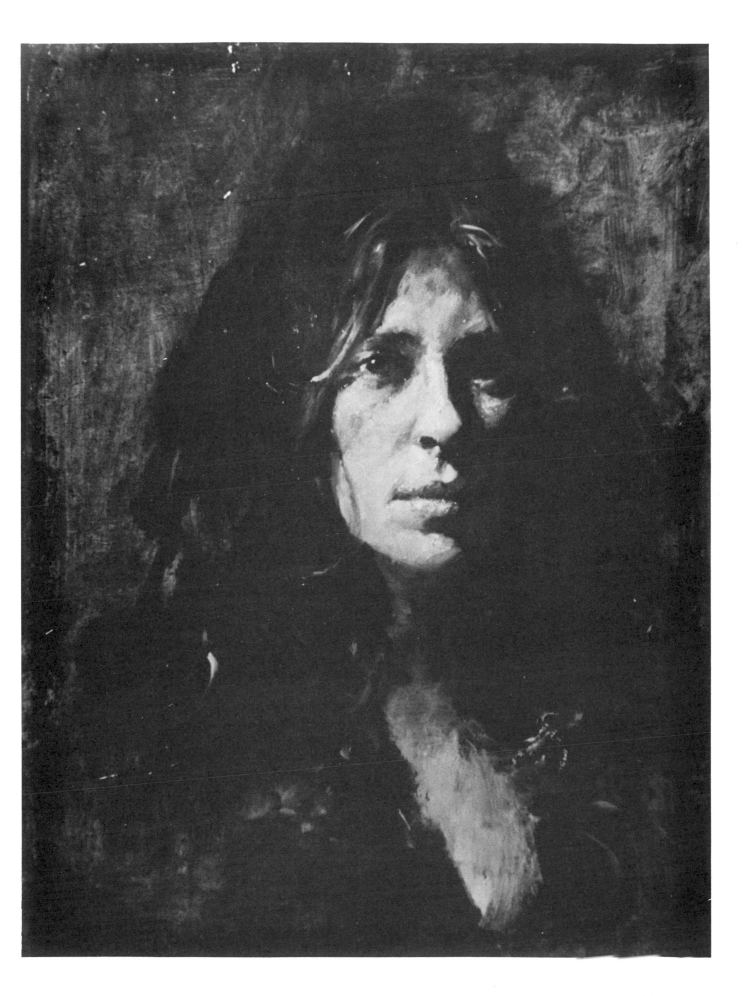

paint a pale Oriental as basically a sallow white person.

Leffel prepares his own canvas grounds with the traditional priming of rabbit-skin glue sizing followed by two coats of lead white. For his smaller portraits, he prefers panels of Novoply or flakeboard to the customary Masonite panel, which he feels has a tendency to warp. He paints on these panels in a varity of ways. Sometimes he paints with no preparatory priming at all, since the panels contain enough glue to accept oil paint. Or he sizes them with rabbitskin glue or primes them with lead white, gesso, or Maroger medium. He might also tone his surfaces with umber, a touch of cobalt blue, and Maroger.

He uses filbert brushes, preferably of the Grumbacher Degas brand. He doesn't use a knife for painting and uses it only to scrape down a passage or to prime his grounds. His painting medium is the widely disputed Maroger medium, which he concocts himself.

Leffel doesn't do any preliminary sketches—he pitches right into the painting. His technique is direct *alla prima*, and he works in what he considers the natural sequence—from dark to light. The richness of his paintings may mislead one as to the way he works; but he doesn't glaze, and he keeps his strokes precise and sculptural, with a minimum of blending. Basically, he puts down a brushstroke and lets it stand.

Leffel maintains that form has no edges. He uses the contrast of hard versus soft edges to make the light flow and stop. He attains the skin's tactile quality through this skilled handling of edges. He feels that the life of an oil painting is represented in the visible brushstrokes—the factor that lends it its desirable sculptural quality.

Leffel describes his painting procedure as simply putting in the darks first and the lights after. Unlike most painters he doesn't employ the term "halftone." To him there is only shadow and light, and where these two areas meet, the edge, is what most artists describe as halftone or middle tone.

In a portrait, Leffel tends to emphasize the eyes and will possibly subdue a nose or mouth. To relax his sitter he might play music, converse, or set up a mirror so that she can follow the progress of the painting.

He feels that only he can determine when the likeness has been achieved. He might listen to another's opinion, but the final decision regarding likeness must be his. Actually, Leffel says, it's technically possible to be off a bit in the drawing and still capture the essence of the person.

When the artist finds himself merely changing but not improving the portrait, it's time to stop.

Step 1. *On a previously toned board, Leffel marks in his basic shadows and makes some indication of where the eyes will be placed. There is no line drawing as such—the treatment is totally tonal, with several rough placements of light to guide the general apportionment of values. Leffel paints the head as if it were emerging from the background and, therefore, seldom outlines the back of the head where it will subsequently be lost in shadow. This is a device used extensively by Rembrandt, particularly in his late portraits.*

Step 2. *Middletones are developed in the lower face, in the nose, and in the hair. Some modeling has already taken place in the nose, cheeks, and forehead, but the mouth and chin are yet to be treated. Leffel paints in darks and lights only—he doesn't recognize the halftone, which to him represents the edge where the light and shadow come together. His method is to mix a tone and place it on the surface as is, without moving it about. This leads to a plastic, sculptural, three-dimensional effect in which the planes are very much in evidence. It's the very opposite of the flowing technique of some of the other demonstrators featured in this book.*

Step 3. *Still ignoring the mouth, Leffel has softened the edges between the darks and lights by covering them with strokes of cool tone. This makes the form appear to turn. Note how the nose seems to protrude and flow into the cheek from the corner of the right eye. It's not necessary to actively fuse areas to make them seem to come together. Placing gradually varying values next to each other achieves the same effect. Leffel has also modified the starkness of the shadow on the face by suffusing it with lighter color. Soon he will turn his attention to the mouth and chin.*

Step 4. *Both eyes have been placed with some degree of accuracy, and the wing and nostril area of the nose has been lightened and rounded off. Also, the first placement of the mouth is evident, and the contour of the chin is defined. In forthcoming stages, some of these statements will be modified, but for now, they suffice as a base upon which to build additional structural layers. Leffel never consciously goes after likeness. He is much more concerned with solving the other challenges of painting, and he feels that a reasonable likeness is a natural result of a successful solution of the more pressing problems.*

Step 5. *Resemblance comes closer as the subject's characteristic expression begins to emerge in the enigmatic Mona Lisa-like half-smile. More light has been thrown into the right jaw-line, and we see where it separates from the deep cast shadow bathing the neck. A strong light illuminates the center of the forehead, and additional lights are apparent in the right cheek, the corners of the mouth, and the chin. A highlight shows the rounded form of the right eye. The eyelids are shown in greater detail, and the lips are more carefully sculptured. Some additional light also indicates the form of the upper shoulder and collarbone.*

Step 6. Brett, *oil on panel, 20" x 16" (51 x 41 cm). Leffel did additional work on the mouth, narrowed the nose, and rounded off and shortened the chin slightly. The left eye curves down more, and is no longer so wide open. Lights have been placed in the irises, the corneas and the rims of the lower eyelids, and the cheek has been highlighted to emphasize the smile. The line of hair on the right edge of the face is fused into the skin to make the transition softer and more natural. These touches enhance physical likeness, even though Brett's inner presence was already in evidence. Leffel wisely left these corrections for last, first satisfying his initial priority—achieving a good work of art. The finished portrait reveals the deep spiritual quality of the subject who is very close to me. (To see selected steps of this demonstration in color, refer to pages 86–87.)*

Bibliography

Birren, Faber. *The History of Color in Painting.* New York and London: Van Nostrand Reinhold, 1965.

Blake, Wendon. *Creative Color: A Practical Guide for Oil Painters.* New York: Watson-Guptill, and London: Pitman, 1972.

Bullard, E. John. *Mary Cassatt Oils and Pastels.* New York: Watson Guptill, 1972.

de Reyna, Rudy. *Creative Painting from Photographs.* New York: Watson-Guptill, 1975, and London: Pitman, 1975

Fabri, Ralph. *Artist's Guide to Composition,* New York: Watson-Guptill, 1970.

Henri, Robert. *Art Spirit.* New York: J. B. Lippincott, 1930.

Hogarth, Burne, *Drawing the Human Head.* New York: Watson-Guptill, 1965, and London: Pitman, 1975.

Kinstler, Everett Raymond. *Painting Portraits.* New York: Watson-Guptill, 1971, and London: Pitman, 1975.

Massey, Robert. *Formulas for Painters.* New York: Watson-Guptill, 1967.

Mayer, Ralph. *The Artist's Handbook of Materials and Techniques.* New York: Viking, 1970.

Ormond, Richard. *John Singer Sargent: Paintings, Drawings, Watercolors.* New York: Harper and Row, 1971, and London: Phaidon Press, 1970.

Sanden, John Howard. *Painting the Head in Oil.* Edited by Joe Singer. New York: Watson-Guptill and London: Pitman, 1976.

Singer, Joe. *How to Paint Portraits in Pastel.* New York: Watson-Guptill, and London: Pitman, 1972.

Taubes, Frederic. *The Painter's Dictionary of Materials and Methods.* New York: Watson-Guptill, 1971.

Taubes, Frederic. *The Technique of Portrait Painting.* New York: Watson-Guptill, 1967.

Index

Page numbers in *italic* indicate paintings.

Edited by Connie Buckley
Designed by Robert Fillie
Set in 10 point Laurel by Publishers Graphics, Inc.
Printed and bound by Interstate Book Manufacturers